VICTORIAN DETAILS

VICTORIAN DETAILS

ENHANCING ANTIQUE AND CONTEMPORARY HOMES WITH PERIOD ACCENTS

BY JOANNA WISSINGER

E.P. Dutton
New York

Published in the United States by E. P. Dutton,
a division of NAL Penguin Inc.,
2 Park Avenue, New York, NY 10016.

Library of Congress Catalog Card Number: 89-50789
ISBN: 0-525-24844-7 (cloth)
ISBN: 0-525-48536-8 (pbk)

VICTORIAN DETAILS
was conceived and produced by Running Heads Incorporated
55 West 21st Street, New York, NY 10010

Editor: Sarah Kirshner
Managing Editor: Lindsey Crittenden
Production Manager: Linda Winters
Designer: Liz Trovato
Photo Researcher: Ellie Watson

Typeset by Trufont Typographers.
Color separations by Hong Kong Scanner Craft Company Ltd.
Printed and bound in Singapore by Times Publishing Group.

1 3 5 7 9 10 8 6 4 2
First American Edition

I would like to acknowledge and thank the people who were of help to me during the writing and production of this book. Sarah Kirshner, my editor at Running Heads, was terrific to work with and I am grateful for all her effort and support. Thanks to my husband Paul Mann, who typed the original manuscript onto disk; to Leslie Garisto, for her perceptive and thoughtful comments on the manuscript; to Barbara Curry Walsh, for generously supplying me with several books on Victorian design; and to Ellie Watson at Running Heads and Sue Manby for their photo research for this book.

Thanks also to Judith Thorn at Artistic License, to Cyril Nelson at E.P. Dutton, and to Gillian Gibbins at Virgin Books for their support and enthusiasm as well as their practical advice.

CONTENTS

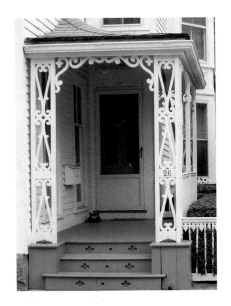
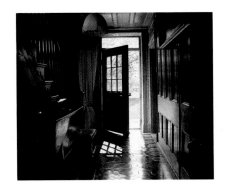
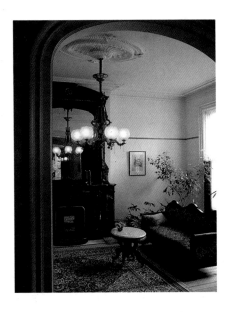

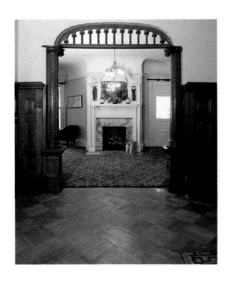

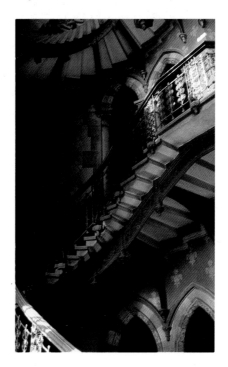

INTRODUCTION

Events seem to have come full circle. Despite the vigor of the Modern Movement, two world wars, and the upheaval and rebellion of subsequent decades, we seem to have returned to the nineteenth century. Almost one hundred years after Queen Victoria's death, the Victorian spirit is everywhere.

Newspapers herald the reign of the "new traditionalist." Examples of this trend abound in fields ranging from home furnishings, decorative accessories, and architectural details to fashion, restaurants, and magazines. In Britain and North America, people are restoring Victorian homes, redoing nondescript older houses in Victorian style, and building new homes that resemble their nineteenth-century ancestors.

Several factors sparked the current Victorian revival. Those who love antiques but can't afford to spend enormous sums still find the nineteenth century a fruitful hunting ground. Others, overwhelmed by the contemporary rat race, perceive the Victorian era as a romantic period of lace, ruffles, and soft colors. Still others appreciate the Victorian attention to detail and exuberance toward domestic style.

A love of Victorian ornament was also stimulated, surprisingly enough, through 1960s psychedelia. Hippies living in San Francisco's Haight-Ashbury neighborhood were among the first to appreciate the virtues of Victorian interior decoration. As the 1970s wore on, the grass-roots movement in Victoriana grew, and came to the attention of cultural institutions. Museums and private galleries showcased the best examples of nineteenth-century architectural details and decorative objects. The importance of Victorian design became clear to the general public.

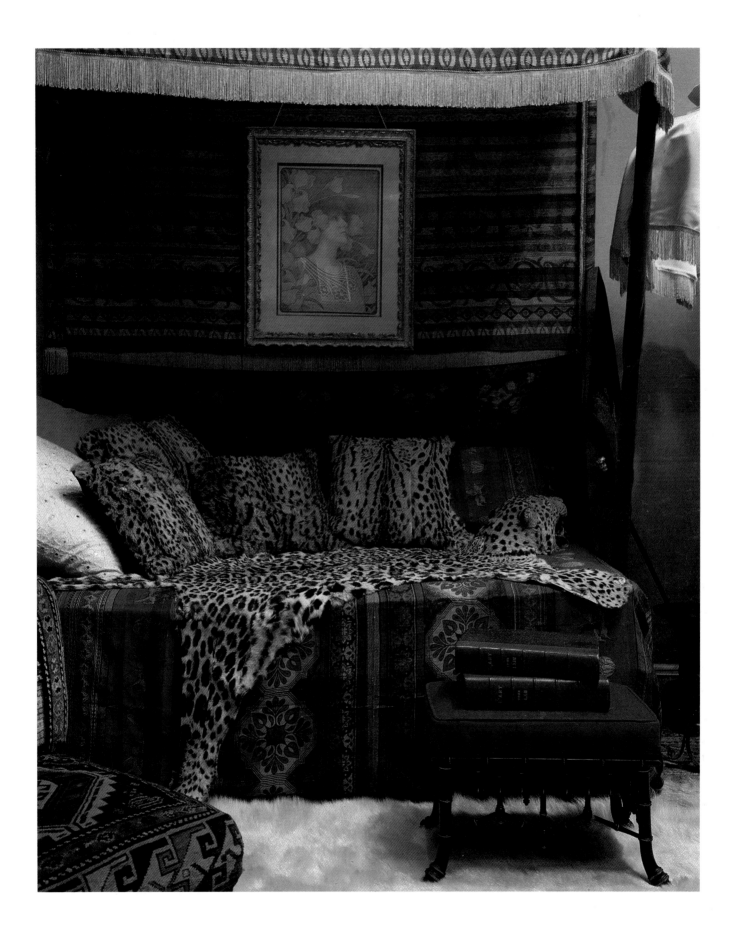

A TIME OF CHANGE

It's not just the current crop of furniture and home designs that seem to turn back the clock. There are many social and historical parallels as well. The nineteenth century was a time of change. Although Queen Victoria ascended the throne of Great Britain and Ireland in 1837 and ruled an empire for almost seventy-five years until her death in 1901, the era was only superficially unified by the extraordinary length of her reign.

During this three-quarters of a century, Britain gained an empire, and first dealt with the consequences of urbanization and industrialization. The North American continent was fully settled; the young nation passed through an agonizing Civil War and celebrated its first centennial not long after.

The social consequences of this historical turbulence are clear. For the first time in both nations, a significant group of people belonged to an educated middle class. They were conditioned to believe in the value of private property, the importance of commerce, and the sanctity of the family. They owned their own homes and decorated them with attention and care. Men worked outside the home, while women, "the angels of the hearth," maintained the sacrosanct domestic circle.

Our own era seems to build on many of these Victorian precepts, such as love of home, the importance of family, and devotion to children. All of these parallels, of course, take place with a modern twist. Women as well as men face the rigors of the commercial and corporate worlds, and either sex may don an apron to cook dinner when the long work day is done.

The panoply of lighting paraphernalia enhances the richness of surfaces—gleaming metal, sparkling glass, the warm glow of wood. The combination of chandeliers and candles with electric lamps with elegantly fringed shades, above, shows the Victorian Age as a time of technological change.

AN AGE OF VARIETY

The Victorian era is generally divided into three parts. The early period lasted from Victoria's coronation in 1837 to the Great Exhibition held in London in 1851. During the 1830s and 1840s, the Gothic, Elizabethan, and rococo styles began to replace the late neoclassical style in architecture and interior design. Exuberant and "picturesque" asymmetry was the rule.

Middle or high Victorian dated from 1850 to 1870. Renaissance and Rococo Revival styles came into full flower in these years. This period marks the high point of Victorian eclecticism.

Late Victorian covers the period between 1870 and the queen's death in 1901. The Aesthetic Reform movement arose in England during the 1870s through the 1890s in reaction to the profusion of poorly designed, machine-made goods that were then available. It emphasized simplicity, craftsmanship, and medieval themes. An American outgrowth of this movement, known as the Craftsman style, shared design domination in the United States at the end of the century with neo-traditional Colonial Revival styles that harked back to the eighteenth century.

The nine-year Edwardian age, 1901–1910, served as a Victorian postlude. Named after King Edward VII, Victoria's son, it distilled the themes of the Victorian Age into a true essence of its own.

Throughout the era, Great Britain (with some competition from France) was the arbiter of taste and the dictator of style. The youthful United States, still half wilderness, was only too happy to follow the decree of English taste in matters of home design and decoration. The Americans did go off on some tangents of their own—Carpenter Gothic houses are one such example, the "Painted Ladies" of San Francisco another—but on the whole, the history of design in both countries follows a similar path,

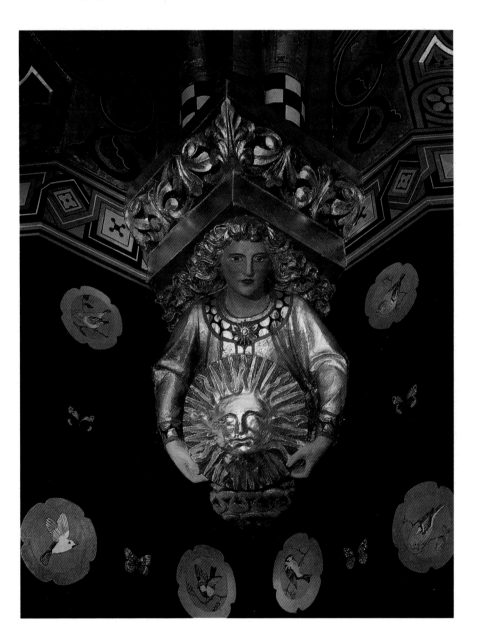

A carved figure from Cardiff Castle combines gold leaf, stencils, and painted surfaces in silent witness to Victorian eclecticism, above.

with the English generally somewhat in advance.

During the Victorian era, both countries experienced explosive economic growth. Consumer goods became available on an unprecedented scale. Referred to under the umbrella term "Victorian," a vast array of goods in a range of historical revival styles fall into categories that occasionally overlap but are generally fairly distinct.

Elizabethan Revival
(1840–50)

Rococo Revival
(1845–65)

Renaissance Revival
(1850–75)

Louis XVI (1860s)

Greco-Egyptian
Revival I (1860–70)

Japonisme, inspired
by Oriental art (1876–85)

Colonial Revival
(American, 1876–1910)

Greco-Egyptian
Revival II (1890)

Louis XV Revival
(1880–1900)

Aesthetic Movement
(1875–1900)

Arts and Crafts
(1880–1910)

Although the Victorians did not change their façades as frequently as they redid their parlors, architectural styles reveal a similar diversity of taste. While the Victorian age inherited classicism from the eighteenth century, it was soon replaced by Gothic Revival. In turn, the era ended with the beginnings of Art Nouveau—most definitely not a Victorian style.

In between, architects experimented with a variety of historical styles, including Elizabethan, Italianate, Tuscan, Second Empire (distinguished by

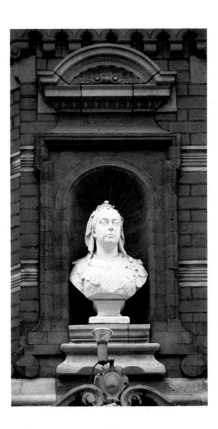

A bust of Queen Victoria looks out from the corner of a London building, above. The combination of limestone and brick was a nineteenth-century favorite.

mansard roofs), Romanesque Revival, and Queen Anne, known in the United States as "Eastlake." They also innovatively came up with some types unique to the era, including the Shingle Style, octagonal houses, and the Stick Style.

Some Victorian homes exhibit combinations of details from several styles. The Victorians regarded eclecticism as a virtue, particularly throughout the high Victorian period beginning at mid-century. They excelled at mixing and matching styles in inventive, fanciful ways. A Victorian home owner's imagination was limited only by the size of his fortune (and sometimes the size of the house).

Late Victorian interior decoration rebelled against this heterogeneity and over-ornamentation. The Arts and Crafts Movement, exemplified by the writing of Charles Eastlake and the designs of William Morris, arose in these years. Committed to returning art and design to what he regarded as the perfection of the medieval era, Morris designed furniture, textiles, and wallpapers with simple motifs based on historical examples.

With the rise of the Modern Movement in Europe in the early years of the twentieth century, Victorian design—from classical to Gothic to Greco-Roman-Assyrian Revival—fell into disfavor and was relegated to the dustbin of history. Even the clean lines and honest materials of Aesthetic and Craftsman-style furniture and decorative arts met with rejection. The Jazz Age succeeded the genteel Edwardians and the pressures of progress swept the Victorians from the stage.

VICTORIANIZE YOUR HOME

The Victorians reinterpreted classical details to suit their own taste. Technological innovations such as carving machines allowed the mechanical production of intricate historical styles previously available only to the very rich. The Victorian love of exotic plants resulted in the fashion for flower-filled conservatories, a *de rigeur* addition to upper- and middle-class nineteenth-century homes.

The eclecticism and love of the past prevalent in the fashion, food, and decorative arts of our own time echoes that of the Victorian era. The slow trickle of the Victorian Revival has grown to a spate of reproduction

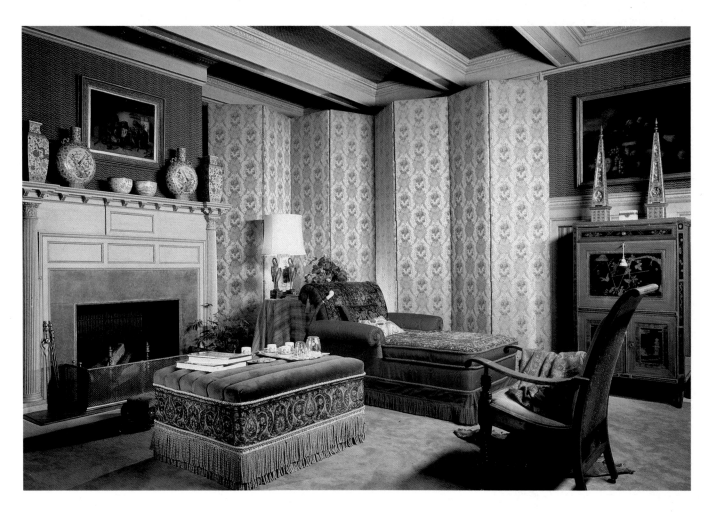

and original items now available in the marketplace. As a result, the contemporary revivalist enjoys a variety of decorative choices in every realm, inside and out.

This book proposes to serve as a guide to Victorian style. It's neither a how-to manual nor a renovation handbook. Instead, it's intended as an introduction to the Victorian decorative sensibility, presenting nineteenth-century ideas that you can adapt to suit your own taste and style.

To aid you in your quest, we have included a directory of sources. These include businesses that re-create and reinterpret Victoriana for today, as well as antique shops, salvage yards, and dealers.

New York City-based interior designer J. P. Molyneux has created this Victorian Revival interior, above, through the skillful use of rich fabrics, sumptuous trims, and judiciously chosen accessories such as the vases on the mantel and the throw over the chair arm. The chaise longue and tufted ottoman contribute to the romantic ambiance.

Part One

The Exterior

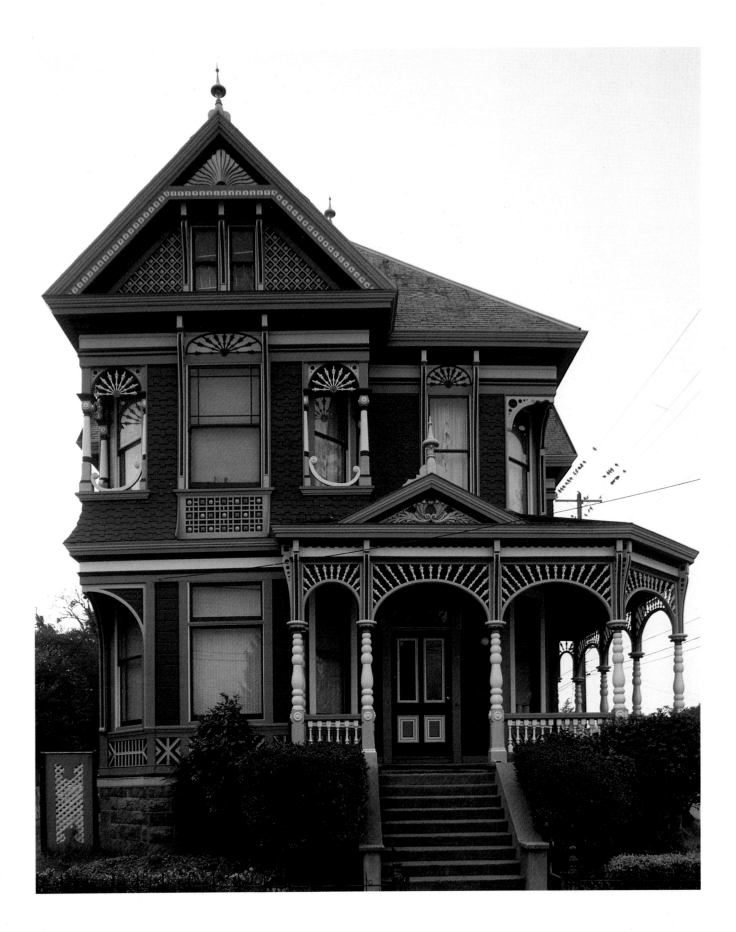

FAÇADES

In the United States, Andrew Jackson Downing, author of *Cottage Residences* (1842) and *The Architecture of Country Houses* (1850), was the single greatest influence on early nineteenth-century domestic architecture. His house-pattern books were used as models by carpenters (only the very rich could afford to employ architects) across the country. He was influenced by the Italianate and Gothic styles and by the exotic Alpine chalet, distinguished by deep, overhanging eaves and trim ornament of sawn wood (the original inspiration for Victorian "gingerbread").

In Britain during the 1830s and 1840s, a different architectural consciousness prevailed. The pointed Gothic and Italianate styles favored by Downing derived from houses built in late eighteenth-century Europe. These designs became popular in England first, then found their way to the United States via English house-pattern books.

In the 1850s, the influence of the critic John Ruskin led to the overwhelming popularity of the high Gothic Revival. Architects built many country homes in this mode, featuring asymmetrical massing, often around a central tower or spire, created by the use of several different types of steep roofs. Crisp Gothic details—pointed arches, carved moldings, and vaulted ceilings—further elevated the style.

During this period, the middle class participated in the building of architecturally significant detached houses for the first time in Britain. The word "villa" ceased to denote a large Italianate house on its own estate and instead suggested a moderate-sized home on the outskirts of town. These relatively modest dwellings (modest at least in comparison to the mansions that preceded them) were the most important architectural form of the nineteenth century.

On the American front, Downing recommended the Gothic style for its informal asymmetry, which he believed harmonized with the natural landscape. He detested the prevailing (c. 1830s) Greek Revival mode, referring to buildings in the style as "tasteless temples." He believed that the

Gothic style, marked by steeply pitched roofs, narrow arched windows, hood moldings, irregular outlines, was better suited to houses. It was decorative and romantic, even on a small scale.

The most eye-catching feature of these American Gothic houses (also known as Hudson River Bracketed, after their prominent roof brackets and the area of the country where a number were built) was the bargeboard, or vergeboard, located at the peak of the gable, which Downing emphasized with sculptural ornament—an innovative idea at the time. His vergeboards were richly three-dimensional, carved with pointed arches and crosses and deepened with molding. They were later copied in a flat, naive fashion by rural carpenters in a style that became known as Carpenter Gothic. These were simplistic interpretations of Downing's sophisticated style, but they too had their charm.

Italianate homes are characterized by simple lines, and complemented by projecting terraces, balconies, and porches. Window frames and doorways are often arched. Brackets support projecting eaves. Small square towers, known both as campaniles and cupolas, rise above the main body of the house, and serve as the style's hallmark.

In *Cottage Residences*, Downing acknowledged that square or rectangular houses were less expensive to build, but he urged the addition of oriel and bay windows, porches, and decorative trim. This concealed dull, boxy outlines and gave the house a more complex silhouette.

Downing's late-century counterpart was British critic and supporter of the Aesthetic design reform movement, Charles Eastlake, who published *Hints on Household Taste in Furniture, Upholstery and Other Details* in Britain in 1868 and in the United States in 1872. Like other theorists of Aestheticism, such as William Morris, he excoriated the excesses and clutter of mid-Victorian taste and proposed a simpler style, strongly influenced by designs and motifs from the Middle Ages.

After publication of his book, the Eastlake style, a popular version of the Aesthetic style, was all the rage in both England and America. His name was soon appended to a variety of manufactured items, from wallpaper to teacups. In architecture, the Queen Anne style, with its ornamented structural members, was also known as "Eastlake." These houses also featured decorative panels under eaves or between win-

dows and doors. They often showed stylized flowers, suns, or geometric designs, another example of Eastlake's influence.

His prestige also shows in the colors that Victorians chose for their homes in the 1870s and 1880s. Eastlake inspired the fashion for houses painted in a variety of harmonizing shades. Terra cotta was another of his favorite materials, and is often seen used for decoration on the exterior of Queen Anne houses. Other Eastlake motifs are decorative incised ornament, set-in spindles which create a gallery effect, and the arrangement of sticks in a geometric pattern on porch rails or as a gable decoration.

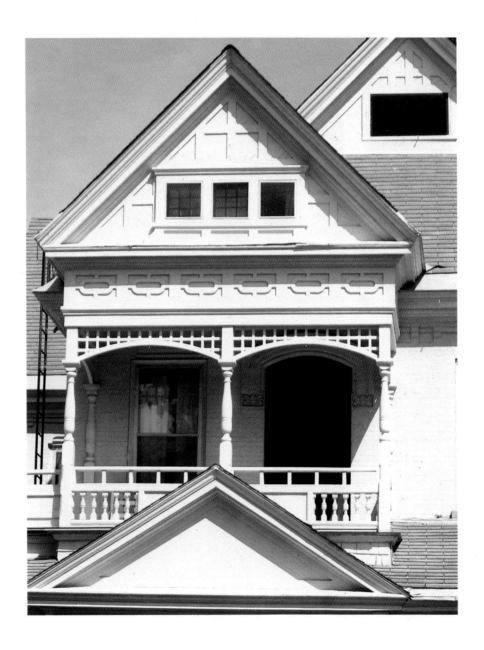

PORCHES

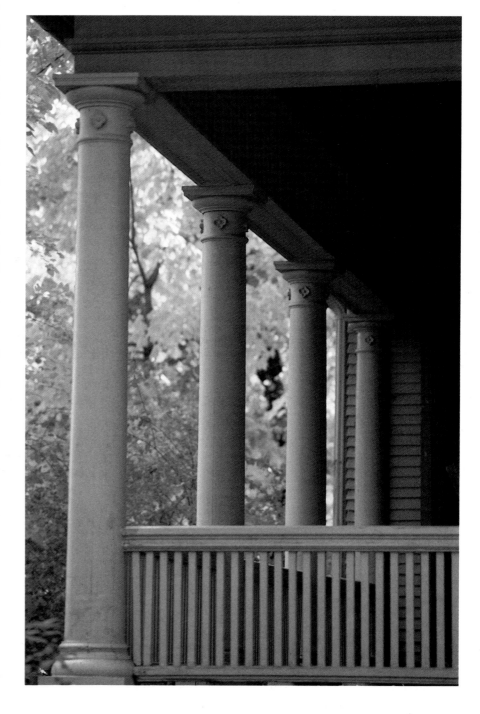

More often than not, Victorians referred to the porch as the "veranda," a word that originated in British India. Victorian verandas are more than just porches—the word implies broad, roofed expanses, almost like outdoor rooms. The Victorians certainly treated them as such, equipping them with gracious wicker furniture and sometimes a built-in swing, and using them for everything from eating to reading to entertaining guests. Was there ever a more delightful spot for tea on a summer afternoon?

Porches were practical additions to Victorian homes. They were open to cooling breezes, comfortable on all except the hottest days. Awnings were another practical and shady feature often seen on nineteenth-century facades. They served to shield the exterior walls from the sun and help to lower the temperature still further. They also provided distinctive accents, employing bold stripes of color.

Victorian verandas usually had either pitched or flat roofs, depending on the style of the house to which they were attached. Sometimes, however, verandas featured "tent roofs," whose concave curves resembled in shape the light and graceful swoop of a canvas awning.

Porches often feature ornamental railings and are adorned with sawn-wood gingerbread trim. Their roof brackets exhibit a variety of styles. Some bear curvilinear designs reminiscent of looping vines. Others have stylized rays or floral cutouts. Balusters, balustrades, rails, and posts display an equally appealing variety, often designed to echo the bracket motifs.

Adding a porch to an existing house isn't difficult. Of course, a porch addition can be custom-designed by a local contractor. In addition, many kit-home manufacturers can also supply both lumber for the designs, and customized ornamental details as well, for much less than the cost of hiring an architect for the job.

For an existing porch that has

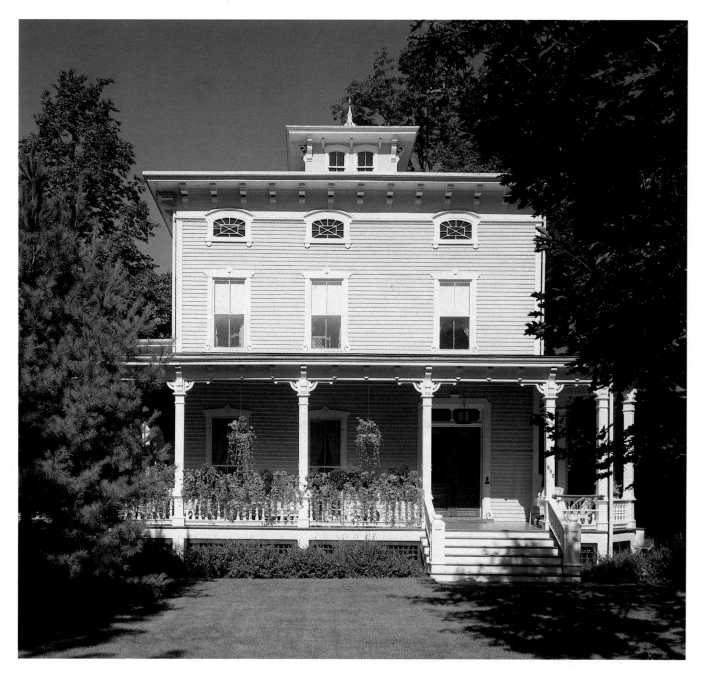

been stripped of its details—or never had them in the first place—there are also several companies that make customized architectural mill-work and fixtures, such as porch railings, posts, and fretworks.

The Cumberland Woodcraft Company of Carlisle, Pennsylvania, is one of these. All items are carved and turned of solid poplar. Silverton Victorian Millworks, of Durango, Colorado, can provide similar elements, including turned or sawn balusters in four different styles. All are of pine. For home owners on a budget, Silverton makes "economy" posts and balusters of pine or hemlock that are hollow inside—thus you can also save money on shipping charges.

Doric columns and a straightforward railing, opposite page, contribute to the serenity of this neo-Greek house in Evanston, Illinois. A more elaborate and idiosyncratic treatment, above, suits this Italianate home in Saratoga, New York. Hanging plants and leafy vines create a shady retreat for sunny days.

BALCONIES, PORTICOES, AND BALUSTRADES

Balconies, porticoes, and balustrades are other Victorian decorative features that are easily added to the façade of a house to give it a historical air. Balconies are essentially porches on an upper floor. A portico is a small porch that occupies the area immediately around the door, emphasizing its importance as the main entrance to your home. In a very grand Victorian home, the front portico supports a second-floor balcony, creating an imposing entry composition.

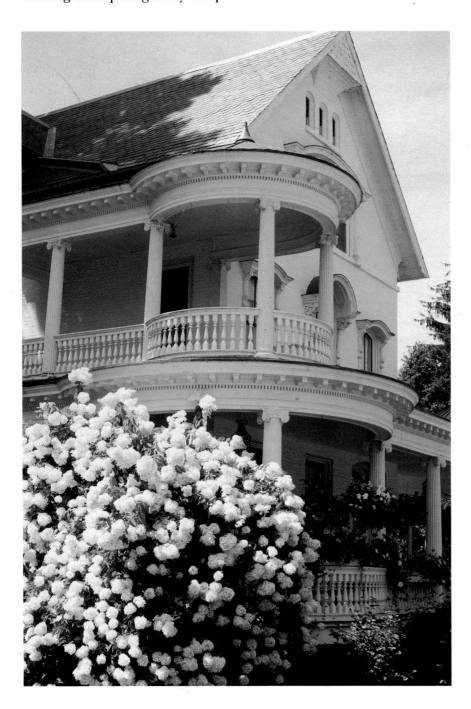

A balustrade usually consists of parallel horizontal rails attached to full-height porch posts or pedestals, with the space between the rails filled in with decorative posts known as balusters. These ornamental railings can top off a portico or trim a balcony. They can also run along a projecting ledge to serve as an ornamental division between stories.

In addition to full-scale porticoes with wooden columns and railings, Victorians also employed door canopies and hoods, resembling porticoes without side supports. Intricate sawn-wood ornament often bedecked these.

If you have a nice view or ornamental window that you want to emphasize, a balcony is the thing. A house with a graceful railed porch would look very attractive with the same railing repeated, perhaps in miniature, on an upper-story balcony. A portico can help to reduce energy costs as well. In the summer, it prevents sunlight from reaching and heating the interior. In the winter, it helps to keep cold air out. Lumberyards and millwork specialists can provide the decorative wood elements necessary to create any of the three.

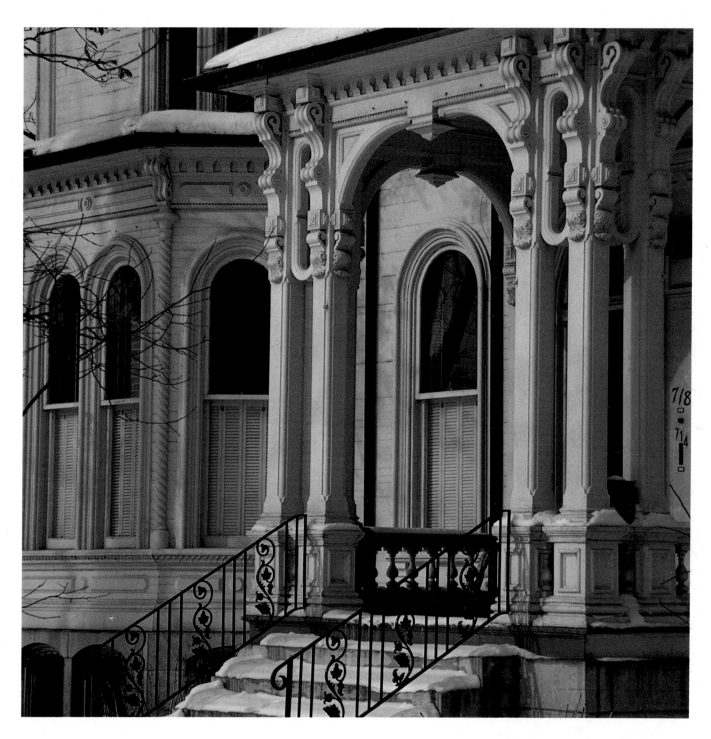

A semi-circular balcony echoes the curve of the first-floor veranda, opposite page. The balcony's asymmetrical placement lends a picturesque touch to the otherwise balanced façade, an effect much appreciated by Victorians.

The rich carvings of this portico on a Victorian home in Kalamazoo, Michigan, above, serve to frame the doorway and enhance the importance and ceremony of entrance.

WINDOWS

O ne of the Victorians' favorite exterior accents was the projecting bay or oriel window. Projecting windows on the ground floor are called bays; those on upper levels are known as oriels. (In fact, one of the colleges at Oxford University is known as Oriel, after the numerous windows of this type that adorn the building's exterior.)

Other types of windows common in the Victorian age were lancets, round-headed windows, and bull's-eye or oculus windows. Lancets are tall, narrow windows with pointed tops, most often seen on Gothic Revival-style

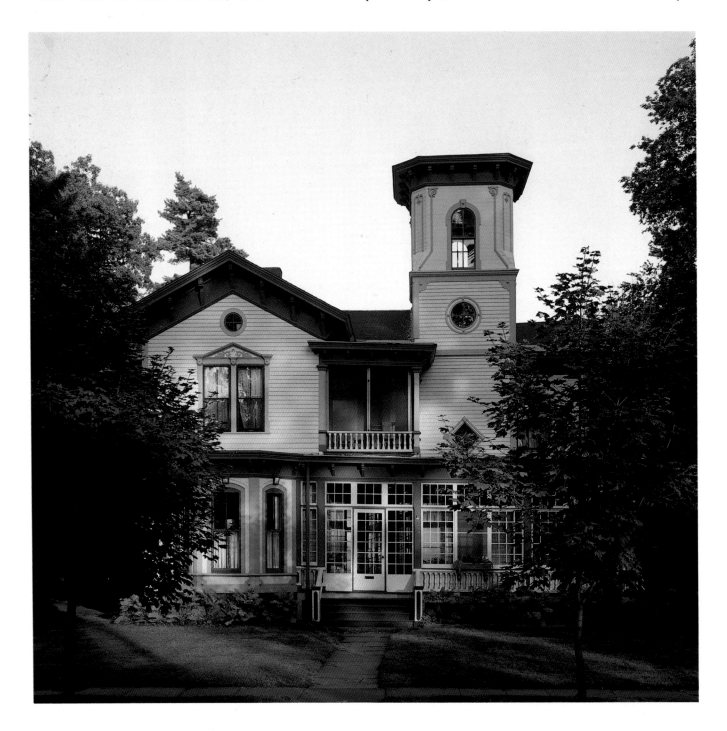

homes. Round-headed windows, usually found on Italianate and Romanesque Revival houses, have semicircular tops. Bull's-eye windows are small and round, most often found at the peak of a gable or pediment, or sometimes above a door.

Towards the end of the 1860s, as the Victorians began to run out of historical styles to revive, designers began to mix various styles. As a result, Gothic lancet windows and Italianate round-headed windows would often appear on the same house. The treatment of window panes changed as well. Earlier in the era, home owners had favored simple one-over-one pane arrangements, happy that the science of glass-making had progressed to the making of such large sheets; beginning in the late 1860s, windows sporting elaborate arrays of fancy muntins, etched glass, multiple panes, and small decorative windows were installed—all for the sake of decorative ornament.

The window surrounds received their share of decoration as well. The lintels, the simple caps above the frame, and the stiles, the vertical portions of the frame, were enhanced with incised or carved ornament. Carved foliage was a favorite choice. Window caps, which sat above the lintel, shared in the decorative bounty.

Today, kits, including lumber and plans, are available for the addition of bay and oriel windows. Several window companies make facsimiles of Victorian lancet, lattice, and round-headed windows. New windows can do more than just change the exterior of the house. As well as allowing more light into the room, bays and oriels give additional space and offer the opportunity for exciting window treatments and seating areas. In addition, a bay or oriel window can serve as a mini-conservatory—a truly Victorian touch to a room.

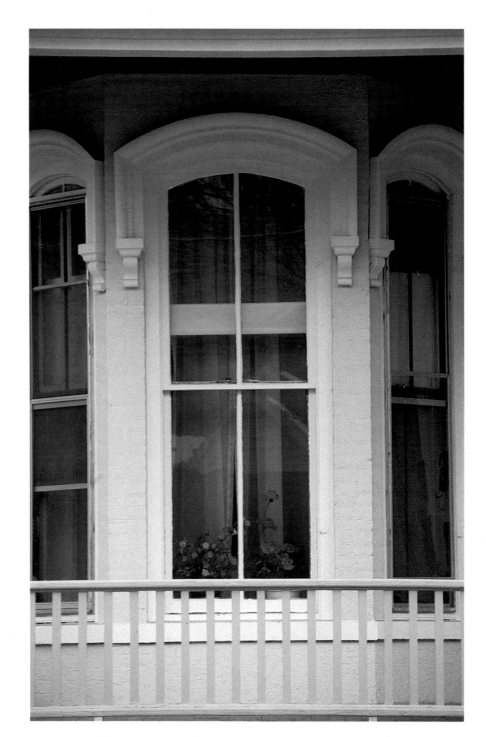

A profusion of various window shapes and sizes—oeil-de-boeuf, lancet, lattice, and round-headed—enliven the façade of a house in Saratoga, New York, opposite page. A tall, narrow window, above, with two-over-two panes and a Gothic hood molding, is typically Victorian.

SHUTTERS

S hutters were an important feature of the Victorian home. Operable shutters gave essential protection against the bright summer sun. The style of the shutters (also sometimes called blinds) depended on the overall style of the house. As with other types of sawn-wood ornament, they often reflected the fanciful verve and imagination of nineteenth-century carpenters. Popular designs included interpretations of classical ornament, stylized flowers, rising suns, and idiosyncratic decorative shapes.

Less opulent but equally authentic are shutters in the neo-Greek style, which exhibit simple rosettes or tasteful rondels. Arts and Crafts shutters featured curvilinear, organic designs, using stylized flowers and leaves, while Gothic-style homes sported pointed shutters carved with angels.

Plain or fancy, the most popular nineteenth-century color for shutters was green, usually a dark hue such as bronze green or "park lawn green" (a dark forest green). But shutters were also painted to match the house—any tint from somber to flamboyant. Sometimes frames and louvers were painted in different colors.

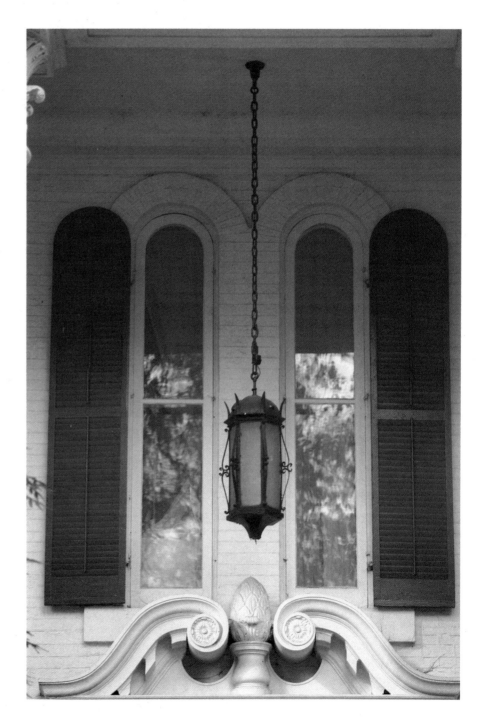

A graceful pair of tall, arched windows above a curved pediment, right, in Evanston, Illinois, has matching round-headed shutters.

CLAPBOARDS AND DECORATIVE SHINGLES

While many nineteenth-century homes have façades of stucco or stone, the Victorians also used wood for a host of exterior decorative purposes. Not only did Victorians adorn their homes with sawn-wood gingerbread, as described elsewhere in this chapter, they made use of more prosaic elements, such as clapboard siding and shingles, in various inventive and imaginative ways.

One of the most effective of these methods, especially common on Queen Anne-style houses, was to combine regular clapboard siding with decorative shingles, which came in a range of shapes. The overlapping, round-ended shingles known as fish-scale shingles were quite popular. Other styles resembled basket-weave and herringbone, as well as other geometric motifs.

Sometimes shingles were introduced as a decorative panel on a clapboarded wall, filling in between windows, for example, or between a wall and a door. Another way to combine the two featured a recessed balcony sided with clapboards on the façade of a shingled house.

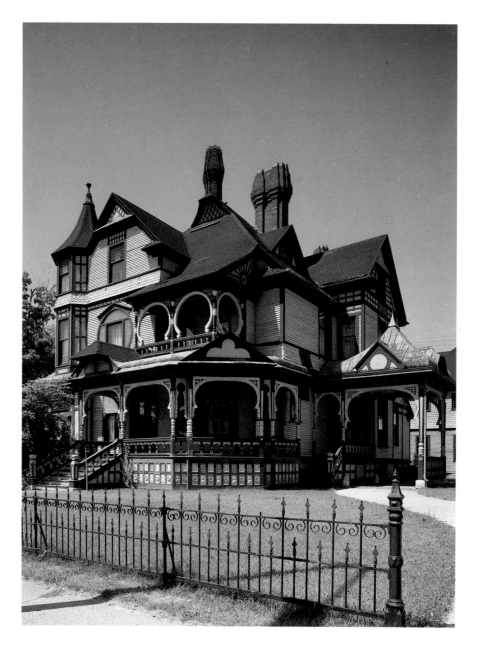

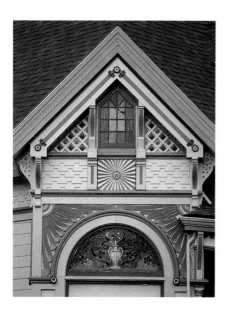

Decorative lattices and carved sunbursts adorn a gable and create a rich, sensuous play of light and shadow on a house in the Bay Area of Northern California, above.

The Hackley House in Muskegon, Michigan, above, displays a variety of decorative exterior surfaces. Note the fishscale shingles on the corner porch gable, as well as the repetition of keyhole arches on the second floor.

SAWN-WOOD ORNAMENT

The crowning glory of the Victorian ornamented cottage was its sawn-wood trimming, which we've come to call gingerbread. The style arose in the United States (there is no real British equivalent) as local carpenter-builders interpreted the ideas of A. J. Downing and Charles Eastlake. The houses they built were commissioned by middle- and working-class home owners living in rural areas who could not afford to hire expensive architects or employ costly materials like stone or brick, but reveled in counterfeiting expensive carving and casting in sawn wood.

The result was charmingly naive. Gingerbread ornament, often made of lumber left over from the construction of the house itself, is generally found at roof and porch eaves and around windows; a particularly popular spot was at the peak of a gable. These ornamental moldings, known as bargeboards or vergeboards, took a variety of forms: They could be light and lacy, rigidly geometric, or solidly three-dimensional.

Sawn-wood ornament makes a striking addition to a house, especially in combination with paint applied in a multiple toned scheme to emphasize its curves and scrolls. For just a hint of Victoriana, a bit of lacy trim and a carved pattern around a window or door or at least the eaves provide a sense of ornamentation without a lot of fuss.

Another style of hewn embellishment, associated exclusively with the theories of Charles Eastlake, appeared in the final decades of the nineteenth century. Most often seen on Queen Anne-style houses, it consists of designs, usually floral or geometric, carved into window lintels, door frames, and other moldings. While essentially low-key, it serves well the Victorian ideals of complexity of texture and detail on every possible surface.

The millworks mentioned earlier in this chapter can supply both stock patterns and custom-made ornamentation. Salvage yards are a good source for vintage gingerbread. And some of the simpler items could be produced in a home workshop.

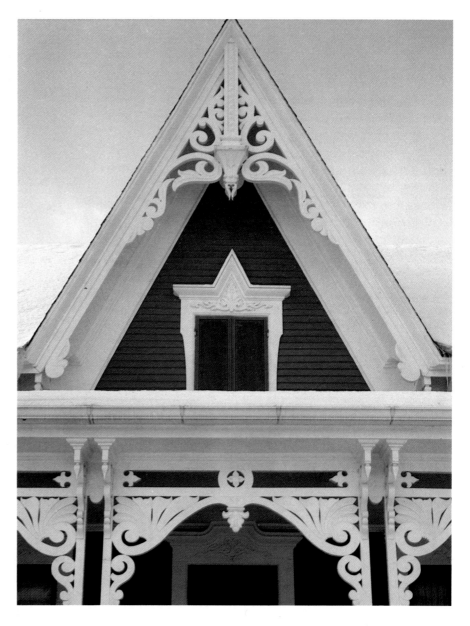

Delicate, elaborate curvilinear sawn-wood ornament, known familiarly as "gingerbread," adorns the peaked gable and cornice of this home in Romeo, Michigan, above.

SPINDLES

astlake-style houses often featured spindles set into the exterior wall for a decorative effect. Smaller in size but similar in style to those used in ground-floor porch railings, the spindles sometimes served to echo the porch design. (They were used on upper-story balconies as well.) Standardized spindles are available at many lumberyards or can be ordered from the millworks mentioned earlier.

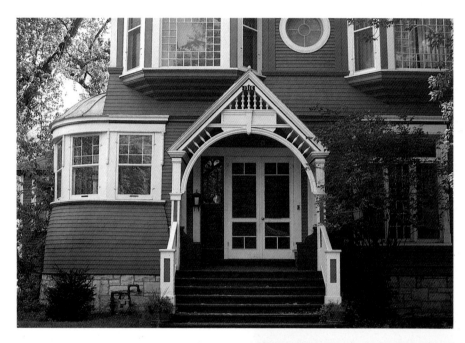

Turned spindles of different lengths combine to form an airy and refined portico, left, for the front door of a home in Evanston, Illinois.

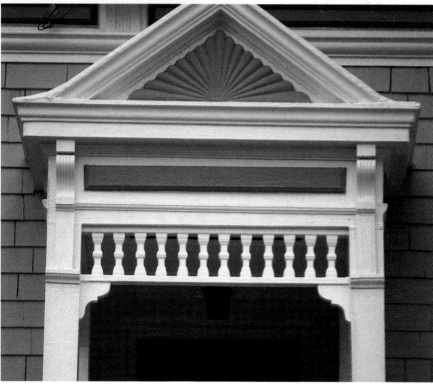

A brief fringe of spindles trims the cornice of a Northern California doorway, right.

BRICK AND STUCCO SIDING

Brick, stucco, and stone, used both for the structure of the house itself and for decorative details, were very popular in the nineteenth century. During our own time, however, the vast majority of homes were built using wood framing. Since the 1940s, advances in technology have provided artificial versions of these materials that can be applied over a wood-frame house to look like the real thing.

The most flexible of these new siding processes is acrylic stucco. This lightweight coating is applied by an expert crew over any kind of base. It can also be employed with foam blocks to create architectural details such

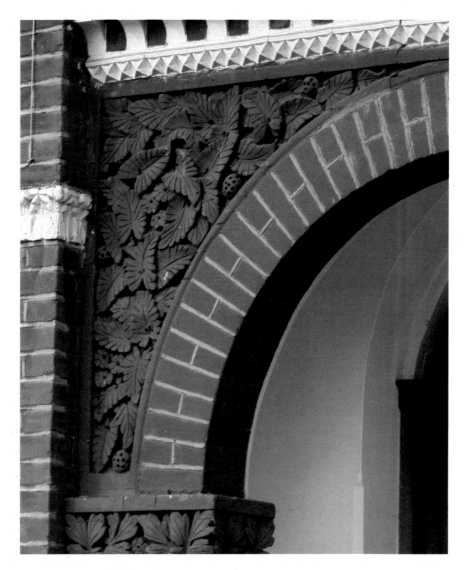

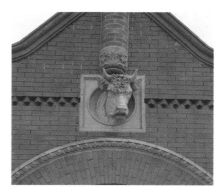

Turn-of-the-century brickwork and terra cotta in Tooting, South London, embellishes the arch of an entryway, left. A cast-terra-cotta bull's head, above, projects from a Victorian façade in Evanston, Illinois.

Also in Evanston, decorative brickwork enhances a corner by creating the illusion of a quoin, above.

as keystones, lintels, and quoins where none existed before.

Struck mortar and cultured stone are other types of applied sidings that create the look of masonry. They can be used in conjunction with acrylic stucco to turn a wooden house, for example, into one that's "brick" with "limestone" details. Painted the proper color, this combination can also give a credible imitation of the popular Victorian twosome of brick and terra cotta.

MOLDINGS, MEDALLIONS, AND DECORATIVE TABLETS

A variety of exterior moldings were common on Greek Revival homes. Among them were the anthemion, or honeysuckle, used singly and in bands, for friezes; the Greek key fret, also seen as a frieze; ornamental roundels known as "paterae," and egg and dart moldings, habitually seen on building cornices. Also prevalent in cornices were dentils, small solid blocks, and decorative swags. These swags often appeared by themselves on ornamental tablets, placed between or above windows. Combined with bows, they made a charming ensemble.

It was on Queen Anne houses that the decorative medallion reached its apotheosis. Carved panels showed up all over the exterior of the house, from the spandrels above the porch to the ornaments on the gables, and everywhere in between. These panels came in various materials: cast iron, wood, and terra cotta, to name a few. In the 1800s, they generally bore classical or floral detail. A frequent example of this was the sunflower, the symbol of the Aesthetic movement. All over the United States and in Great Britain, thousands of structures erected in the 1870s and 1880s were adorned with this motif.

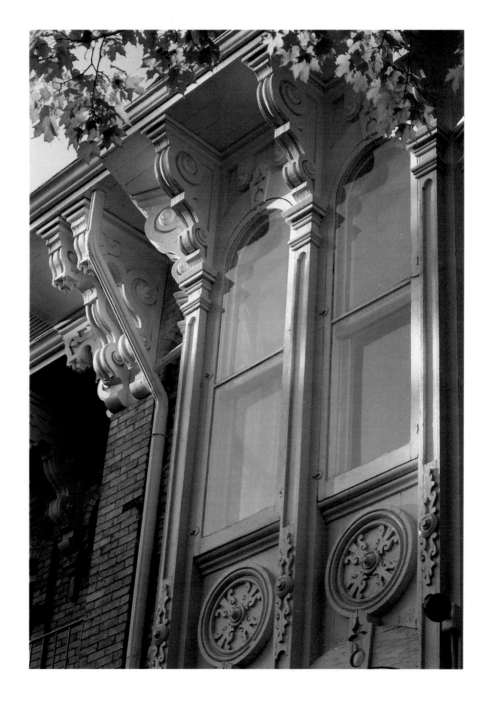

Intricate medallions combine with carved and incised ornament to decorate the window aprons of a building in Owosso, Michigan, right.

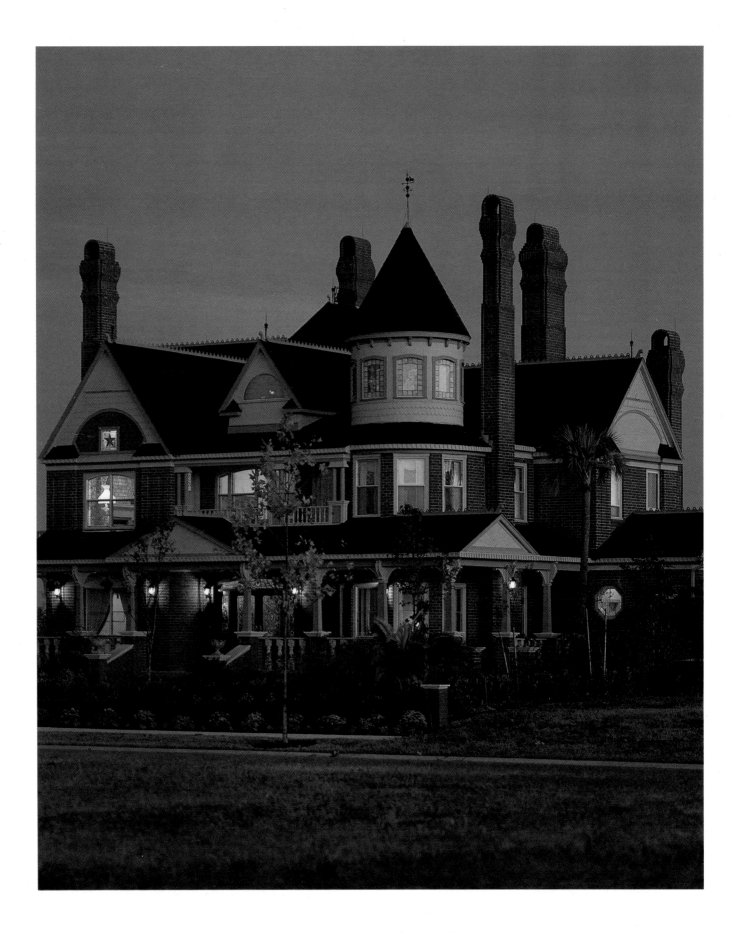

2

UP ON THE ROOF

Up on the roof of the Victorian house lay a wonderland of ornamental details. The influence of American architect Andrew Jackson Downing and British theorist Charles Eastlake, the major design theorists of the nineteenth century, extended to the roof as well. Downing's endorsement of the picturesque and irregular, a fashion that originated thirty years earlier at the turn of the eighteenth century in England with the buildings of John Nash, led to the construction of homes that bore spires, turrets, domes, and cupolas.

Eastlake, writing later in the century, spoke out against what he perceived as the excessive clutter and eclecticism of the mid-Victorian house. As a replacement, Eastlake favored the simplicity of medieval motifs. Along with his fellow British interior-design theorists, Walter Crane and William Morris, and American Louis Comfort Tiffany, he proposed a return to the straightforward craftsmanship that he believed prevailed before the Industrial Revolution. He supported the use of strong uncomplicated shapes adorned with geometric ornament. While this philosophy of design may sound familiar to modern ears, it proved radical and revolutionary to our nineteenth-century ancestors. "Eastlake" became synonymous with a decorating craze that swept the United States and Britain. Young women were given Eastlake's *Hints on Household Taste in Furniture, Upholstery and Other Details* as a wedding gift. According to Victorian writer Harriet Spofford in *Art Decoration Applied to Furniture* (1878), "all its dicta were accepted as gospel truths."

Architects and builders incorporated many of his ideas into their designs. On the roof, the Eastlake influence appeared in the form of fleurs-de-lis and Gothic crosses.

SHINGLES

Victorian roofs were generally covered with shingles made of either wood or slate. Slate, while expensive, is an attractive and durable material. During the Victorian era it was the predominant roofing material in Britain, quarried in Wales; in the United States, wood predominated due to its low price and wide availability. There is no reason why a well-maintained and cared for slate roof should not last indefinitely. Slate comes in a variety of colors: blue-gray, blue-black, and black; red, green, dark gray, and purple; and a range of gray shades.

These colorful slate shingles allowed the Victorians to indulge their taste for architectural whimsy in details such as striped roofs. Many nineteenth-century houses feature variegated roofs banded in two different, usually contrasting, tones of slate. Mansard roofs, with their nearly vertical sides, provided a particularly good way to display this striped effect, as did steep peaked roofs and gables.

Another decorative possibility offered by slate's colorful nature was the formation of ornamental motifs in various hues. A roof designed in tones of gray might sport a quatrefoil—a leaflike ornament with four lobes—in red. A green roof might display ornamental motifs in black or purple. A noticeable contrast in colors is important. Simple designs, trefoils, quatrefoils, and diamonds, were popular with the Victorians.

Wood-shingled roofs were most often made of cedar, which during the nineteenth century came mainly from thousands of trunks found perfectly preserved in the New Jersey swamps. (The United States, with its abundant resources, also exported wood to the rest of the world.) The Victorians often cut their roof shingles in ornamental shapes. There were four principle types: octagonal, diamond-shaped, segmental (the arc formed by a third of a circle), and half-circular.

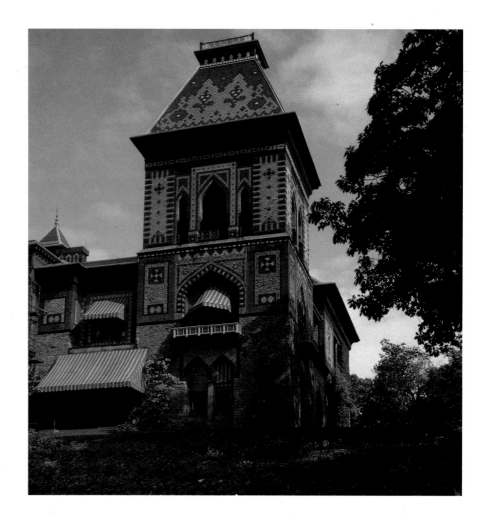

While wood shingles lacked the intrinsic hues of slate, Victorian home owners compensated by staining their wood-shingled roofs in various colors, including dark red and olive green. The modern home owners who can't afford slate or wood shouldn't despair. Asphalt tiles, while not strictly Victorian, do come in close-to-period colors.

Lustrous slate shingles, above, shine from the mansard roof of Olana, artist Frederick Edward Church's home and studio in the Hudson River valley in New York State.

METAL AND TILE ROOFS

The basic Victorian Revival roof begins with slate or decorative wood shingles. However, the enterprising Victorians were not averse to experimenting with new materials. Many Victorian homes, particularly those in urban areas, had roofs made of tar paper, asphalt, and gravel. Even metal made an appearance on nineteenth-century roofs in the form of "tinplate," iron coated with an alloy, most often of lead and zinc, to prevent rust. These roofs, manufactured in England and imported to the United States, were joined into rolls with flat seams. On the roof itself, the rolls, laid out flat side by side, were sealed by standing seams that created

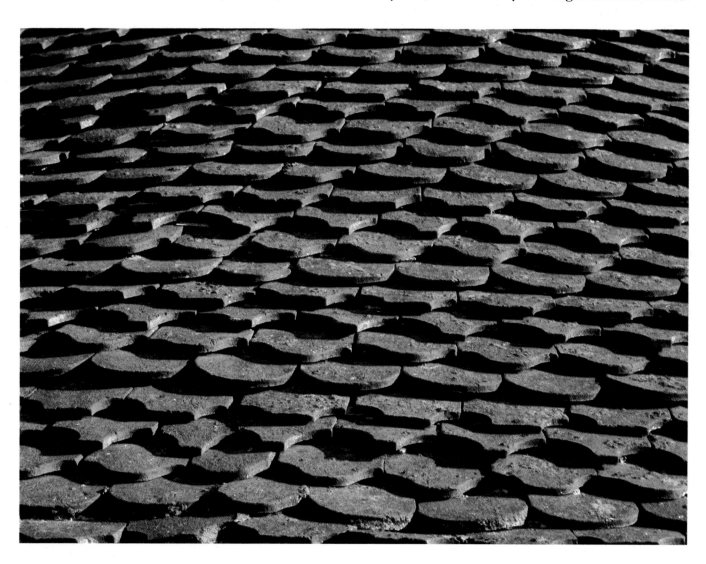

parallel lines leading from ridge to eave. The areas thus defined were often painted in alternate colors to form stripes. Victorian homes in the Mediterranean style frequently had roofs made of wavy-edge terra cotta barrel tile, yellow or reddish-brown.

A detail of a roof from a Victorian building in Cowes, Isle of Wight, above, shows the texture created by the uneven edges of the tiles.

GABLES

A gable, in the dictionary definition, is the triangular section (called the tympanum) at the end of a pitched roof, bounded by the two roof slopes. On Victorian homes, with their multiple roof slopes, gables often appeared as part of the roof. Sometimes gables were half-timbered, in imitation of the architecture of Tudor England. On the original medieval buildings, the exposed timbers were the actual structure of the building, and the spaces between were filled with plaster, stucco, stone, or brick. Victorian half-timbering was purely decorative, but often employed the same materials.

The tympanum was also often shingled, usually with the same type of decorative shingles seen on the roof. When shingles were used, they were often painted a lighter color than the body of the house or the rest of the roof, usually yellow, terra cotta, or orange, rather than the dark reds common for roofs.

Gables also sported ornamental bargeboards, discussed in the chapter on façades.

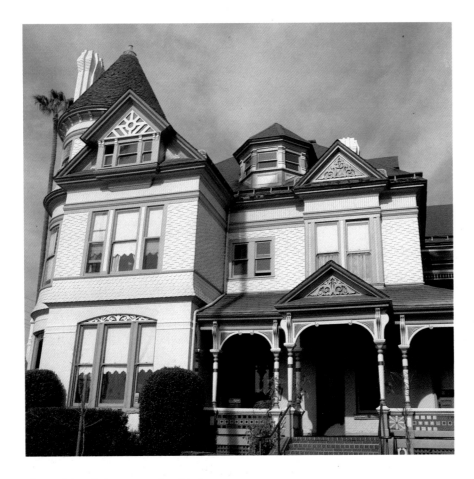

A variety of ornamental gables serve to unify the façade of the 1887 Baby Del house in Coronado, California, above. There are gables even where the roof slopes do not warrant them: above the porch entrance and topping the bay window, for example.

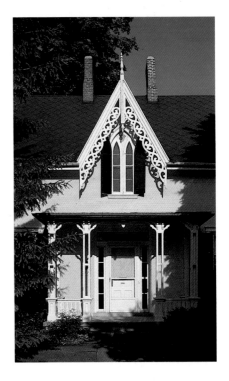

Atop a house in Marshall, Michigan, a Gothic-style gable sports lacy "gingerbread" trim and shelters a pair of narrow, pointed windows with matching shutters, above.

DORMERS

Dormer windows set into the roof were a key element of the Victorian style, appearing on a variety of houses, from Gothic to classical. Their panes might be patterned with diamond lattices and topped with miniature pediments. Gothic Revival dormers sported decorative trefoils and quatrefoils, in addition to medieval tracery and arched ogee moldings. The "roof" of a dormer window is known as the hood.

Another type of nineteenth-century dormer window, built into the architrave of the house just below the eaves, was known as a "lie-on-your-stomach" window. Very low dormers with semicircular hoods are called eyebrow windows.

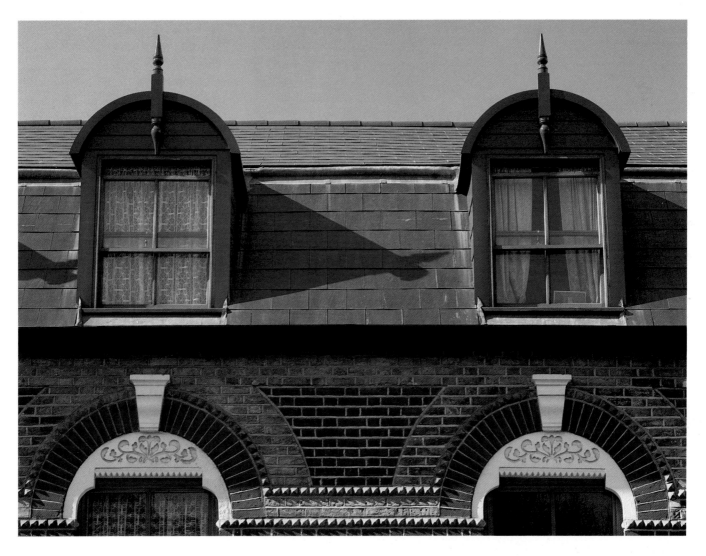

Dormers, either simple or elaborate, enhance the Victorian Revival house and add a graceful Victorian note to more modern exteriors as well. Dormers are particularly useful in opening up attics to light and air.

A pair of round-headed, finial-topped dormer hoods, above, echo the keystone-accented curved lintels of the windows on the story below.

CROCKETS AND FINIALS

Crockets and finials—decorative roof elements shaped like miniature spires, crosses, and globes—frequently adorned the peaks of Victorian dormer hoods. The finest Victorian crockets and finials are found atop buildings in the Queen Anne styles: Their medieval provenance (the original crockets appeared on Gothic cathedrals) suited the Aesthetic Movement's love for simple, straightforward ornament.

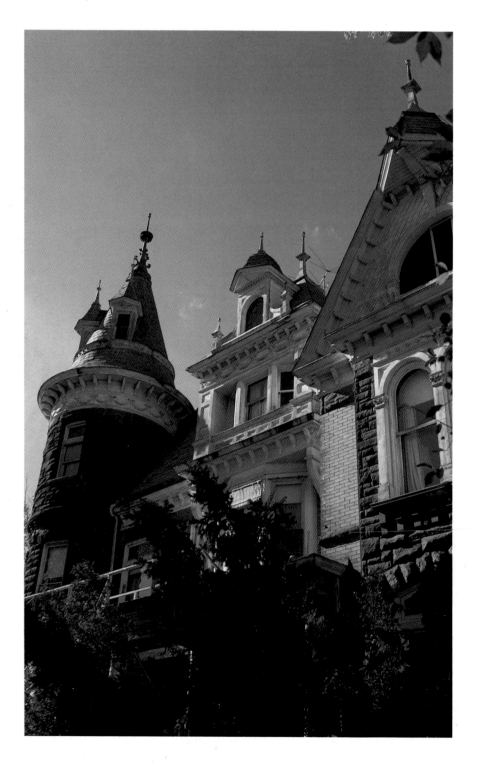

The original Victorian items were made of carved wood, stone, or wrought iron, but modern versions are often made of cast fiberglass resin, a lightweight material that has the additional advantage of being impervious to the worst extremes of weather. Contemporary reproductions of Victorian crockets and finials are available from manufacturers of period architectural ornament. Another source of these items is salvage yards.

An extravagant number of crockets and finials topping a profusion of turrets and gables emphasizes the saw-toothed silhouette of a Victorian house in Kalamazoo, Michigan, left.

CRESTING

Roof cresting, a peculiarly Victorian form of ornament, appeared in two different forms. The first, usually seen on houses built in the 1880s, consists of a decorative cap of tiles or shingles, distinguished by shape or color, laid along the ridgepole to the roof's edge, ending in a small upright finial. This finial might take the form of an acroterion, a motif borrowed from classical architecture that generally appears as a stylized flower such as an acanthus leaf or honeysuckle blossom. It adorns the points of a triangular gable.

The other common form of roof cresting consists of decorative iron filigree. Sometimes this kind of cresting looks like a miniature wrought-iron fence magically transported to the top of the roof. It is embellished with various motifs: spearheads, Gothic crosses, fleurs-de-lys, circles, swirls, and scrolls. Some Victorian houses bear elaborate wrought-iron cresting at the top of a complex series of mansarded pavilions to delightful effect.

The tiles, shingles and finials used for roof cresting are available from roofing-supply companies and manufacturers of reproduction architectural ornament; the finials can be found at salvage yards as well. The same is true of iron cresting, the most unusual of the choices, but the costliest as well.

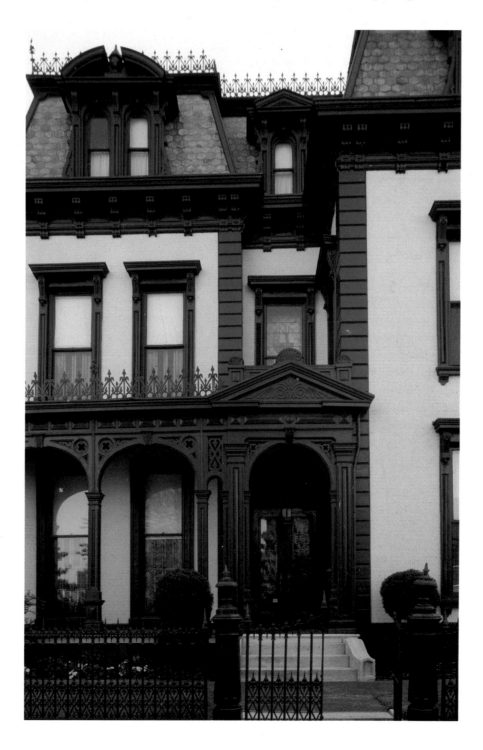

Fanciful roof cresting edges a mansard roof like ornamental lace trim, right. Similar ironwork demarcates the first and second stories.

CUPOLAS

Acupola is a small tower, round, square, or polygonal in shape, that sits atop the roof. The cupola was often the crowning glory of the Victorian home and remains the most familiar feature of late nineteenth-century houses, whatever their architectural style. The Victorian cupola often sported a band of windows, sometimes louvered, which provided a wonderful place to sit and watch the world go by. Large cupolas were often furnished, or had window seats and bookshelves.

The cupola, in most cases, served a double duty, both decorative and functional. It added height and interest to the roof of the house and served as another "canvas" for the display of ornament—carving, moldings, decorative shingles and the like. It was also the perfect site for fancy windows.

In addition, the cupola served to cool the house in summer: Its sets of louvers or operable windows could be adjusted to open either partially or all the way, letting out warm air and drawing cooler air down into the house. In the winter, it acted as a rooftop sunroom. A fan usually helped circulate the heated air through the rest of the house.

Cupolas, attractive today for their energy efficiency, are available in a variety of forms. A carpenter or builder, of course, can add a custom cupola. Or you can purchase a cupola kit consisting of lumber cut to measure and instructions on installation. Readymade cupolas are also available.

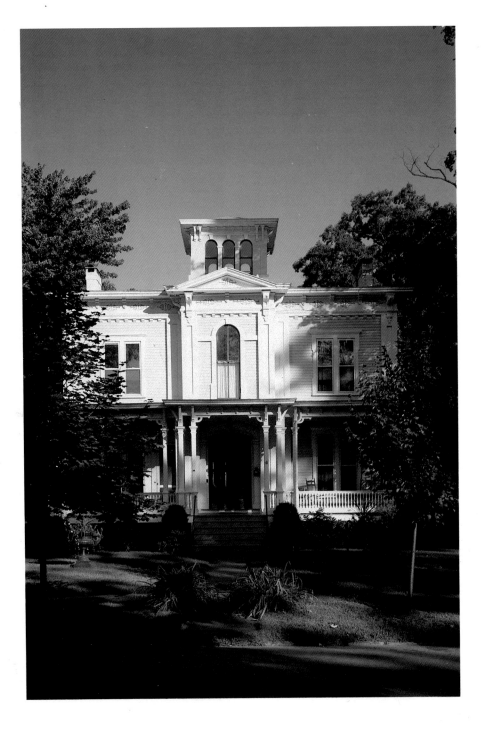

Arched windows, a flat roof, and decorative roof brackets distinguish the large cupola atop this Italianate home in Saratoga, New York, right.

STEEPLES AND SPIRES

Victorian steeples and spires took the form of either an elongated pyramid (a steeple) or cone (a spire). They appeared on roofs at the center of the ridgepole, at the apex of a pediment, or at the ends of a gable. They derive from the spires atop medieval cathedrals and were generally found on Gothic-style houses. They often contained louvers to aid in ventilation.

The Victorians liked to finish off steeples with finials, crockets, or weather vanes. Larger ones were decorated with ornamental shingles. Steeples also appeared as the graceful finish to the conical roofs of round towers.

Like cupolas, steeples can be custom-made or ordered from kit manufacturers or companies that specialize in roof ornaments.

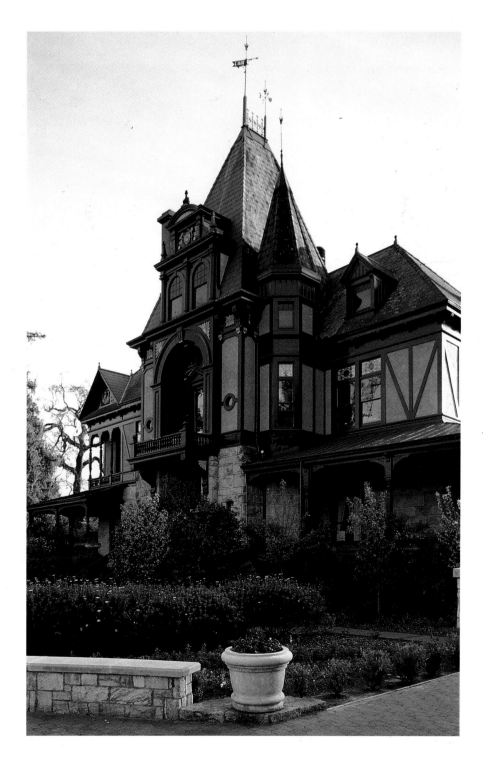

The tall entrance bay of this Napa Valley, California, house continues into a tall mansard roof complemented by an adjoining steeple, right. Both eminences serve to extend the complex articulation of the façade up into the roof.

MANSARDS

Mansards are steep roofs with nearly vertical sides sloping upon four sides to a flat top. Named after the seventeenth-century French architect François Mansard, they have a distinguished lineage. Mansard roofs saw a renewal of popularity, first in France during the Second Empire period (1860s) when Napoleon III ruled. The style spread to England and then the United States.

In the nineteenth century, many home owners and architects used mansards to add a new top floor, thus gaining additional room without adding bulk to the outline of the house. In addition, a mansard roof, with its very nearly vertical slope, is the perfect spot to display many of the other decorative motifs discussed in this chapter, including colorful slates, decorative shingles, and roof cresting, to mention only a few; its slope allows for the use of decorative trim at the top and bottom. Dormer windows, too, combine well with mansard roofs.

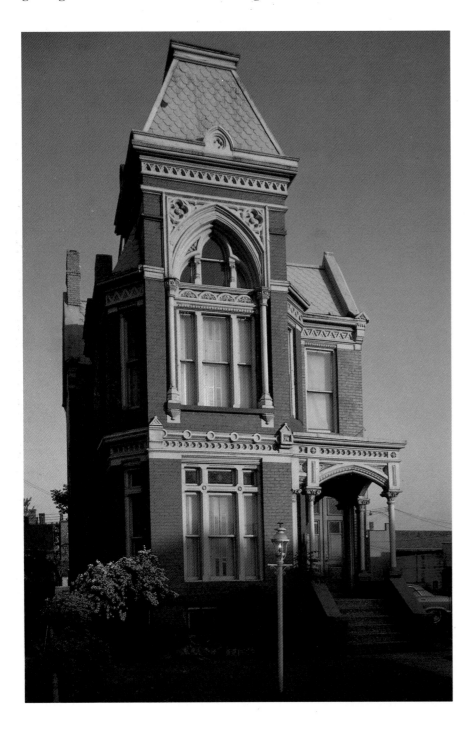

The handsome texture of slate shingles functions to complement the severe outlines of a mansard-roofed pavilion, left.

CHIMNEYS

Most of us think of the chimney as an unadorned brick box, but the Victorians embellished their chimneys in a variety of ways, from graceful flared lips at the top to recessed arches and panels and stepped courses of brick on the shaft. These chimneys were often eight to ten feet high, commanding the rooftop in the same way as a steeple or cupola.

In addition, Victorian chimneys were often painted to match the body of the house: The body of the chimney was painted one color while the details were picked out in another. The colors matched those used on the molding and trim of the exterior walls.

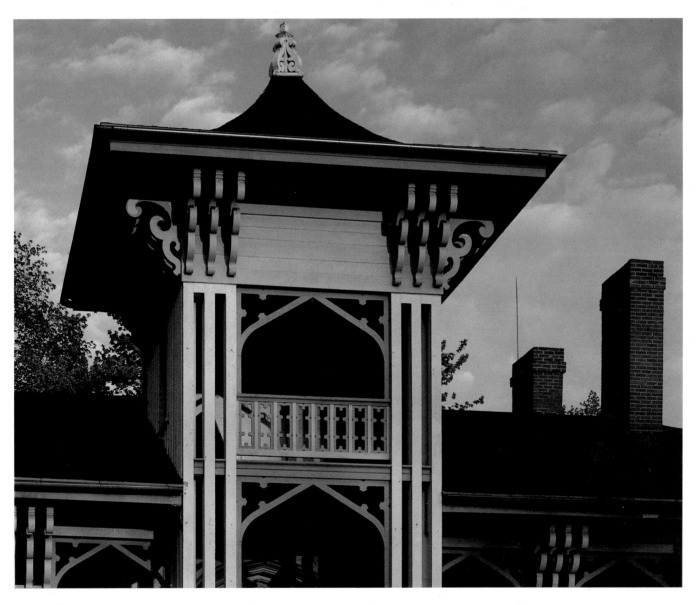

The complex silhouettes of a pair of chimney pots are a fitting embellishment to a gingerbread-edged roof peak, above.

WEATHERVANES

The steeples, cupolas, and mansards of the classic Victorian roof supplied the home owner with various peaks and valleys that required ornamentation of their own. While crockets and finials, as described earlier, may have sufficed for much of the roof, other details abounded. Weathervanes provided a touch of sophisticated whimsy as well as decoration, since they were often figurative—shaped like angels, birds, fish, or even clipper ships under full sail. Toward the end of the century, the Japanese craze influenced the design of weathervanes, as can be seen in examples adorned with graceful filigreed scrolls.

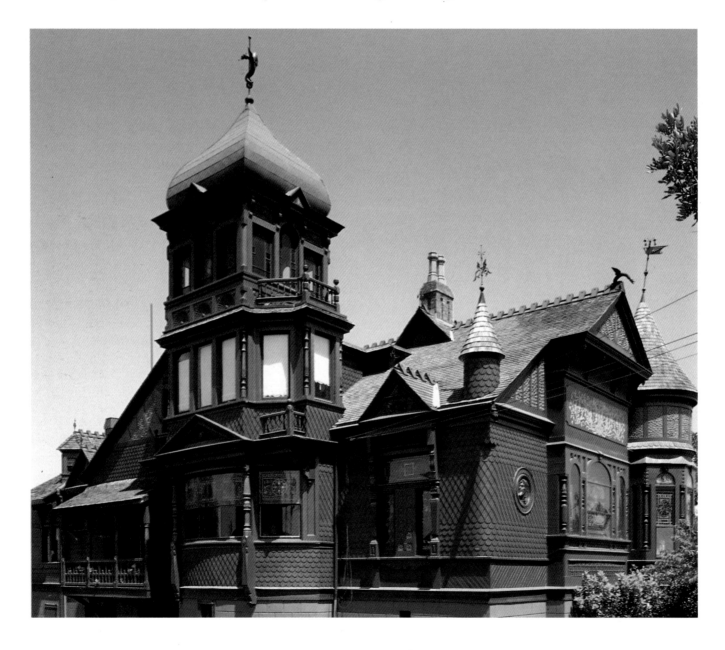

Fanciful weather vanes crown the peaks, spires, and turrets of an ornate Victorian roof, above.

ROOF BRACKETS

Another authentic Victorian embellishment is the use of roof brackets at the eaves. They are most often seen on Italianate Revival houses. These elements project from the wall beneath the cornice. They look as though they support the roof by attaching to the soffit, or underside, of the eaves. The Victorians regarded brackets as a perfect place to exhibit ornamental moldings and carvings.

Nineteenth-century carpenters and builders commonly purchased wooden brackets from the catalogues of millworks that mass-produced building elements. They were then shipped to building sites by ship or rail.

These wooden brackets come in two different styles. Simple brackets consist of an L-shaped flat plank, usually two inches thick, with the inside of the "L" cut into a decorative filigree. These were the least expensive forms of brackets. Sandwich brackets were made of two decoratively sawn boards applied on either side of a plain one, thus the term "sandwich."

Another type of bracket, a modillion, is seen on classically influenced houses. It can take the form of a scroll ornamented with acanthus leaves or rectangular blocks. Small rectangular modillions are called dentils.

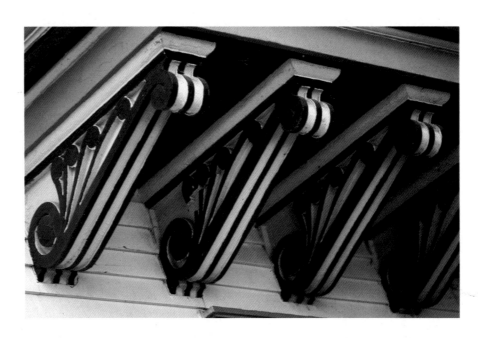

Elongated S-scroll brackets are adorned with bold painted edging, above. A spray of curlicues, highlighted with paint, reveals the Victorian appreciation for ornament.

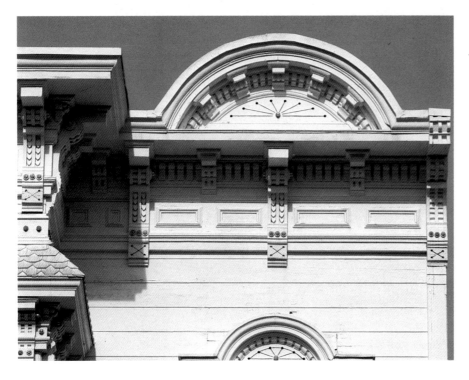

Decoratively incised modillions mark the curve of an arched pediment, left. The roof cornice itself is articulated by large and small brackets.

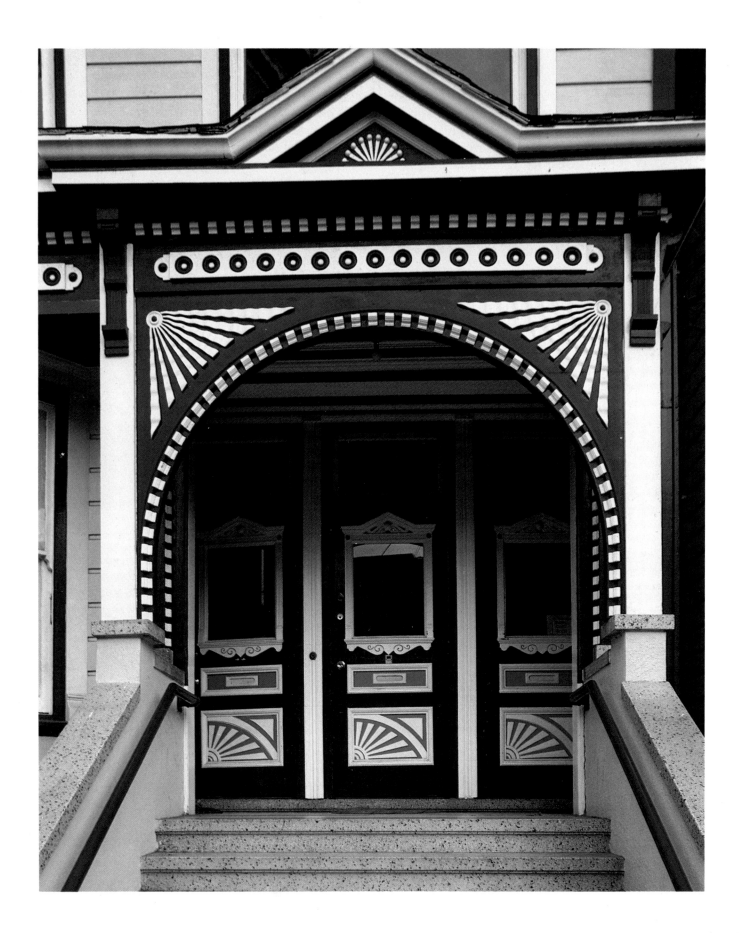

3

DOORS AND ENTRIES

Victorian home owners lavished great care on planning and decorating the entryway. The entry, and the hall it opened into, served as a kind of transition zone between the busy world of commerce and the serene sphere of the home. It was a public space that marked the beginning of the private realm. As such, the Victorians adopted a deliberate attitude toward its decoration, selecting the color scheme, furniture, and decor with great care.

The entry hall often adjoined the stair hall. This section of the house played a key part in the traffic circulation. Once a visitor was through the portals of the front door, he or she had gained access to the heart of the house. Victorians had very strong ideas about social place—almost every house had a servants entrance and a back stair for the help. The decoration of the entry and stair hall played an important role in establishing the ambience of the house, the face the family wanted to turn to the world. An entryway that was sparsely decorated was considered common or lower class; at the same time, heavy decoration was considered vulgar—a sure sign of the social arriviste. The entry hall could be a narrow passage or it could be a magnificent antechamber, but its significance never wavered.

DOORS

To understand the nature of the entry hall, it must first be approached from the outside. The typical Victorian front door was a monumental affair, surrounded by ornamental wood molding and often painted and grained to resemble exotic, expensive woods. It was adorned with massive brass hardware, including impressive hinges and substantial, solid bolts and locks, kept to a high polish by legions of servants. Even the screened door was grand, made of wood painted or grained to match the main entry.

The style of the door varied according to that of the house. A Gothic Revival house might feature a doorway set within a pointed arch, the door itself arched to fit the frame. Italianate and Romanesque Revival homes often displayed round-headed doors with semicircular tops. Whatever the style, however, doors were always paneled, never plain. Door frames were carved and paneled to match the doors themselves.

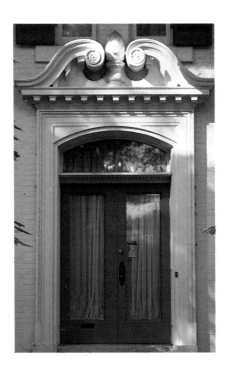

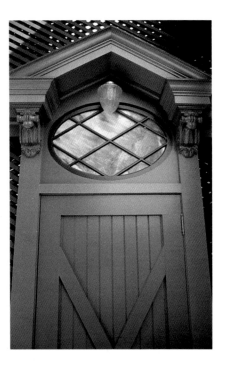

Salvaged doors, custom-made doors, and reproduction doors provide alternative means of adding a Victorian door to a modern home. Recycled doors, rescued from destruction by architectural salvage yards or antique dealers, have the advantage of authenticity, and are often beautifully carved. You will have to adjust your entryway opening to accommodate the dimensions of an existing door, however.

You may see a door you like and want to have copied on an existing house. Another source for door designs that can be custom-made are photographs and product catalogues from the Victorian age. These are often illustrated in advertisements in nineteenth-century magazines. Once you find an appropriate door, you can have it copied by a local carpenter.

Reproduction Victorian doors are available in a variety of authentic styles. They have some advantages over antique and custom-made doors. They are easier to install, since they come as a single unit with the frame. Some reproduction doors are also insulated, making them highly energy-efficient.

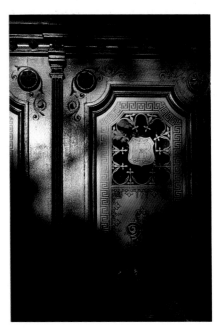

The curves of a graceful broken pediment crown a massive door frame in Evanston, Illinois, above left.

An elegant, diamond-latticed oval of leaded glass adorns a San Francisco entryway, above.

Etched glass and fanciful scrolls distinguish another door at the Benjamin Harrison house, the home of America's nineteenth president, in Evanston, Illinois, below left.

STAINED GLASS

The use of stained glass to ornament the entry hall was widespread in the nineteenth century. Initially inspired by the popularity of Gothic ornament, stained glass appeared in all types of settings by the 1880s and 1890s. Design critics recommended stained glass for use in stair halls and vestibules.

Appropriate subjects for stained glass windows varied. They could be as elaborate as an urn draped with floral garlands and topped with a pineapple, or as simple as alternating panes of red and white glass defined by heavy leading. Sometimes the stained glass appeared as an ornate screen surrounding the main door or the entry to the stair hall. Alternatively, it could be used more modestly in the transom.

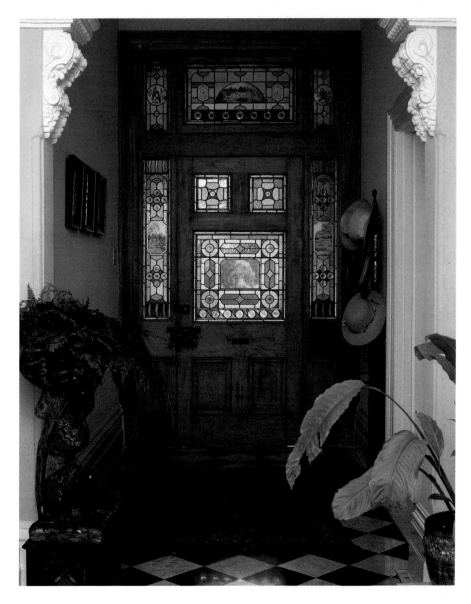

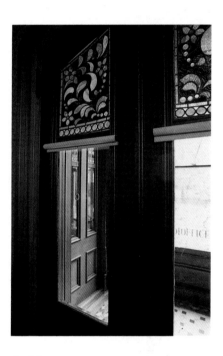

Brilliant stained-glass panels brighten the entryway of the Moller House in Wethersfield, Connecticut, above.

Delicate leaded-glass windows fill both door and door frame in this London entry hall, above. The geometric motifs are typical of the Anglo-Japanese period.

WINDOWS AND SIDELIGHTS

Victorian houses often possessed a second set of inner entry doors, also known as vestibule doors. These doors often displayed decorative glass inserts. In some cases, the glazing filled the top half. In other examples, the glass insert was in the shape of an oval or polygon. Some inner doors seemed almost to be made of glass, held in place by a wooden frame.

Door inserts were available in various types of glass. Small panes of stained glass were sometimes seen, as were frosted and etched, and even leaded or plain, glass. Otherwise unornamented glass panes were frequently enlivened with beveled edges. Sometimes all of these different types of ornamental glass appeared on a single door.

Etched glass was expensive, so penny-pinching Victorian home owners sometimes faked the effect by sponging a bag full of putty over the glass, creating an opaque layer that was varnished when dry. Used over a stencil, this technique simulated the appearance of etched and clear glass. Sometimes lace was applied to glass and then varnished.

Those who could not afford stained glass mimicked it through a variety of techniques. These included applying decals, painting patterns over glass in transparent colors, and using transparent-colored cellophane or tissue paper sandwiched between sheets of heavy paper cut into designs.

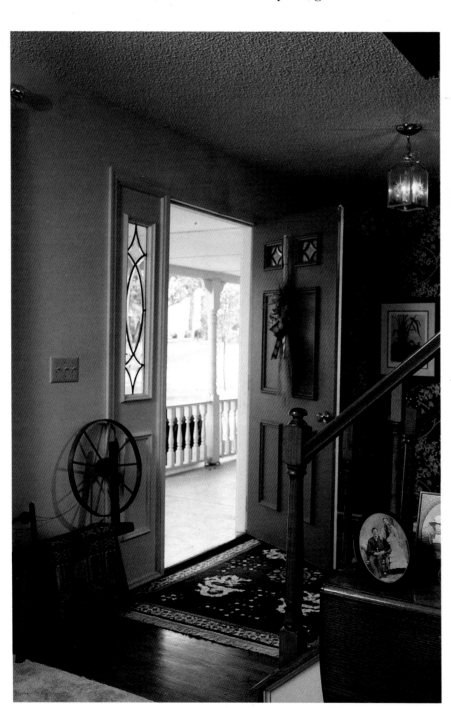

Delicate arabesques of decorative leading adorn the clear-glass sidelights of a London entryway, left.

50

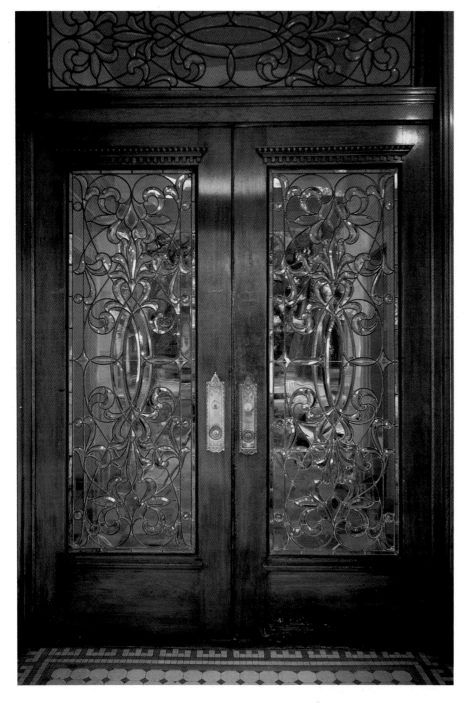

*A **curvilinear floral** design in clear leaded glass embellishes these Victorian Revival door panels, left, manufactured by Pinecrest, Inc.*

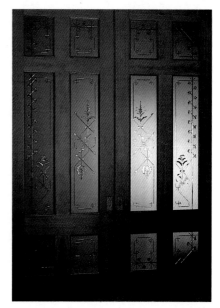

Ethereal geometric motifs etch the frosted-glass panels of a Victorian doorway, above.

Another ornamental effect was the use of decorative muntins, the slender strips of wood that separated the panes. Victorian muntins were set in a variety of patterns. Most familiar were the crisscross and herringbone.

The exterior door of a Victorian house was often flanked by narrow windows called sidelights. These featured the same range of decorative effects employed on the glass of vestibule doors. As a final distinction, a transom, or narrow band of glazing, might extend across the top of the door and above the sidelights as well.

COLOR SCHEMES

During the early- to mid-nineteenth century, decorating critics felt that the use a room was intended for should determine the color choice. Entry halls and stair halls were considered "sober" rooms. Therefore, the most appropriate colors for paint or paper were gray, stone, or drab.

Since the hallway had other rooms opening off of it, neutral tones were chosen, so as not to make an excessive contrast. The usual gray was a color formed by mixing charcoal dust with white. The color known as stone came in two hues: dark, created by mixing yellow ocher and lampblack with white; and light, of Prussian

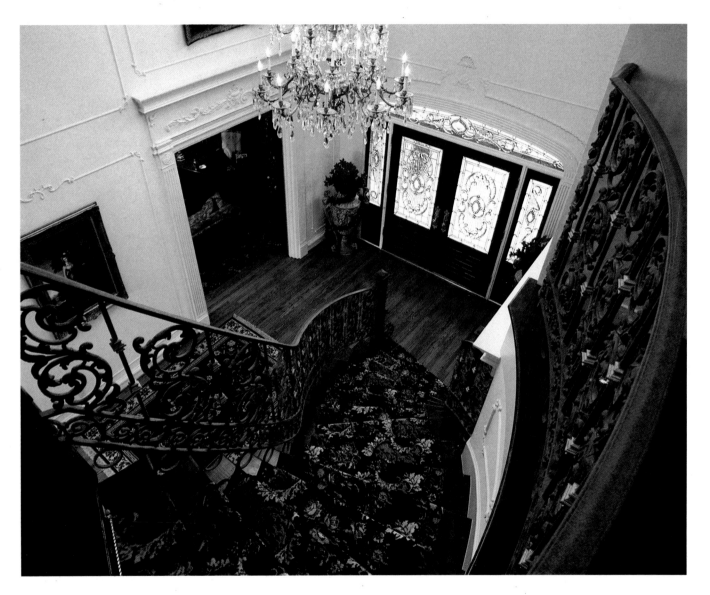

blue (dark blue with a hint of gray), spruce-yellow, umber (dark yellow-brown), all blended with white. Drab, a dull yellowish brown, resulted from the combination of raw umber and white.

All three of these colors, in various intensities, provided a good base for marbleizing. This technique was common in the nineteenth century, although today it is the province of spe-

Graceful scrolled railings, patterned carpet, wide double doors, and a chandelier stand out against pale-colored walls, giving this entry hall a sense of drama and grandeur, above.

cialists. Continuing the somber masonry theme, another popular wall treatment for entry halls was "ashlar," or simulated cut-stone blocks. In some homes, residents achieved this look by carving lines of "mortar" into the plaster of the walls while they were still wet. Once dry, walls were either marbleized or painted a solid color, with the lines painted slightly darker to firmly establish the resemblance to stone. For those whose foyer walls were already plastered, ashlar wallpaper provided an alternative. This was favored as a very practical alternative, since worn "blocks" could be replaced without having to repaper the entire wall.

By the 1870s, fashions had changed. The convention of dividing walls into three parts—dado, fill, and cornice (see chapter 5 on walls for further information) extended to the entry hall as well. The proclivity for subdued colors remained. By this time, the range was somewhat broader. If the foyer was sunny, it might be painted Pompeiian (dark orange) red; if not, delicate greens or warm grays were considered suitable. Charles Eastlake felt that walls in the entry should be painted rather than papered, because wallpaper could not stand up to the heavy traffic found in the hall.

In the following decade, the vogue was for much brighter colors in the entry, although the tripartite division remained. Sometimes dadoes stretched six or seven feet up the wall, in an attempt to minimize wall damage from knocks, bumps, and kicks. The ashlar papers popular earlier in the century were considered hopelessly passé—walls were pa-

pered in solids or patterns, while woodwork was painted in a contrasting hue. Some suggested combinations included turquoise walls with maroon dado and woodwork, pale salmon with dark bronze-green, or yellow walls with cherry woodwork and a wallpaper frieze in olive, dull blue, and gold. Floors were stained to match, in hopes of standing up to the wear and tear of many

footsteps, in colors such as deep olive green or mahogany brown.

The dark colors popular for use in entry halls resulted in spaces that were dark and comforting, presenting a solid welcome to the rest of the house. An entry decorated in these tones offered a sanctuary from the clatter and noise of the busy street outside, a relief from the glare of the sun and the gusting breeze.

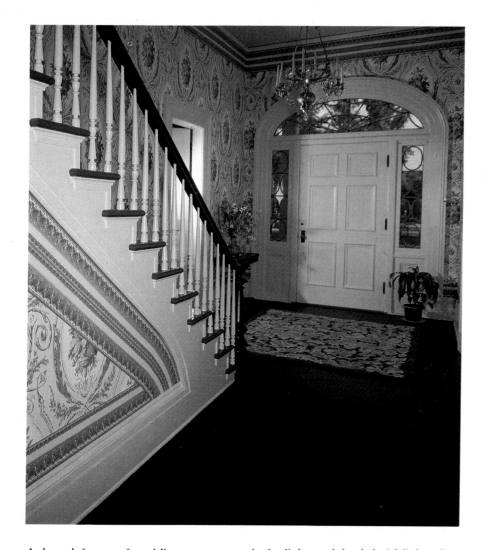

A broad frame of molding, an overscale fanlight and leaded sidelights distinguish the massive entry door of the Banning Museum in Wilmington, California, above. Bold patterned wallpaper edged with a matching striped border and bare wood floors add to the feeling of solid Victorian comfort.

Part Two

The Interior

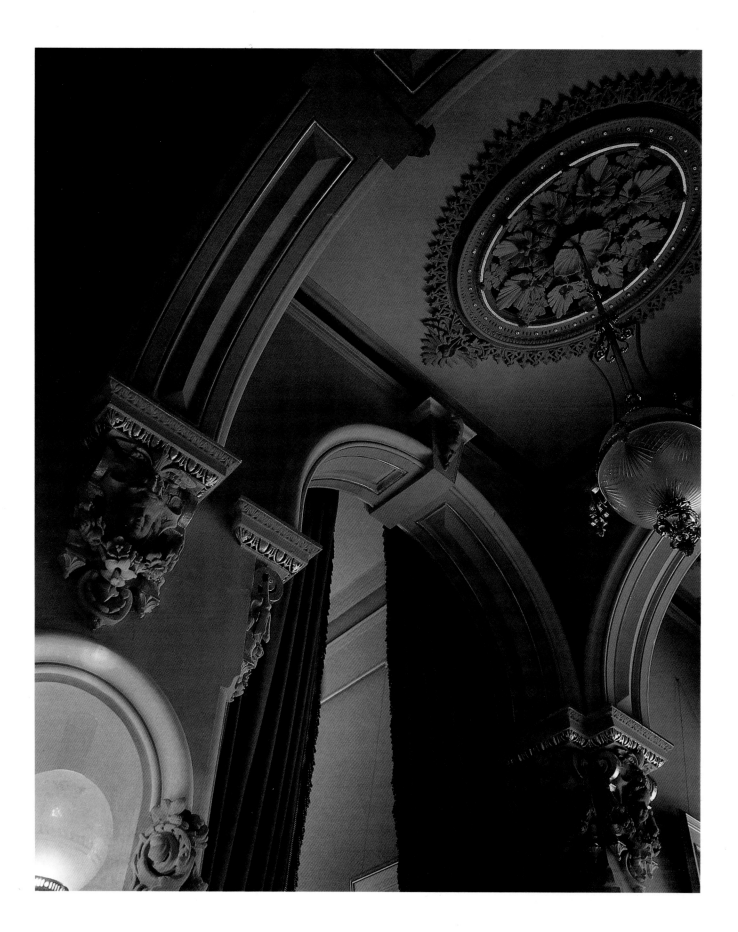

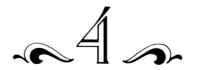

CEILINGS

The Victorians loved ornament. The ceilings of nineteenth-century houses offer a case in point. The modern ceiling is often bland, white, unadorned. In comparison, the Victorian ceiling fairly erupted with color and pattern.

This predilection had a variety of sources. Victorian ceilings were much higher than present ones. While today eight feet is standard, in the 1800s it was not unusual for even quite modest homes to boast ten, twelve or even fourteen-foot ceilings. With this much distance from floor to ceiling, there was enough space for viewers to appreciate the particulars. And these details were worthy of appreciation. Towards the end of the century, as the Victorian passion for decoration grew ever greater, ceilings took on a level of complex embellishment that seems staggering today. Much of this detailing derived from a series of revival styles. Ceilings were painted with imitation Italian frescoes, and adorned with cast and carved plaster that mimicked the details found in grand Renaissance palazzi. Often, these two motifs were combined, with rococo scrolls and cartouches enclosing panels painted with mythic scenes of Greek myths. In an alternative style, other house-proud and deep-pocketed Victorians beautified their homes by coffering the ceilings in geometric patterns using carved beams. Sometimes gilded medallions were set within the coffered squares. In Britain, architects and designers revolted against the tyranny and "sham" of imitation Gothic and rococo. Here, the revival style peaked earlier and was not as popular as it was in the United States. Instead, the Aesthetic Style and the Arts and Crafts movement captured the fancy of the avant-garde crowd, leading them to adorn their ceilings with printed papers.

Certainly few contemporary home owners possess either the means or the inclination to install reproductions of these examples of Victorian decor in their own homes. But less grandiose examples of ceiling ornament do exist, and many of them fit very well into a twentieth-century home.

CEILING MEDALLIONS

In the 1830s and 1840s, during the early Victorian period, the ornate plaster ceilings of the eighteenth century were out of vogue. Instead, middle-class home owners preferred simple designs of wood, plaster, or papier-maché on their ceilings.

In Victorian homes, medallions generally were placed in the center of the ceiling. They often circled the mount of a hanging light fixture, such as a chandelier or gasolier. Early Victorian medallions were no more than two feet in diameter. Designs were based on a single flower motif, with petals stylized and flattened into a disk; a neoclassical motif such as a wreath of acanthus leaves or bundled reeds; or a fairly plain disk circled with a beaded molding. Late Victorian medallions follow a similar pattern, but are much larger and are often cast in more elaborate relief patterns.

Those who wish to stick with their plain white ceilings but who want to add some detail might consider installing a ceiling medallion. Several manufacturers, such as Focal Point, make reproductions of Victorian designs in a range of motifs, in easy-care polyester resin. This material is very lightweight, so there are few structural concerns with its installation, and it can be painted to match any decor.

The leaf-filigreed ceiling of a house in Marshall, Michigan, right, is further dignified by a small but elaborate medallion that supports a hanging light fixture.

TIN CEILINGS

Ceilings made of pressed tin became popular upon their introduction in the late 1880s. They were originally supposed to mimic the elaborate carved and cast plaster ceilings that were then in vogue, but they soon became fashionable in their own right.

Pressed-tin ceilings offer many advantages as a ceiling treatment. While they come from the factory in a metallic finish called "lusterless white," they can be painted any color. In fact, since the tin ceilings were supposed to imitate plaster, the Victorians always painted them. Of course, since modern home owners are not constrained by Victorian fashions, they are free to leave them bare if they prefer. Since the ceilings come in prefabricated, fireproof panels, they can be installed over existing ceilings, or as dropped or acoustical ceilings. They can even be put in place as a do-it-yourself project.

Pressed-tin ceilings look good in any room, but they are particularly useful in rooms where humidity is a problem. The Victorians employed pressed tin for kitchens, bathrooms, and the scullery. Of course, only museum houses still have sculleries, but the laundry room makes an excellent modern substitute.

Pressed-tin ceilings are still readily available to those inspired by nineteenth-century decorative schemes. Many manufacturers of pressed-tin ceilings have been in business for a century, and still utilize the same machinery and dies. Several original Victorian designs have survived to see the renaissance of their popularity.

A pressed-tin ceiling and cornice display such classical motifs as fleurs-de-lys, right.

PLASTERED AND PAINTED CEILINGS

During the nineteenth century, plaster was the most popular interior-surface material. It was applied over the laths and studs of walls and ceilings to create a smooth surface for the final decorative treatment, usually paint or paper. Sometimes, the plaster itself became the decorative material, carved or cast into relief ornament which included plain beaded moldings, neoclassical motifs such as urns and acanthus leaves, and realistic natural designs of flower garlands.

Hand-crafted ornamental plaster is a rare sight these days. It requires expertise and patience. Skilled plaster

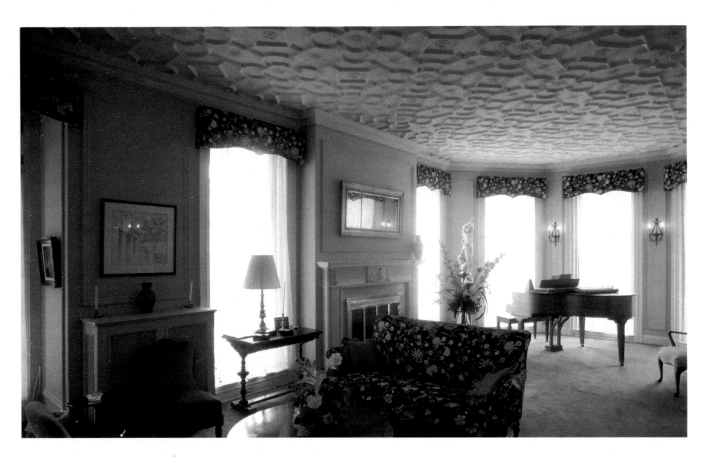

artisans are few and far between, and most often earn their living as restoration craftspeople. Fortunately, this type of ornament can be reproduced through the modern technique of cast polyester resin. The garlands, urns, and acanthus leaves can be appended to plain twentieth-century ceilings very easily for a touch of Victorian grandeur. These designs differ from ceiling medallions in that they are applied anywhere on the ceiling.

They might form the edge of a coffered band, or be placed in the corners to complement an existing medallion.

Another virtue of old-fashioned plain plaster was its velvety texture. Contemporary plasterboard, its replacement, just doesn't compare. However, a technique known as "skim coating" can reproduce the texture of plaster without its attendant messiness and time-consuming installation. This method involves

the application of a very thin layer of plaster over a new or existing surface. Skim coating works best and looks most believable when applied over a smooth surface. Ironically, plasterboard is the best choice.

But the Victorians didn't settle for plain ceilings once the plastering was complete. In fact, a white ceiling was frowned upon, unless the rest of the room was white. In general, decorating experts advised home owners to use three

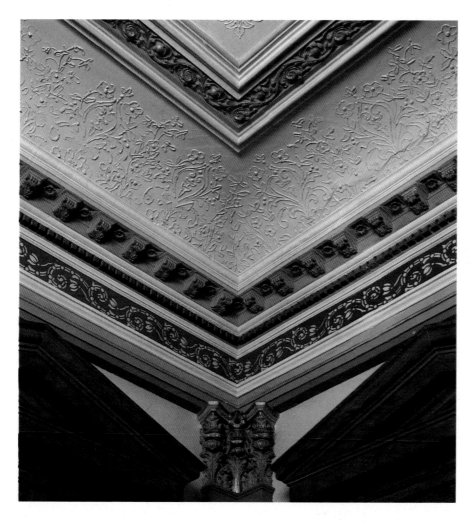

A dense honeycomb of plasterwork covers the ceiling of a neoclassical-style room in the Mansion Inn bed and breakfast, Rock City, New York, opposite page.

Ornate rosettes, dentil moldings, and a scrolled border in a London room show the range of decorative effects possible with the use of carved and cast plaster, left.

separate colors on ceiling, walls, and woodwork, with the lightest tone applied to the ceiling. A light ceiling was held to give the effect of height (still true today).

During the middle Victorian period, from the 1850s to the 1870s, home owners employed an often conflicting (at least to modern eyes) combination of colors on ceilings, walls, and woodwork in a single room. Color was never employed indiscriminately. Many rules concerned its choice and placement. *The Laws of Harmonious Coloring* (1828), by Scottish house painter and writer David Hay, was the oft-cited guidebook. Hay presented two approaches to the choice of colors

for room decoration. One, called "harmony by analogy," used colors, such as crimson and purple, yellow and gold, or deep red and rich brown, that are next to each other on the color wheel.

The second, termed "harmony by contrast," used colors that opposed each other, such as red and royal blue, yellow and dark purple, black and white. This approach proved to be the most popular. Many books, particularly those published in America, mentioned only the theory of "harmony by contrast."

Furthermore, many theorists held that the tints or values of the colors employed didn't matter; they did not have to match in in-

tensity. Indeed, some said that mixing the primary hues together would result in a third, neutral tint that could be used in the room scheme as well. However, the theorists did admit that when colors were equal in intensity, their use in a room created an "exciting" contrast; when not equal, the effect was one of "repose." Repose was preferred.

By the 1880s and 1890s, ceiling colors were not as intense. While walls were still fashionably dark, ceilings were generally painted in a lighter hue such as lavender, peach, or gray. Stenciled ceilings, painted with various motifs, usually taken from architecture or nature, were also popular.

COVED CEILINGS

Acove molding creates a gentle curve between the top of the wall and the plane of the ceiling itself. The cove can take many forms, from a small arc that barely eases the transition from one to the other to a deep semicircle that nearly transforms a plain-Jane flat ceiling into a Renaissance dome. Cove moldings are easy to apply—they're really just a plain curved version of crown moldings (discussed in chapter 5 on walls). They are an ideal way to merge walls and ceilings. The treatment of the cove depends on the height of the room itself. If the ceiling seems too low, you can create an effect of height by painting the molding the same

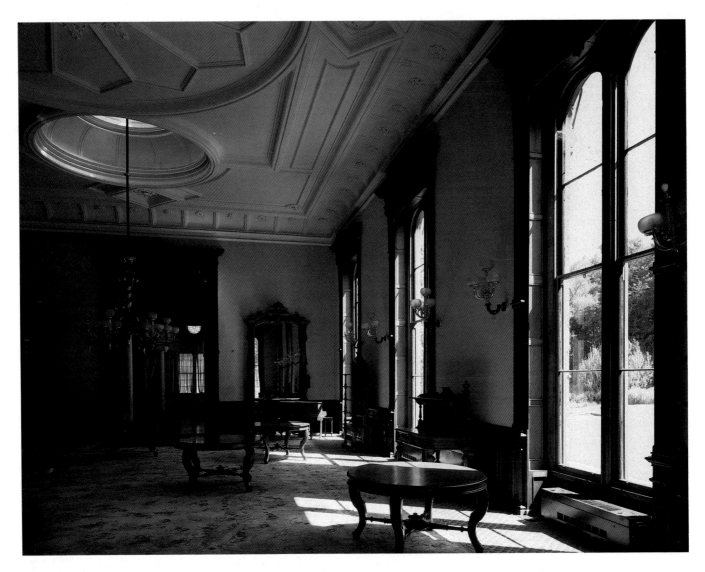

color as the wall itself. If you want to lower the ceiling a bit, paint the cove to contrast with the wall. The ceiling itself can be a third color, lighter or darker depending on the effect you would like to achieve in the room.

A coved ceiling elaborated with ribs and rosettes adds to the grandeur of this dignified high-ceilinged room in Saratoga, New York, further distinguished by a coved oculus, above.

PAPERED CEILINGS

During the 1880s, decorative "ceiling papers" were very popular. They allowed home owners to answer the fashionable call for ornate ceilings in the simplest manner. They often imitated frescoed or painted ceilings with scrolls and cartouches enclosing printed scenes or floral garlands. Paper patterns generally consisted of a central rectangle containing a small-scale motif, generally geometric or floral in theme. These were surrounded by an overall pattern, similar to the "fill" of a wallpaper design. These were further edged with an ornate border, often consisting of several bands of different but harmonious designs.

Papered ceilings remained modish into the 1890s, although the preferred designs were simpler and better integrated into the room as a whole. Ceiling borders often matched wall friezes. Decoration and color were not confined to the center and edges but extended into overall patterns. The doctrine of Aesthetic simplicity, which originated in Britain and then became popular in America, called for plainer ceilings and an end to "pyrotechnic" effects.

This change resulted in two popular decorative strategies. First, a ceiling might be papered in an overall pattern of a subdued nature, which often extended down to meet the plate rail (a decorative molding which ran around the room anywhere from six inches to three feet below the ceiling). Alternatively, the ceiling could be painted in a plain color to match the dominant hue of the wallpaper design.

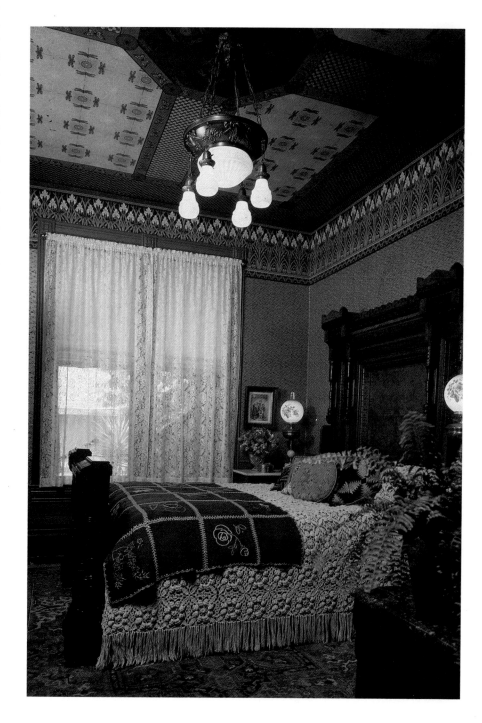

A suite of coordinated wall and ceiling papers from Bradbury & Bradbury transforms a boxy bedroom, right, into a High Victorian fantasy.

COFFERED CEILINGS

Acoffered ceiling is one in which shallow partitions (these can be as substantial as beams or as slender as strips of molding) subdivide the ceiling area into recessed compartments. The most common forms of coffering employ a central square or an overall grid. The recessed areas can be filled in in a number of different ways: with patterned paper or stencils; polyester-resin or plaster ornament cast in relief; or with a shade of paint that contrasts with the walls and the protruding portions of the ceiling. A ceiling may also be coffered by a square enclosing a diamond or circle, to create triangular or segmental recessed sections. These receive the same ornamental treatment as square areas.

This type of ornamentation can be used in rooms with ceilings of any height, although, as with most of the decorative treatments described in this chapter, it really works best on a ceiling higher than the standard eight feet. But even on these lower ceilings, you can create coffered patterns using very shallow moldings and pale colors, playing down the contrast between the recessions and projections and concentrating on the play of texture created by the molding.

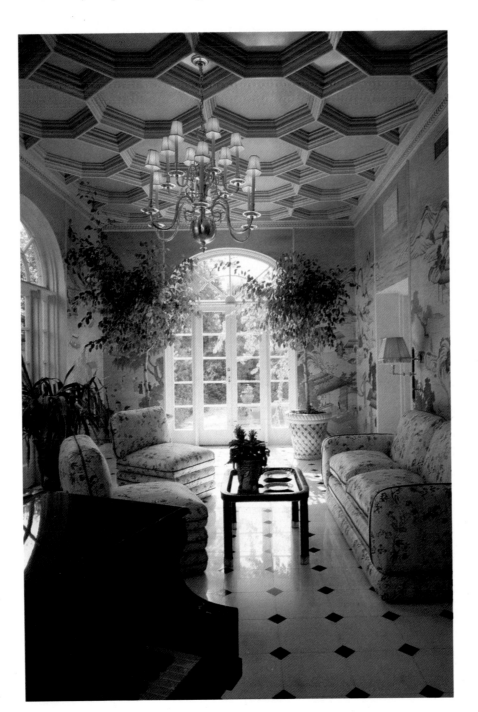

Deep recesses and high-profile moldings combine to form a dramatically coffered ceiling in a room designed by Clare Fraser Associates, left.

Projecting ceiling beams create two very different feelings in two rooms. White-painted beams in a wood-paneled stair hall lend an airy quality, opposite page, left, while dark wooden beams transverse a cathedral ceiling to create a more rustic feeling in a room designed by Noel Jeffrey, Inc., opposite page, right.

WOODWORK

C eilings were also often decorated with patterns in wood. These included exposed beams and truss work as well as carved brackets. Beams were generally employed to give a rustic ambience. Perhaps the most famous and imposing examples can be seen at any one of the great Victorian country homes that served as summer retreats for the nineteenth-century robber barons. These were built in the Adirondack wilderness of upstate New York, in the Massachusetts Berkshires, and on the Maine shore, to name a few areas.

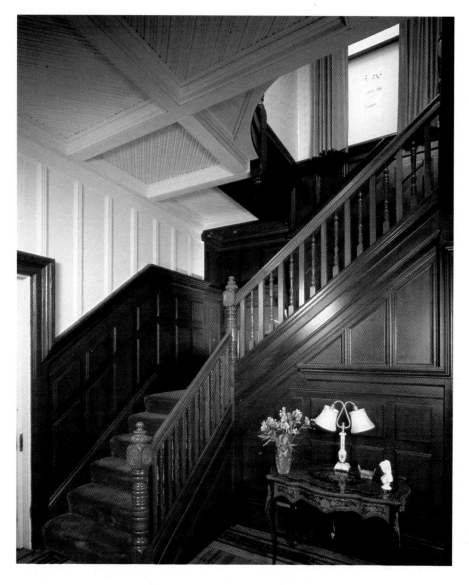

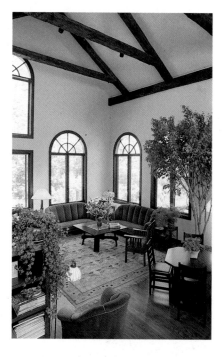

These lodges, often erected by local artisans and carpenters, boasted spectacular interior spaces with cathedral ceilings accented by exposed rafters crafted of hand-hewn logs. While not many modern homes are built on such a grand scale, many do feature cathedral or open ceilings. These can readily be redesigned to incorporate decorative beams for a Victorian effect.

Another use of beams is to set them into the ceiling surface, so that they create a series of shallow, rectangular recesses. The regular rhythm of projecting and receding areas acts to draw attention to the ceiling and accent the shape of the room. You can achieve the same effect in a less insistent manner through beaded paneling. The shallow, parallel grooves that characterize this style of paneling, like the more aggressive projecting beams, serve to rhythmically emphasize the shape of the room. Both beams and paneling may be painted a variety of colors. The recesses between beams or the grooves in the paneling can be emphasized by painting them a contrasting color.

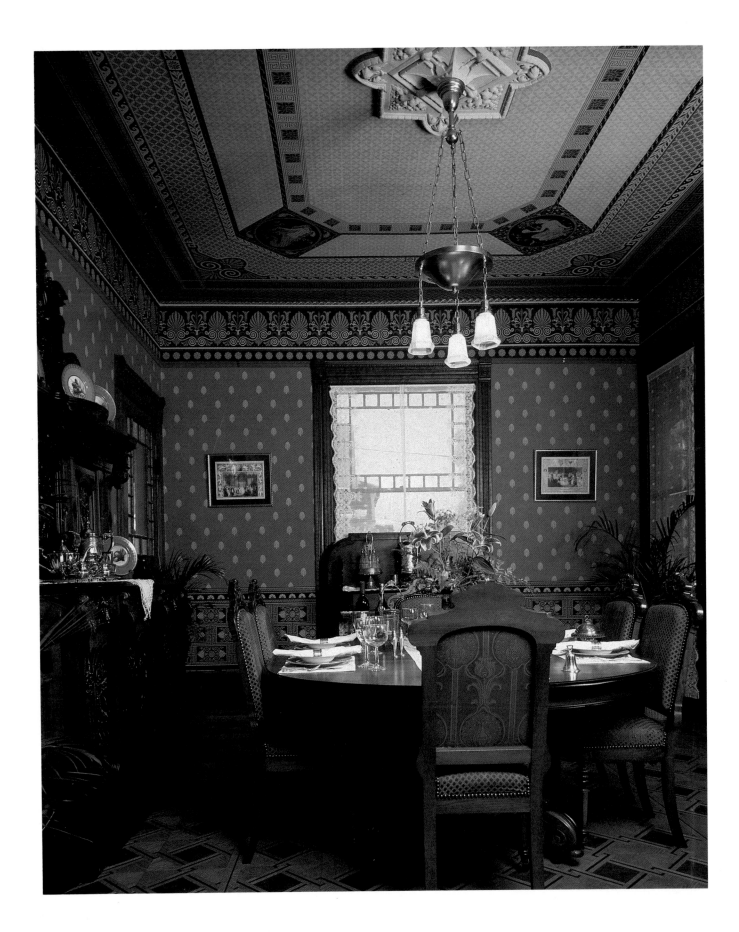

5

WALLS

The Victorians were very concerned about their walls. In fact, *What Shall We Do With Our Walls?* was the title of an influential book by decorating expert Clarence Cook, published in 1881. But that forlorn cry had been heard much earlier in the century. Nineteenth-century home owners explored a variety of wall treatments, including paneling, wainscoting, paint, and wallpaper. Since they valued beauty over convenience, they took the time to create elaborate wall ornaments, such as lavish overmantels, niches, and medallions as well. To the Victorians, the surface of the wall was perhaps the most important thing in the room.

The most common form of wall decoration consisted of tall, boldly scaled baseboards (perhaps as tall as ten or twelve inches); a chair rail at the wall's midpoint; and a plaster cornice at the top of the room, just below the ceiling.

But this standard composition included many variants. All three elements—baseboard, chair rail, cornice—did not appear in every room. Sometimes the baseboard stretched up to become wainscoting. The chair rail occasionally reappeared higher up on the wall as a plate rail, a projecting molding used to display treasured china too good for every day use. The cornice offered the most possibilities for change—it might materialize as a decorative frieze, a bas-relief band at the top of the wall, or a deeply carved crown molding, projecting as much as a foot onto the ceiling and forming a bridge between the two surfaces.

In addition to these embellishments, the areas in between could be treated in a number of different ways, from wallpapering to paneling to stenciling. They were even simply painted, although with the Victorians nothing was ever simple—they often made use of bravura faux finishes such as marbleizing, ragging, and stippling.

The range of Victorian wall treatments is a treasure trove for modern home owners. To say that there's something for everyone is to employ a truism that for once is only the truth.

WALLPAPER

From the 1840s on, wallpaper was the preferred treatment for walls. In fact, the Victorian age is virtually synonymous with the age of wallpaper. The popularity of wallpaper was due in part to some technological advances. In 1840, the British invented a machine that made paper in a continuous roll. Prior to this, all paper was made by hand from rag pulp; it was a laborious process and the sheets were limited in size. In addition, wallpaper designs had to be printed and colored by hand as well. The result was that wallpapers were available only to the very rich. Machine-made and printed paper, available in the 1840s, was a great advance over these earlier techniques.

The popularity of wallpaper itself never wavered, but the preferred style did. In the 1840s, wallpaper was most often applied in the "French" style. This mode used the same pattern from baseboard to cornice, with separate borders applied as additional ornament. The dominant color in the wallpaper usually determined what tone was used on the ceiling and woodwork.

The list of patterns popular in the Victorian age is a lengthy one: architectural motifs, landscapes, natural scenes containing plants and animals, historical papers showing scenes from the past (these were also known as "biographicals" and presented episodes from the lives of famous people), ashlar papers that simulated cut stone, and those that mimicked damask or brocade.

Architectural papers imitated the ornamental features of a room—panels, cornices, friezes, moldings, and columns, adding these details to a room that lacked them. Marbleized papers were also used, shaped to feign panels atop a plain background. Scenic papers were also known as landscape papers or *paysages panoramiques*, since the best were manufactured in France. While they had only a fleeting vogue in Britain, they proved extremely popular in the United States, where they were widely used in

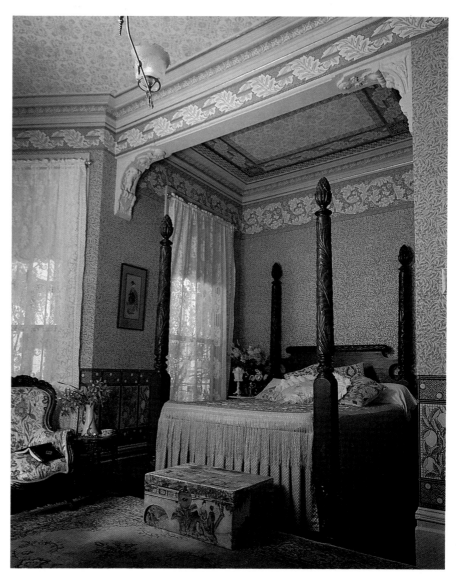

Wallpapers from Bradbury & Bradbury include patterns designed specifically for wainscoting and ceilings as well as walls, with coordinated borders, above.

Chloé wallpaper from Scalamandré, opposite page, features a trompe l'oeil design of drapery over a rich damask background pattern.

private areas. Some were printed on rainbow backgrounds (also known as "ombre" or "irisé") that featured shaded bands of color forming stripes of light and dark. Printed and flocked paper was another fashionable choice. Such papers often hung in the best rooms in the house.

Wallpaper borders were just as important as the paper itself. They were always used with wallpaper, often covering mistakes made during installation. Early borders from the 1840s are narrow (about three inches high). The most common motifs were florals, trailing vines, or architectural details. These included neoclassical motifs of urns and acanthus leaves. Another type of border imitated swags of fabric. According to *The Encyclopedia of Victoriana* (1975, edited by Harriet Bridgeman and Elizabeth Drury), some borders were printed in sets of four, each with the light coming from a different point, so that a clever paper hanger could hang them to take into account the natural sources of light in a room.

By the 1860s, America rivaled Britain in the production of wallpaper. The 1850s saw the introduction of wood pulp paper, but it was not widely used until the 1880s. Although it was less expensive than rag paper, it became brown and brittle with age. Statuary paper and landscape scenes remained popular patterns. Paper printed to resemble wood grain came into vogue. Patterns were not subdued; they repeated their motifs over and over again, so that they were crowded together in as many colors as possible.

Among the fashionable designs were baroque and rococo configurations of flowers, asymmetrical

hotels as well as private homes.

Another popular pattern was known as statuary wallpaper. Early versions showed Greek gods and goddesses, but these were soon adapted to suit the Victorians' hunger for decor that reflected the news of the day. By the late 1840s, national heroes were depicted in busts in both Britain and the United States. In addition to George Washington, Thomas Jefferson, Benjamin Franklin, and Marquis de Lafayette, the more contemporary Henry Clay and James

Buchanan could be added to the canon. In England, Admiral Nelson was always a favorite. These papers were often combined with trompe l'oeil pedestals and niches, to bring the look of an aristocratic sculpture gallery to middle-class homes.

Other papers, printed with small-scale, overall designs of stripes, simple geometric patterns (diapering, or diamond motifs arranged diagonally, were prevalent), arrangements depicting fruits, flowers, and ribbons, were used in bedrooms and other

cartouches, undulating stripes, and pseudo-architectural motifs. Some quieter choices were small geometric patterns, quatrefoils, and marbled papers in colors of light gray or yellow.

Tastes in colors changed as well. Lighter, subtle colors, such as yellow, pale green, or pale blue replaced the dark, warm colors previously embraced. More abstract designs also became fashionable. By the end of the 1860s, the taste for rococo finally showed signs of ending.

The new styles included diaper patterns in subdued colors as well as patterns using abstract natural motifs such as ivy, oak, or fig leaves. There were several popular ways of hanging these new patterns. A room might be papered in the same design from top to bottom, with a narrow border at cornice and baseboard. The color of the border often contrasted with that of the wall, following the theories of color harmony then in vogue. A blue paper would have a red border, a yellow one a violet border.

Large-scale baroque and rococo designs enjoyed a last gasp as imitation frescoes. They were applied to the upper part of the wall. The dado was either painted or covered in a plain-colored paper. Louis XVI-style rooms sported walls hung with panels of paper or fabric.

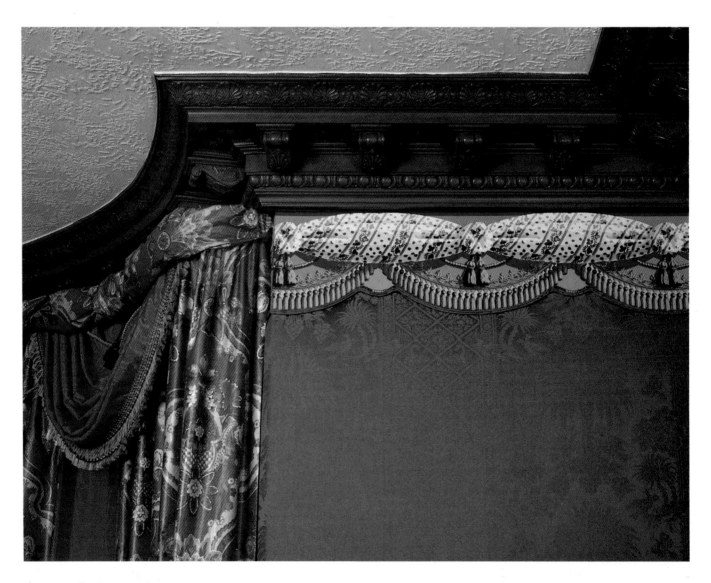

A trompe l'oeil paper features a gathered garland and looped swags, above.

THE TRIPARTITE WALL

Arevolution in taste swept through the design world in the 1870s. Charles Eastlake, author of *Hints on Household Taste*, condemned earlier styles of wallpaper. His influence was so pervasive that the style he championed remained fashionable for the next two decades.

His chief introduction was the new three-part horizontal division of the wall surface, also known as the tripartite wall. The bottom third of the wall was either paneled (known as wainscoting), papered (in a pattern different from that on the rest of the wall), or painted, in which case it was known as a dado. The frieze or cornice ran around the top of the wall. The area of wall between the top and bottom was called the fill or field. Each section of wall received its own treatment.

While these elements had been used together before, Eastlake was the first to advocate that they be applied in all rooms of the house. Suddenly, wainscoting was a must. Everyone had to have it. Other decorating writers jumped on the bandwagon, declaring that the new scheme was the perfect home-design solution. The lower half of the room could be dark and somber, a suitable background for clothes and furniture, while the upper walls were light and colorful, to show off paintings.

Still others felt that wainscoting relieved the monotony of a

A dado of Lincrusta, an embossed relief paper greatly in favor during the last decades of the nineteenth century, brings distinction to an entry hall, above.

A stylized iris-pattern dado paper from Bradbury & Bradbury is further adorned with several tiers of abstract-motif borders, including concentric circles, waves, a checkerboard, and rayed sunbursts, right.

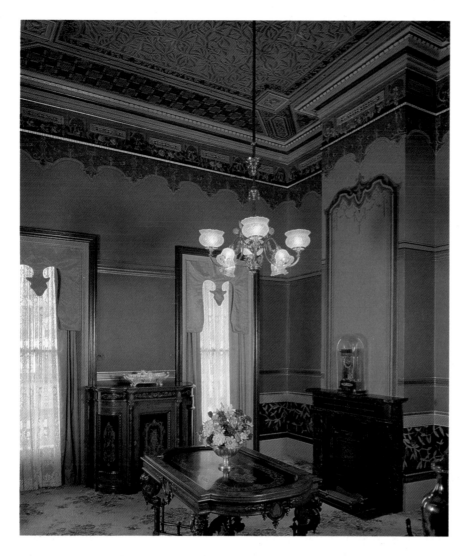

William Morris, the British designer, supported this practice.

A third method of creating the tripartite division was the employment of suites of wallpaper especially designed for the purpose. These offered three different patterns that simulated the division of dado, field, and frieze. The dado, for example, might feature stylized pots of flowers. A line of neoclassical egg and dart molding defined the chair rail. The wall field sported leafy swags punctuated with large flowers, while the frieze was another classical motif—robed caryatids alternating with leaf-filled urns, for example.

Embossed papers, such as Lincrusta and Anaglypta, were also used as dadoes. Made of embossed linseed oil on a canvas backing, these raised-pattern papers were invented by Frederick Walton, the creator of linoleum. They resembled carved wood or stamped leather. Lincrusta's great durability made it best suited for use as a dado; it could withstand the wear and tear. Lighter-weight Anaglypta was used as a frieze and on the ceiling.

The reign of the tripartite wall was over by 1890. In its place came two distinctly different decorating styles—revival (in America, mainly Colonial Revival; in Britain, Jacobean and eighteenth-century motifs adopted the traditional mantle) or Arts and Crafts style. In either case, the wall of the 1890s was much simpler in design than its predecessors. Wainscoting or a frieze might grace a room separately, but seldom in tandem.

While expensive wall treatments were seen in wealthy homes, the middle class had to

single wallpaper pattern. In the aforementioned *What Shall We Do With Our Walls?*, Clarence Cook wrote, "the old style . . . was to cover the walls with one vast expanse of paper, from end to end, and from cornice to mop-board. It would be hard to say which had the more disheartening effect upon the visitor, the sight of this desert when the paper was of a pale tint just off the white, or when it was of a dark ground with a sprawling design, or else with a very set pattern profusely relieved with gold."

This tripartite division appeared in various guises.

Wainscoting could be of wood paneling, in a pattern custom-designed for the room. Only wealthy families could afford the expense for more than one or two rooms. However, fashion-conscious home owners could buy ready-made wooden wainscoting in various patterns (including arches, ovals, and stripes) and install it themselves, finishing it off with a wooden molding.

Others settled for a simpler solution, marking the top of the dado with a chair-rail molding and using paint or paper (usually two different colors or patterns) on the sections thus defined.

settle for wallpapers that imitated fresco paintings, paneling, and tapestries. Patterns were based on French Empire styles, including stripes, florals, and Renaissance-inspired "tapestries." One popular striped design employed two tones of the same color; more elaborate versions inserted wreaths, ribbons, or flowers among the stripes. Continuing the two-tone theme were flocked papers printed on same-color backgrounds (the difference in texture created the illusion of different colors). Floral papers could be paired with matching chintzes or cretonnes for a custom-designed look, as well.

Such traditional schemes usually employed wallpapers with coordinating friezes. These frieze designs had various widths, from as narrow as five inches to as broad as two and a half feet. A simple room scheme might combine a painted or papered wall and a patterned frieze, pasted up just below the ceiling. Not only did the pattern of the frieze harmonize with that of the wallpaper, it was frequently even printed in the same colors—a definite switch from the "harmony by contrast" theories that prevailed earlier. There were several variations on the theme of paper and frieze. A home owner might match a patterned paper with a frieze of the same background but lacking a pattern. Another option was a frieze bearing the same pattern as the wallpaper but printed over an ombre background as mentioned above. A third alternative saw both paper and frieze with the same design but with the colors reversed. Sometimes a plate rail separated the two; or the edge of the frieze

might overlap the main paper.

But Arts and Crafts wallpapers employed a very different sensibility. These patterns usually consisted of geometric, abstracted patterns based on themes taken from nature. Arts and Crafts designs first became popular in England; wallpapers designed by William Morris and W. De Morgan are outstanding examples of the genre. For those who could not choose among the patterns, solid-colored walls, usually covered in a textured material, were recommended by reform-minded designers. Burlap and canvases were popular materials for this purpose as well. Occasionally they were decorated with stencils in various patterns.

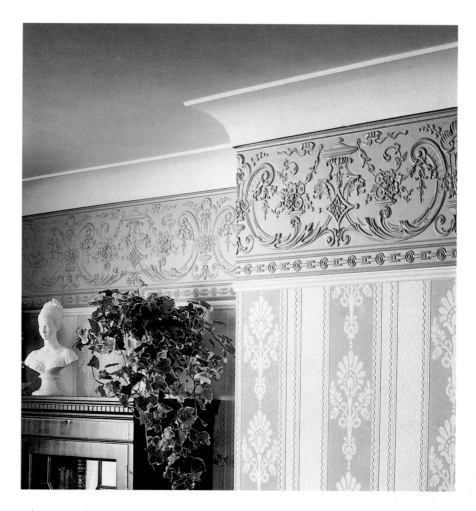

A neoclassical cornice of embossed Anaglypta in combination with a shallow cove molding adds a graceful note to this tall room, above.

Tall windows begin at floor level in this lofty Victorian room, opposite page. A leafy dado, picture rail, several stripe borders, and a tiered cornice add to the sense of height.

PANELING

Paneling was an alternative to the tripartite wall, though completely paneled rooms were rare in Victorian homes. Indeed, they were usually found outside the home, in libraries and gentlemen's clubs. When paneling was employed, it was often of less expensive wood, such as yellow pine, painted and grained to resemble exotic hardwood. Later in the century, with the development of the American hardwood industry, which brought prices down somewhat, hardwood paneling appeared in middle-class American homes.

But fully paneled walls never matched wainscoting in popularity. When walls were fully paneled, they

employed motifs similar to those seen in wainscoting—arches, squares, ovals, and octagons, sometimes used in combination (rows of square panels topped with a border of arched panels). Beaded paneling, consisting of broad strips delineated with shallow grooves and low-profile vertical rounds, appeared stained both in one color and striped in two tones. But what we today would call paneling (reaching up to a few inches below the ceiling) was to the Victorian mind only a very tall dado.

Paneling lends dignity to this music room, above, designed by Kemp Interiors in the Victorian tradition.

WOODWORK

Woodwork was a very important element of the Victorian interior. It consisted mainly of baseboards, chair rails or plate rails, door and window moldings, and cornices. In rooms with fireplaces, mantels and overmantels were also a factor. Wall medallions, niches, and brackets also fall into this category. Because of the expense entailed in using hardwoods, woodwork in the 1840s and 1850s was usually made of less expensive wood, painted to match the colors of the room or grained to imitate more costly hardwoods.

Paint colors used for woodwork were carefully considered. There were many theories about the best tones to use. In the 1840s, it was generally considered best to make the woodwork either lighter or darker than the walls (with the ceiling lighter than both). Most rooms had cornices, as it was felt that they looked unfinished without them. White woodwork was considered inappropriate unless the walls were also white. If the walls were painted a solid color, the woodwork was painted a tone of the same color (usually darker to hide dirt). In addition to graining, marbleizing was also favored for door and window moldings, baseboards, cornices, and fireplace surrounds and mantels.

By the 1850s, however, it was considered acceptable to paint woodwork white in order to make it stand out against dark walls. This period also saw the new popularity of the chair rail. This was a projecting molding (usually about two and a half inches deep) that ran around the room at dado level (about three feet above the floor). The chair rail was welcomed as a device to protect the wall against knocks from furniture and other hazards, as C.P. Dwyer wrote in *The Economic Cottage Builder* (1856): "Housewives will surely bear us out in this opinion when they consider how destructive to walls the effects of chair backs, or, worse still, of the heads of gentlemen who find a luxury in assuming an inclined posture of the body by tipping back their chairs."

Simple woodwork designs saw the century out. Arts and Crafts interiors employed stained and varnished woodwork, while that in revival rooms was usually painted a color that harmonized with the walls. Painted woodwork was also recommended in kitchens, bedrooms, and bathrooms, since it was considered easier to keep clean.

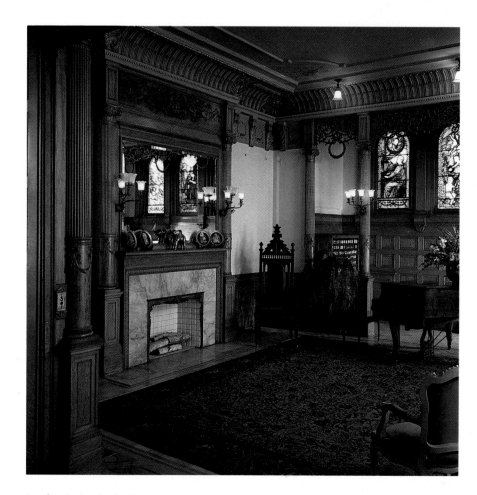

A ribbed cove molding, chair rail, and carved overmantel contribute to the richly textured interior of this room, above, in the Whitney House, Detroit, Michigan.

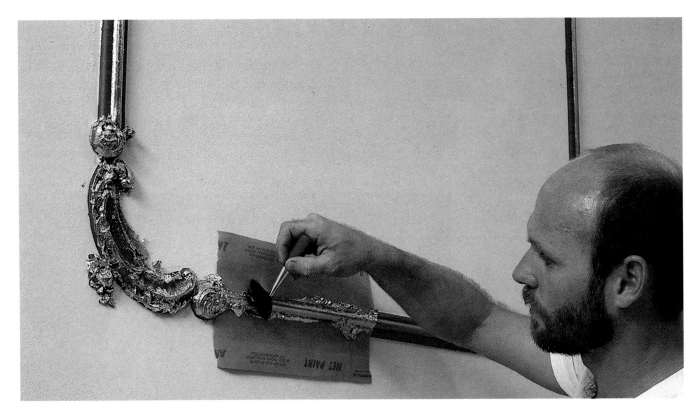

By the end of the century, cornices were also painted in various colors, often derived from those found in the wallpaper. The diagram for one suggested color scheme includes the use of gilt, green-gray, light cream, pink, green-blue, deep cream, and deep old gold. Another used tones of buff, moss-green, bronze-green, Indian red, and blue, with gilt trim. These colors picked out the complexities of the cornice molding for a very decorative look.

During this period, the standard rules for room decor demanded that the woodwork be painted the darkest color in the room. Hardwood was generally stained a natural hue, while softwood was painted to correspond with the shades found in the room. White was one of the few colors not in favor for woodwork. The preferred tones were in-tense; among them were black, maroon, chocolate, dark blue, and bronzy-green. Doors and windows were often painted in a combination of colors, with the molding around the door in the darkest hue, the stiles and rails of the door in the medium tone, and the panels of the palest. The edges of the panels on these doors might be gilded, or gilt trim added to surround them. Door panels could be stenciled or covered with wallpaper as well. This fashion was popular throughout the 1880s, although by the 1890s doors decorated in this way were considered passé.

The elaborate variety of wall details and woodwork seen in the Victorian age is now available by virtue of reproductions cast in materials such as plaster and fiberglass. These accessories were once an important element of Victorian parlor decor. Me-dallions, for example, often framed light fixtures or panels of fabric or scenic wallpaper. Brackets, frequently in the shape of C- or S-shaped scrolls, other times more fancily carved, provided support for shelves. Brackets can also be used to display a single, treasured knick-knack. Wall niches provide an even more dramatic method of showing off beloved pieces of art or handiwork.

A skilled craftsman restores gilded molding, above. An imposing panel on a light-colored wall, this style of decoration would be suitable in a formal room.

PAINT

Color was an important aspect of nineteenth-century decoration, and paint played a significant part in the treatment of walls. The Victorians' attitude toward color was much more critical than our own, and much attention was given to color combinations within a room. In the early part of the Victorian era, paint was a do-it-yourself affair, mixed up by the individual home owner or house painter from linseed oil, turpentine, and various pigments. Lighting also affected the colors used; one of the reasons for the bright hues preferred in the early Victorian era was that interiors were seen by the light of oil lamps or candles. With the

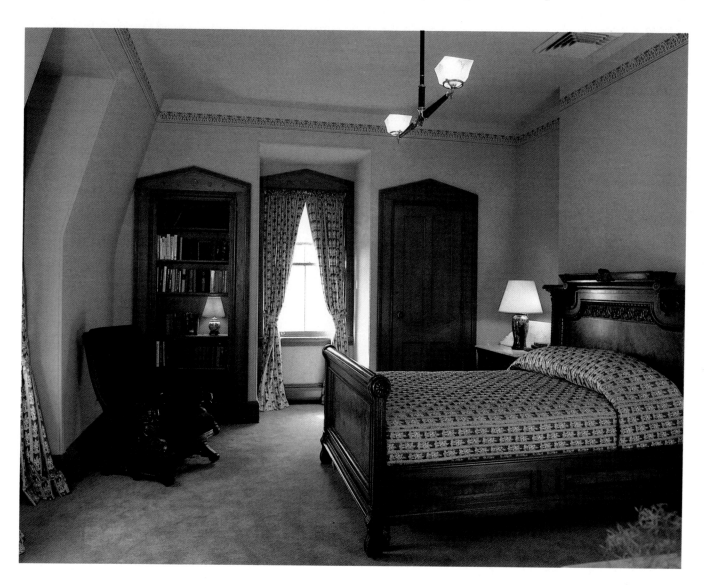

Delicate stencil work by artist John Canning lends a feminine air to an airy bedroom in the O'Neil House in Hartford, Connecticut, above.

A strié-painted wall and a marbleized fireplace, above, both done by artist John Canning in a mansion in Connecticut, show the variety of effects possible with the use of decorative painting techniques.

advent of gaslight and electricity, the fashionable colors became much paler and less intense.

The work of Michel Chevreul, the Director of Dyes for the Gobelin tapestry works in France, had a strong influence on mid-Victorian color theory. His book, *The Principles of Harmony and Contrast of Colors* was published in Britain in 1854 and in the United States in 1869 as *The Painter, Gilder, and Varnisher's Companion.* Chevreul's volume examined two things: how colors work together, and what effect adjacent hues have on the human eye. From these rules stemmed the complex color theories em-

ployed by the Victorians.

These theories essentially resemble the principles of "harmony by contrast" and "harmony by analogy" discussed in the section on wallpaper and woodwork and in the chapter on ceilings. Victorian rooms were beautified according to very strict rules of color placement. Several nineteenth-century decorating critics proposed imaginative painting schemes. These included striping the woodwork and the walls with fine lines of contrasting color to provide interest and brighten the walls. The painting might be used in conjunction with strips of solid-colored wallpaper to create

decorative borders for the windows and doors.

During the period 1870 through 1890, dramatic technological developments fostered a whole new attitude in wall painting. Ready-mixed paints became available, and home owners were subject to the tyranny of fashionable colors. Since color mixing was no longer a haphazard process, the residents of a house could specify exactly what colors they wished to see on their walls, and paint manufacturers strove mightily to make them available. The availability of predictable colors increased the authority of color theories, since fixed hues made scientific analysis of color perceptions possible.

Decorating experts went wild suggesting paint schemes that employed subtle and complex color combinations. These schemes were invented to fit individual rooms, such as the hallway, the parlor, the dining room, and the bedroom. Rules were laid down for the colors that were suitable for use in these rooms, how they should be used, and under what circumstances.

In the parlor, for example, according to Harriet Spofford, author of *Art Decoration Applied to Furniture* (1878), the use of "soft, gay, and delicate" colors, by virtue of the room's "feminine character," was advisable. In the dining room, there should be an aspect of "solid comfort" with substantial colors such as red, blue, green, and brown. Tones of terra cotta, yellow, and olive were also recommended. Sage-green and dull red were among the colors considered appropriate as backgrounds for paintings.

In the 1890s, bright colors and

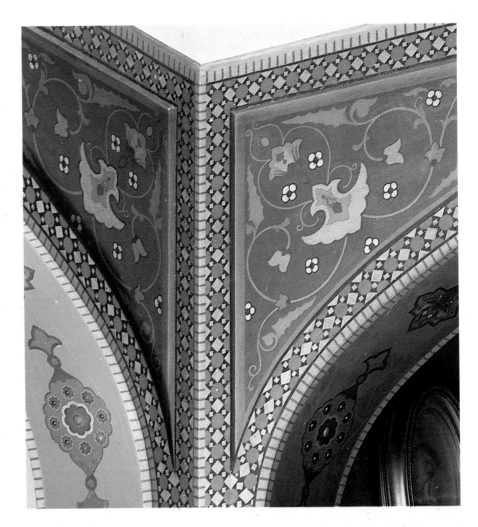

"harmony by analogy"—employing colors that lay next to each other on the color wheel—came back into favor. Rooms were painted in a range of similar tones. The popularity of open planning with all the rooms on the first floor leading into one another encouraged decorating schemes that took the relationship of the rooms into account. "Heavy" colors, such as earthy greens, stone, slate, bronze, and terra cotta, were considered appropriate for halls, dining rooms, and libraries. "Light" colors—pure hues, pale blues and grays, fawns, and foliage greens—were used in parlors and bedrooms.

Bold stenciled Oriental motifs mark the inner curve and tympana of a pair of arched openings at Olana, the home and studio of artist Frederick Edward Church in New York State, above.

FLOORS

In the 1800s, fashions in interior designs changed rapidly, particularly in flooring. The development of the middle class saw its full flowering in the Victorian era. Every member of the burgeoning middle class in both Britain and America, wanted to own his own home and decorate it as splendidly as his resources would allow. As a result of industrialization, wages were higher. The new literacy, brought about by the first compulsory public schools, meant that many more consumers could read magazines and newspapers to learn about decorating fashions.

In the 1830s, floors of softwood boards, often laid in random lengths and widths, were favored. These floors existed in homes of every economic class (with the exception, of course, of those houses too poor to have any floors at all), and were covered with floor cloths of sturdy canvas or other fabrics for protection. In the 1860s and 1870s, Victorian home owners covered floors with wall-to-wall carpeting, patterned in bright geometrics and florals—sometimes a combination of both. By the end of the century, polished hardwood floors scattered with oriental rugs were *de rigeur*.

In Victorian times, as in our own, purchasing power affected choice of decor. The expense of installing hardwood floors to replace softwood was simply too great. Carpeting, too, was forbiddingly expensive throughout much of the era. One solution for keeping abreast of the changing fashions was to simulate the higher-priced materials with a variety of inexpensive imitations. These included painted floors, floor cloths, fabric coverings known as druggets, floor matting, and "wood carpets" that mimicked parquet.

Another Victorian concern was finding suitable materials for the floors of rooms that hadn't existed before the nineteenth century: bathrooms, modern kitchens (the introduction of the stove, the icebox, and indoor plumbing changed the nature of this room entirely), laundry rooms, and high-traffic entry halls. Home owners today can benefit from Victorian ingenuity and sensibility in every room of the house.

PAINTED FLOORS

Of the wide range of flooring alternatives available to the Victorians, perhaps the most versatile was the painted floor, which originally came into favor for practical reasons. The most common wood floors in early nineteenth-century homes were planks of softwood laid in random widths. Because this type of floor scratched easily and was difficult to keep polished, resourceful Victorian home owners turned to paint in order to seal the floors and to provide an additional source of color and pattern in the room. Painted floors imitated other types of floor covering but were usually cheaper.

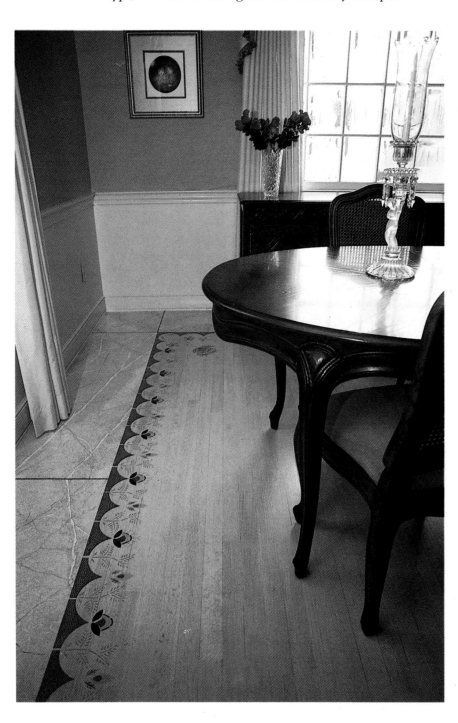

Motifs for painted floors were almost limitless. In the early period, geometric patterns were popular. Floors were also painted to reproduce marble or other exotic woods. Sometimes only the borders were painted, to harmonize with area rugs. Stenciled patterns were also fashionable when used on floors. Stenciled designs, both figured and floral, decorated kitchens, halls, and bedrooms. Other areas, such as parlors, studies, and dining rooms, more often received the benefit of high-priced materials such as carpeting.

It was during the high Victorian period that the art of floor painting came into full flower, stimulated by the popularity of wall-to-wall carpeting. The price of carpeting was too great for the majority of middle-class home owners, but the look of patterned carpets was easy to approximate through the low-price wizardry of paint. Painted floors appeared in many homes. The most popular overall treatment was to apply a single color to the center of the room, and surround it with a fancy boarder, patterned to resemble a carpet. Some home owners painted their houses themselves; others hired artisans to do it for them. At that time, any self-respecting painter was skilled in a variety of painting techniques and would execute them for a reasonable fee.

A less traditional approach of loosely sprawling leaves works well with the accentuated grain of the floor, above.

A stenciled floor, enlivened by a scalloped border and delicate flower sprays, opposite page, is the work of artist John Canning.

In the late Victorian and Edwardian eras, the high Victorian enthusiasm for pattern and contrast was replaced by a trend toward "medieval" simplicity. The fashion for shiny hardwood floors inspired new disguises for the old softwood planks, which were often stained in various colors to resemble inlaid woods and parquet patterning. Another technique was to stain the floor a uniform dark brown and cover it with a gloss of shellac. Less public rooms, such as bedrooms, frequently received treatments reminiscent of an earlier era, with decorative borders painted around the edge of the room and a rug placed in the center for warmth and coziness.

In addition to their durability, painted floors are a real bargain. Paint can be used to counterfeit more expensive materials, such as marble, patterned tile, or exotic woods. There are a number of books that can serve as guides to various techniques of applying paint, such as sponging, spattering, combing, and ragging. A range of stencil-pattern books are also available. These supply a mélange of patterns from the historical to the contemporary. Stencils can imitate a rug in a living room or a dining room; tile in the kitchen or entry. In a child's room, a stenciled alphabet or board game provides a source of fun as well as ornament.

One authentic Victorian floor treatment with a modern feel is spatter painting, known in the nineteenth century as "spatter-dash." This technique dates from the 1830s but was popular throughout the century. It was used in less formal rooms, away from the public eye—bedrooms, kitchens, children's rooms. Spatterdash can blend any mixture of colors, either light on dark or dark on light. The final effect, especially if the spattering is very fine, resembles faux stone. For a period look, choose one of several popular Victorian combinations:

Copper-brown with black, white, yellow, and green spatters.

Black with colored spatters (especially effective with bright primary colors)

Medium-blue ground with red, yellow, and white spatters.

Gray floor spotted with black and white—known in New England as "pepper and salt."

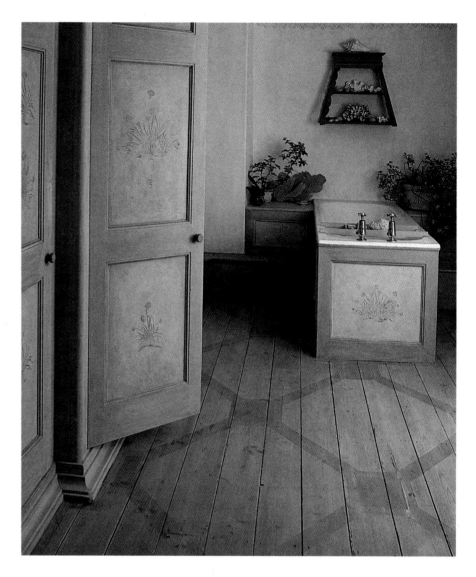

A diapered pattern of darker paint stenciled over bleached wooden floorboards creates a relaxed neoclassical feeling in this Cornwall bathroom, above, especially in combination with stenciled panels on doors and tub.

The ease of spatter-painting makes it a good do-it-yourself project. First, paint the ground color on the floor, then apply the accent colors using a stiff brush or broom to spatter them on. According to *The Old-House Journal Compendium* (1980), a restoration manual edited by Clem Labine and Carolyn Flaherty, a whisk broom makes the best tool. Be careful to protect the walls and baseboard from any stray flicks of paint. You might want to practice on sheets of newspaper first to get the hang of it. There are paints specially made for floors that you can use. These, however, are somewhat limited as to color choices. If you don't mind going to the extra trouble you can cover regular latex with a clear protective finish and it should last. You can also use enamel paint; it's more durable but it takes longer to dry.

Another technique similar to spattering is sponging. Both result in a fairly dense surface, with areas of color placed close together. In sponging, paint is applied using a sponge. Natural sea sponges give the best effect. You can also try using a pad of steel wool. Both give a soft, cloudy effect, less textured than spattering. Pour a layer of paint into a shallow container, such as a foil roasting pan. Then dip your sponge or steel-wool pad into it and dab the paint onto the floor.

DRUGGETS, FLOOR CLOTHS, AND LINOLEUM

A Victorian floor inspiration is the drugget, an inexpensive, coarse cloth, frequently made of woven wool or wool and flax, used to cover the floor. Druggets were used in a multiplicity of ways. They served as covers for expensive carpets, to protect them from wear or staining; they served as floor coverings on their own; and occasionally were placed *under* the main rug, to create a border and hide the floorboards around the perimeter of the room. (Floorboards were considered ugly in the 1830s and 1840s.) These borders were generally very simple in design, often a simple black or other dark color band set in from the border of the

drugget. Druggets were also used to cover stairs. Fancy borders sometimes appeared, usually of geometric patchwork. Druggets made in factories came in patterns of circles, stars, and other figures as well.

Druggets lend an authentic touch to a Victorian Revival interior. They can also serve to protect expensive carpeting or area rugs from the wear and tear of everyday life. Authentic druggets are still manufactured in Great Britain. Awning canvas is also the right weight and makes a good, inexpensive substitute. Modern druggets can be both functional and decorative. In fact, Patrick Naggar, a contemporary avant-garde French interior designer, is known for his use of a painter's canvas drop cloth in lieu of a rug. What's this but a Victorian drugget in contemporary guise?

Another inexpensive floor covering popular with the Victorians was the floor cloth. Although today we tend to associate floor cloths with the eighteenth century, nineteenth-century home owners used them throughout the house, in vestibules and hallways as well as parlors. Victorian floor cloths came in all sorts of patterns. They were made of a blend of cotton, linen, and hemp fibers, woven in sizes from four to

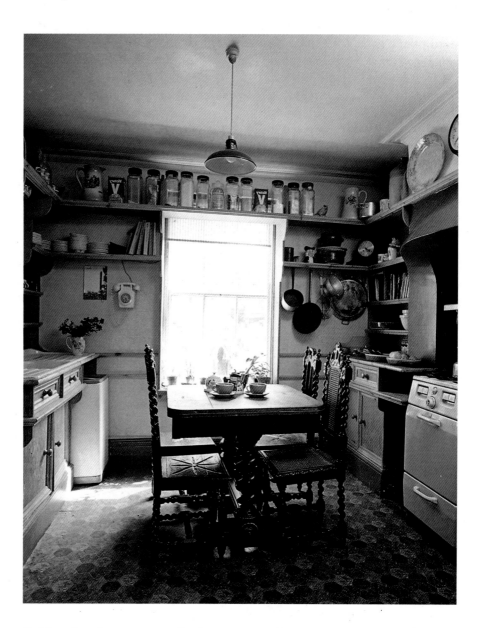

In Victorian times, as now, linoleum, easy to clean and care for, was considered the most suitable kitchen flooring material, as seen in this British home, above.

twenty-seven feet wide and up to seventy feet in length.

According to contemporary accounts, the fabric was first stretched and then sized. It was rubbed with an abrasive to create a smooth surface and to remove the fibers raised by the sizing process. Then it was painted with several layers of paint (up to four on each side) to make it very stiff. Then the floor cloth was painted with a design. Old floor cloths were prized over new, since they had absorbed the paint more fully and were more durable.

Many were hand-painted, although towards the turn of the century others were printed by machine. Numerous examples imitated other materials, such as tile, wood, or marble, while still others were painted or stenciled to resemble carpets. Floor cloths were expensive and somewhat fragile. Nineteenth-century household writers suggested that floor cloths could be cleaned by wiping them gently with water, but advised against scrubbing as this could rub off the paint. According to a tip in *Godey's Lady's Book*, an influential monthly women's magazine published in the United States throughout the nineteenth century, milk served as a good polish.

The nostalgic tendencies of the late twentieth century and the prominence of the country look has led many present-day artisans to take up floor-clothmaking. If a painted floor seems too permanent a commitment, a floor cloth can create a similar effect. Durable and attractive, a floor cloth is also portable.

Linoleum, long associated with the twentieth century, is actually a Victorian invention. Nineteenth-century designs most often imitated wooden floors or ceramic tiles set in geometric patterns. The current Victorian revival has made Victorian-style patterns available once again. Unlike its more cumbersome nineteenth-century ancestor, modern linoleum is easy to install and maintain, and highly durable. So don't turn your nose up at this seemingly mundane product if you're concerned about Victorian authenticity for your floors.

Starting in 1870, decorating guides offered descriptions of do-it-yourself "paper carpets." One method was to layer the floor with newspapers, which were then covered with a thick paste of flour and water, and topped with a patterned wallpaper, which was varnished for durability. A second procedure began with coarse fabric stretched and then tacked into place, then covered with a thin paste. The patterned paper—usually in checked or mosaic designs—went on top of the fabric, which was then shellacked and varnished. Supposedly, if the finish was touched up occasionally, these paper carpets would last for years. Just for fun, you might experiment with making a paper floor covering as an exercise in do-it-yourself Victoriana.

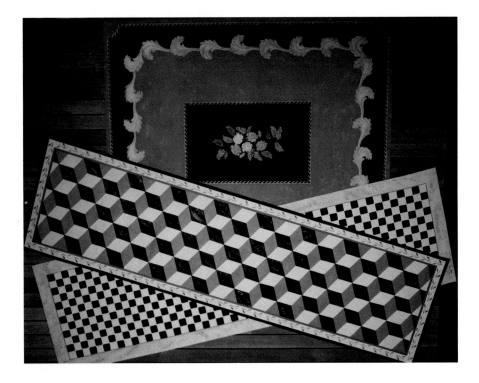

Geometric and floral-pattern floor cloths, above, from Good & Co., floor cloth makers, provide easy-to-clean and sturdy decoration for any interior.

FLOOR MATTING

Victorian decorating authorities, from Lydia Marie Child, author of *The American Frugal Housewife* (1835), to sisters Catharine Beecher and Harriet Beecher Stowe in *The American Women's Home* (1869), recommended floor matting for almost every room in the house. It came in both wall-to-wall form, known as carpet matting, and as individual mats. Carpet matting was generally made of woven plant fibers. Individual mats were also made of this material, although there are examples (generally crafted by individuals) made of dyed and trimmed sheepskin, thick woven wool, and braided and sewn-together rags. Carpet matting was available dyed in solid colors as well as stripes and checks. As with other types of flooring, a solid-color center with a patterned border was a fashionable combination. Victorians were fond of stenciled matting as well.

In the early Victorian period, carpet matting was laid over softwood floors to protect them, and to guard against drafts eddying through the all-too-common cracks in the floorboards. Rugs were frequently placed on top for a layered look and additional insulation. After 1850, floor matting reached the peak of its popularity. Strips of matting were sewn together and bordered with colored tapes to make rugs. Matting was used to cover the floor year-round in country houses; in the city it was a summer replacement for heavy woolen carpets.

Many different types of matting are available today, from sisal to Japanese tatami (woven with cotton threads for additional resilience). These unadorned floor mats can be given a personal Victorian touch by edging them with fabric or painting or stenciling them with floor paint or enamel (you would not want to use the latex and varnish combination here, since the texture of the fibers is part of the appeal) in a pattern that harmonizes with the room. Matting is not suitable for year-round use in entry halls or on stairs because it does not wear

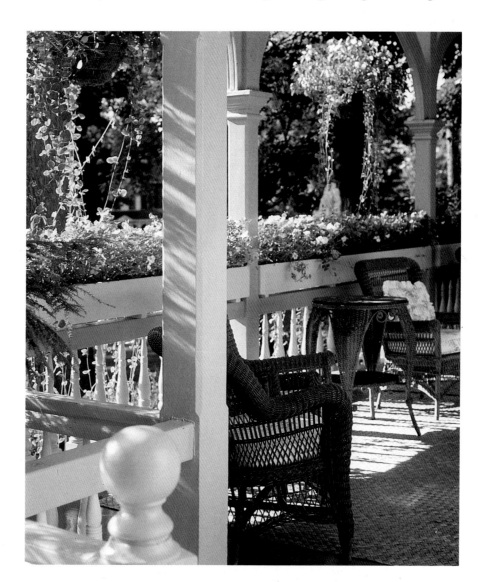

well with heavy use. In addition, constant exposure to moisture can cause it to rot. But it is delightful when used as a summer covering for floors, in a country house, or in low-traffic areas such as bedrooms.

Rush matting, available in several patterns as well as plain, above, makes versatile flooring material for areas that don't get a lot of traffic.

TILES

The Victorians employed tile flooring much as we do—in areas that got a lot of hard wear, such as entry halls, or rooms that needed easy maintenance, such as kitchens and bathrooms. The Victorians used tile flooring for its durability, good looks, and low cost, and it retains those advantages today. Nineteenth-century tiles came in various sizes and shapes. "Plain quarries" were about six inches square and came in red, blue, "drab" (gray-yellow-brown), black, or brownish-yellow. "Figured" tiles were the same size and bore patterns of flowers and interlaced lines. Patterned tiles were more expensive in the United States,

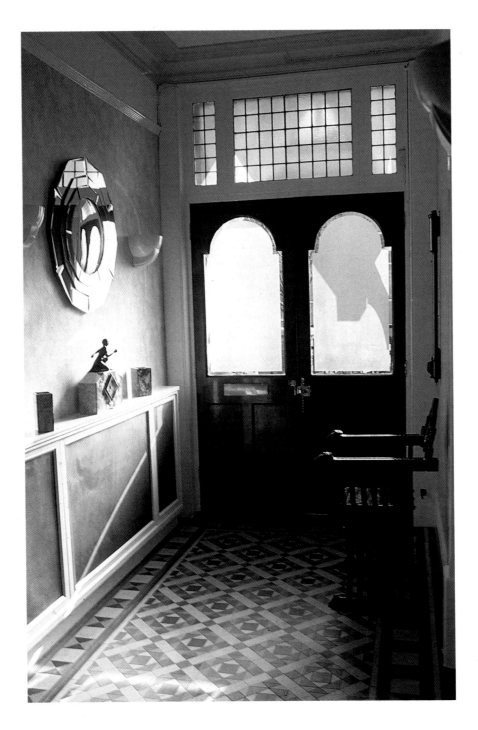

since they were imported from England, and are therefore rarely seen in American homes. Other examples are square or hexagonal in shape; the hexagonal tiles were used in combination with small square tiles, often in a contrasting color. In the period from 1850 to 1890, these different sizes and shapes of tile were laid to create various figures, some geometric, some floral, along with fancy borders that combined motifs (checkerboards and stripes with stylized flowers, for example). By the turn of the century, delicate floral patterns that resembled Roman mosaics and bold checks with geometric borders were all the rage.

In the 1850s, 1860s, and 1870s in Britain there was a craze for Oriental and Arabic tiles, printed in blue and gold, with Arabic script and intricate geometric designs. These lent an air of fantasy to otherwise somber homes. Tiled floors also were used in imitation of rugs, with plain centers and decorative borders.

Another fad of the 1880s was for tile floors designed to look like Roman mosaic work. Some were inspired by mosaic floors found in the ruins of Herculaneum and Pompeii, unearthed earlier in the century. Others—generally used in vestibules—illustrated scenes from classical legends or displayed mottos, such as *Cave canem* (Be-

ware of dog) or *Salve* (Welcome).

Victorian bathrooms were often adorned with black and white tiles laid in geometric patterns, a look that has been enthusiastically reinstated in contemporary and Victorian Revival bathrooms. In kitchens, where the floors were usually of softwood planks, the Victorians often tiled the area beneath the stove to reduce the risk of fire. Completely tiled floors were another alternative in the kitchen.

Tiled floors are appropriate in many of today's Victorian Revival rooms. Victorian mosaics and checkerboards might be used in areas that get a lot of traffic and need to be easy to clean, of course—playrooms, poolside areas, laundries, kitchens, and baths. Any home owner can think of suitable uses. But the true Victorian inspiration comes from the patterns themselves, rather than the rooms they are employed in. Elaborate geometric patterns ex-

ploiting several colors and a variety of shapes are far more interesting than a simple checkerboard. Floral mosaics utilizing tiny hexagonal tiles look as attractive as carpets and wear far better. Tiled mottos can create a personal motif in the vestibule. What about a family name, important dates, or perhaps a portrait of a pet or the house itself laid in tile? If this seems too exotic, there's always that old standby, "Welcome."

Intricate tile patterns add to the grandeur of this imposing interior, right, from the Whitney Mansion on Detroit's Woodward Avenue.

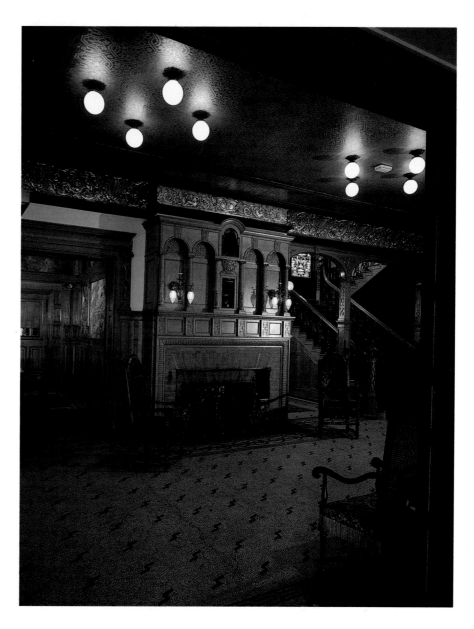

Contrasting tiles in this London foyer, opposite page, are hard-wearing as well as decorative.

RUGS AND CARPETS

Area rugs—used singly, in groups for a patchwork effect, or layered on top of carpeting—are an important component of the Victorian look. The Victorians also used several different types of wall-to-wall carpeting. In the 1830s and 1840s, flat pile carpets known as "ingrains," patterned with stripes and floral motifs, were the most common and affordable type of carpet. These natural fiber carpets were woven rather than tufted or punched, like modern carpets. They resembled craft-style rugs, such as Navajo specimens or Mexican serapes. Looped-pile carpet, with standing loops, was known as Brussels carpet. It was found only in the wealthiest homes because of its high price. Remember, shag carpets are a twentieth-century invention. Low pile, whether looped or cut, is the most authentic choice.

Whatever the type, carpeting was woven in strips which were then sewn together to create larger rugs. Woven carpets were reversible, which increased their practicality. An extremely popular type of woven striped carpet, known as "Venetian" carpet, was often used as a stair runner as well as in bedrooms.

During the high Victorian era, floors were more likely to be carpeted. By the period 1850–1870, carpet had decreased enough in price (due to expanded industrialization) to become a basic home furnishing rather than a luxury. The geometric, small-scale patterns of early Victorian carpets were replaced by brightly colored, realistic designs of flowers and foliage. Black outlines and carefully placed "shadows" lent a three-dimensional effect. The carpets generally combine several different shades of the same color rather than a contrast of hues. Small patterns appeared in small rooms and large patterns in large rooms, a decorating trick that still works well in many rooms today.

Towards the end of the century, area rugs atop polished hardwood floors were the ap-

Striped Venetian carpets, above, were very popular in the 1830s and 1840s.

William Morris's Tulip and Lily carpet design of the 1870s, right, is still available from J.R. Burrows & Co.

A bold carpet motif of floral medallions enclosed within stylized leafy borders dominates this drawing room, opposite page.

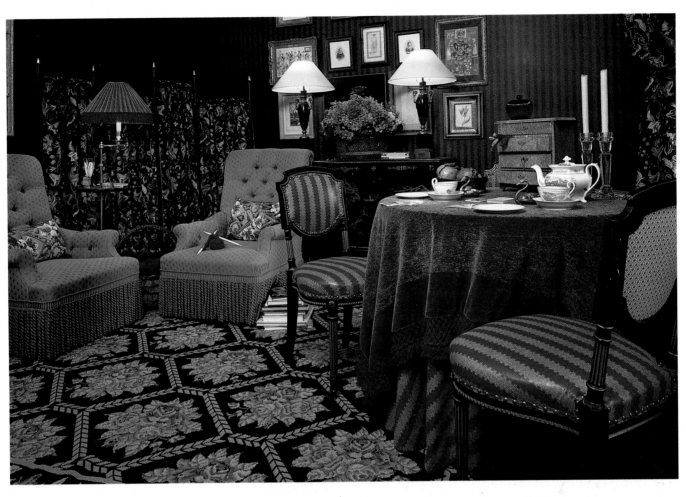

proved look, a change due to Charles Eastlake's book *Hints on Household Taste in Furniture, Upholstery and Other Details*.

The smaller rugs showed off the decorative borders of hardwood floors, and they were easier to care for than wall-to-wall carpeting. Rug patterns were ornate, intricate, and romantic; needlepoint designs, Aubussons, Axminsters, and Oriental rugs were all fashionable. Rag rugs and hooked rugs appeared together in the same room. Layered over carpets, small rugs provided extra warmth in bedrooms. Some popular color combinations in patterned rugs were blue with pink, scarlet with gray, deep red with pale blue, and olive-green with gold. Animal skins, such as tiger, bear, and fox, afforded an exotic touch when used as rugs.

By the turn of the century, carpet patterns and styles had calmed down considerably. The favored carpets were subdued in color and pattern. There were even solid color rugs and carpets to suit the turn-of-the-century trend away from accumulations of pattern on pattern.

In our own era of lowered thermostats and energy conservation, the Victorian passion for rugs and carpets stands us—and our chilly feet—in good stead. The cheerful eclectic look of rugs layered atop carpets, when laid down with an eye for attractive combinations, can be both appealing and cozy. Modern carpet tiles make it easy to achieve the look of a bordered, room-sized carpet.

The long and varied use of carpeting in Victorian homes leaves the modern home owner with a range of choices. Those who disapprove of high Victorian extravagance, or prefer a simpler, less formal look, can select a geometric pattern reminiscent of the early Victorian period, or perhaps an ingrain or Venetian, both of which are still manufactured today. Their high price and poor durability, however, make them less desirable. Modern pile carpets woven in Victorian-style florals and geometrics supply a more practical alternative.

HARDWOOD AND PARQUET

Hardwood floors did not become fashionable until the last quarter of the nineteenth century. Since these floors were easier to keep clean than wall-to-wall carpeting (the electric vacuum cleaner was yet to be invented), household reformers recommended them for sanitary reasons. The look of a gleaming hardwood floor scattered with a variety of colorful rugs has become firmly established as an elegant, traditional style. Equally representative of late Victorian tastes are wood floors laid in parquet patterns.

Victorian parquet came in a number of different patterns, many of which are still available today. Some variations include dark and light stripes, a basket-weave effect, or herringbone patterns. Elaborate borders were a Victorian passion. Examples shown in Eastlake's *Hints on Household Taste* are interlinked diamonds, bordered in white with an inner stripe, edged by a concentric border employing the same colors; a tricolor Greek-key pattern; a strip of octagons with alternating dark and light concentric rounds centered with an eight-pointed star that resembles a pinwheel; and large octagonal stars with dark borders linked by open diamonds. A combination of a pattern and a border gives the most Victorian look. If you feel this is too busy, try an overall pattern edged with a simple stripe, or a plain center with an elaborate perimeter.

A basket-weave motif parquet floor provides a sober foundation for a room in the Bachellor Mansion, Saratoga, New York, left.

Boldly patterned chevrons of dark and light wood create a dominant pattern underfoot in this London room, opposite page.

The Victorians also liked the rich look of hardwood flooring laid in contrasting stripes. Popular woods were oak with walnut and cherry against southern pine. These contrasts were always muted to avert vulgarity. Because of its basic simplicity, a striped-wood floor adds warmth to Victorian and contemporary interiors alike. For a true nineteenth-century look, woods should be stained in dark, mellow tones.

If you have plain hardwood floors in your home, and you would like to give them a more interesting appearance, try one of these Victorian methods. You can stencil your floor in two or three different tones to give it the look of inlaid wood. One technique, popular in nineteenth-century Sweden, was to stencil the floor with black stain in a checkerboard pattern. You could also paint or grain your floor to resemble a more expensive wood.

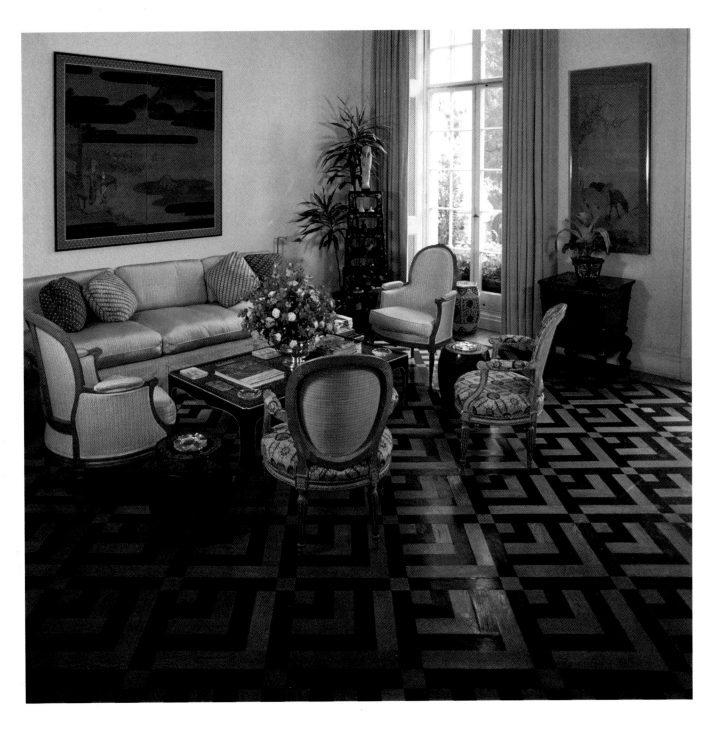

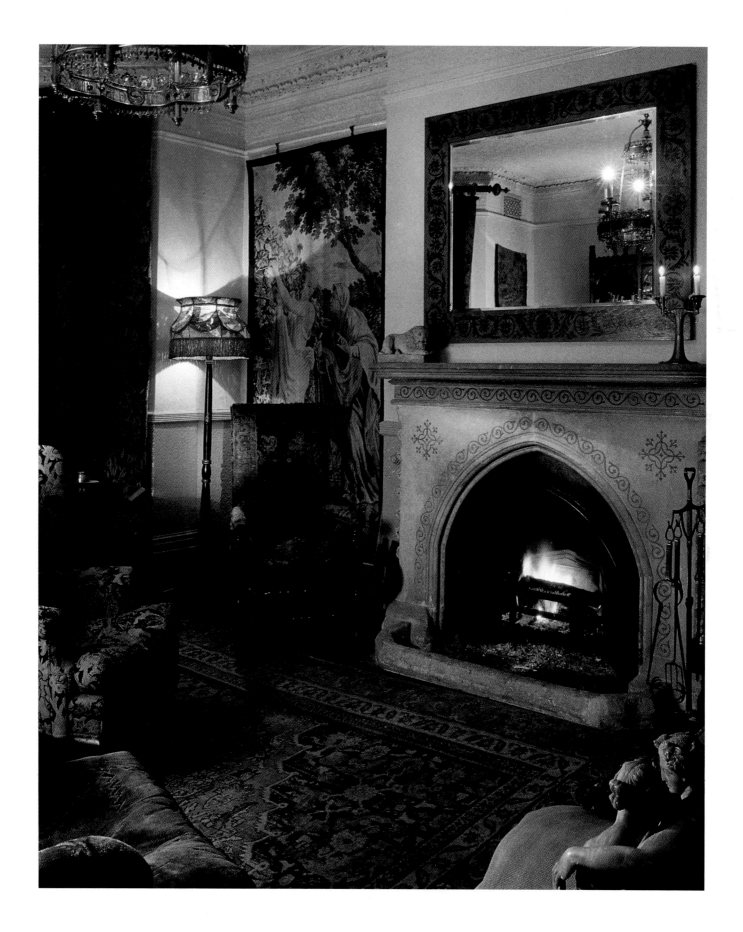

7

LIGHTING

The Victorian era brought with it vastly expanded possibilities for lighting. In earlier times, home owners had to make do with candles and light from large fireplaces after the sun went down. As a result, people all over the world went to bed early. In the seventeenth and eighteenth centuries, Americans had only the Betty, "slut" (a rag dipped in grease or oil), and Crusie lamps to choose from, all variations on a theme of little light and lots of smoke. The British faced a similar paucity of choices, especially in rural areas, where rushlights—with vegetable matter used as wicks to burn grease, fat, or oil—were often the only available source of light. Candles were very expensive in both countries.

In addition to being dirty and, by today's standards, inadequate, early lighting took up a good deal of time. Housewives or household help spent hours filling and cleaning oil lamps and scrubbing smoke stains off walls and ceilings.

The Victorians, however, benefited from the rapid development of lighting technology. After 1790, the invention of several different types of artificial illumination made things considerably easier for our ancestors. As the nineteenth century wore on, new methods of interior lighting continued to proliferate. These new lamps cast clearer, brighter light. Improvements in design eliminated annoying shadows.

Another change was the development of new kinds of fuel. The gadget-loving Victorians embraced every patent fuel that came on the market, from camphene to Burning Fluid. After 1850, the most important and widely used of these fuels was kerosene. Its low price made large parlor lamps and hanging fixtures, previously seen only in wealthy households, affordable for the middle class.

With the advent of gas lighting (only in urban areas), the gasolier, or gas chandelier, became a popular fixture. Gas fixtures were stationary, because of the long tube that connected them to their fuel source, so a room of the late 1800s was often lit both by gas fixtures on the walls and ceiling and the more portable kerosene lamps atop tables. Because gas-

light was brighter than that produced by kerosene, decorated shades became popular.

After the turn of the century, electricity was widely used in urban and suburban areas, although many rural homes were not electrified until after the 1920s. The first electric fixtures were often nothing more than a naked bulb hanging from the ceiling. But the thrifty Victorians adapted oil lamps to electricity by inserting electric bulbs inside the lamp chimneys. Converter kits were sold especially for this purpose.

The Victorian Revival interior can be enhanced with electrified antique pieces, reproduction lamps, or a combination of the two. In general, reproductions are less expensive and have the advantage of employing lighter materials and tougher finishes. Many of the large modern lighting manufacturers, such as Progress Lighting, have incorporated a group of Victorian designs in their product lines in recent years. In addition, craftspeople can create custom lighting fixtures with a Victorian look.

Keep in mind that the Victorians, despite all their newfangled inventions, were in general used to a lower level of light than we are. To compensate for this, they used many lamps within one room, combining candles, kerosene lamps, and gas fixtures. To increase the amount of light available, many lamps incorporated bits of mirror, bright gilt trim, and dangling prisms. Mirrors and gilding also appeared in the room for these practical and ornamental reasons. For contemporary purposes, it might be best to combine unobtrusive modern lighting, hidden in ceiling coves or behind moldings, with decorative but less bright Victorian fixtures.

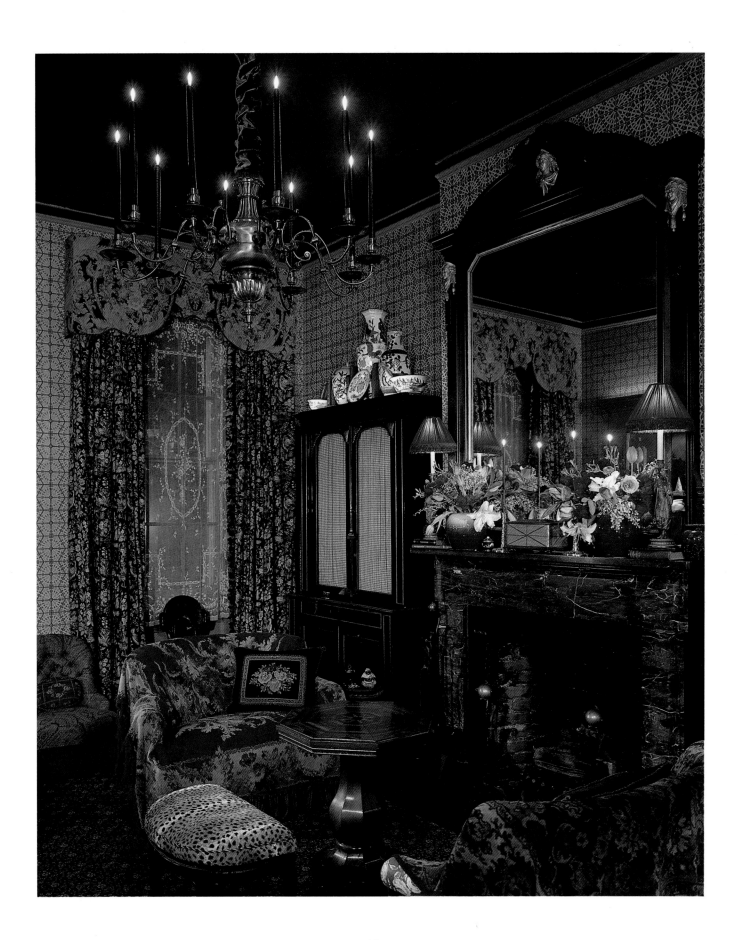

CHANDELIERS

Chandeliers were popular in America and Britain long before the Victorian age. Early chandeliers, of course, held candles. In the eighteenth century, chandeliers were beautifully made fixtures festooned with carved crystal pendants. These were used only by the aristocrats and wealthy merchants who could afford both the fixtures and the many candles required to light them. The popularity of the chandelier style—a hanging fixture with branching arms—continued into the nineteenth century. But as technology evolved, the candles were replaced by kerosene wicks and gas flames, which gave much brighter light and even required the use of shades.

In formal rooms of the nineteenth century, such as the parlor and the dining room, the chandelier or gasolier was a necessary fixture. In the early part of the Victorian age, gas was quite expensive. As a result, gasoliers were ornate productions. Elaborate festoons of grape leaves adorned curved arms that dripped crystal prisms. Later gasoliers featured central brass figurines of women wearing classical drapery surrounded by frosted-glass globes etched with geometric designs.

Modern reproductions of Victorian gasoliers are widely available. Most frequently imitated are styles from the later decades. These fixtures display graceful, curved arms of polished brass sprouting from ornate pendants. These pendants often consist of a pair of brass globes, one on each side, connected by spiral fluted arms. These arms display stylized foliage or cockleshells, also of brass. Shades of frosted and etched glass in various styles provide a finishing touch.

A delicate brass chandelier, above, is of English origin and probably held candles originally.

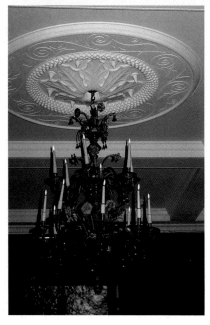

The exquisite beauty of this tiered chandelier is complemented by the carved ceiling medallion, left.

HANGING LAMPS

S impler hanging fixtures were also popular with the Victorians. These were most often installed in less formal rooms, or in rooms that were used for practical purposes, such as libraries, studies, and kitchens. The hanging lamps usually consisted of a dependent bar that supported two lamps, one at each end. Variations on this theme include fixtures with three lamps, one at each end and another in the center, with graceful scrolls connecting the horizontal bar with the vertical support. Another style, which the Victorians called a "library lamp," has a single light source, supported by a U-shaped bar from a horizontal S-shaped scroll.

The whole thing hangs from the ceiling by a chain. Today their gleaming brass details and generally plain opaque or translucent glass shades give these hanging lamps something of a contemporary feeling, and they look especially at home in a casual family setting. Shades can be fluted, round, or flared, with plain or crimped rims. The glass can be clear, milky, colored, or a combination of the three.

Several reproduction firms, such as the Victorian Lighting Works and Roy Electric, manufacture versions of this fixture. Modern reproductions can be wired to be turned on from a wall switch, although period accuracy naturally requires an authentic pull chain. As with other Victoriana, ornamentation is an important element.

A hanging fixture consists of brass scrolls supporting two frosted-glass, bell-shaped shades, still exhibiting their authentic nineteenth-century pull cords, right.

PARLOR LAMPS

Perhaps the most famous Victorian fixture is the tall parlor table lamp, with its decorated globular chimney, oil reservoir, and footed base. These are often known as *Gone With The Wind* lamps for their appearance in the movie, although their use was an anachronism, since they did not become popular until twenty years after the Civil War. The globe or vase-shaped shades were most often ornamented with painted flowers. Since lamp painting was a favorite hobby of Victorian ladies, the decoration was often dictated by personal fancy.

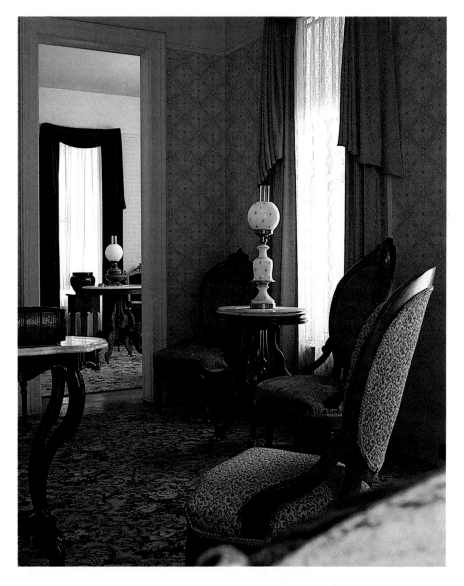

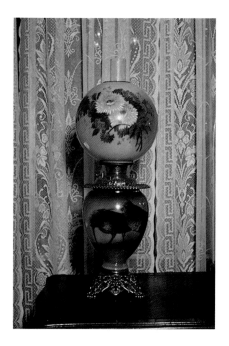

A parlor lamp, boldly painted with flowers and birds, is actually a contemporary fixture manufactured by Illustrious Lighting Co., above.

A globed lamp dominates a sitting room in Kalamazoo, Michigan, left.

Other versions of the parlor lamp were the Rochester lamp and the banquet lamp. The plainer Rochester saw duty in the library, bedroom, and parlor. It had a tall, vase-shaped chimney and a colored glass shade in the shape of an inverted bowl, with a round metal oil reservoir. Banquet lamps bore frilly shades over fancy bases shaped like cherubs, angels, or shepherdesses.

STUDENT LAMPS

Of all the various types of lamps developed during the nineteenth century, the student lamp was the most popular. The design consisted of an upright baton on a heavy base, with a vertical brass tube, which served as the fuel reservoir, cantilevered out to one side, balanced by a cylindrical glass chimney, and frosted glass shade on the other. The base was weighted to keep the whole thing stable. This very practical arrangement eliminated shadows and allowed the source of light to be placed directly over the surface that required illumination. Student lamps came with both double and single lights, as well as in wall bracket and hanging versions.

The student lamp is still very popular, and modern interpretations are easy to find. One of the best known variants, from Edwardian times, has an oblong glass shade and a brass base.

These handsome, practical lamps work well in functional settings—a den, or a library, or a work area within a larger room. There are many fine examples of electrified student lamps from the nineteenth century still available as well as a plethora of reproductions. Put one by the telephone for taking notes, or by the bed for reading.

A shaded student lamp serves as a handy reading light in this London sitting room, right.

NEWEL-POST LAMPS

A winged cupid or classically draped lady, both holding torches on high, standing at the base of the staircase and lighting the way upstairs, is the usual idea of Victorian newel-post lamps. But these lamps, so evocative of the gaslight age, came in many different shapes, styles, and sizes. They were popular enough to be mass-produced. The Victorian love of individualized designs led to newel-post lamps that could be assembled from various bases, stands, tops, and glass shades. Home owners would select elements to create a whole to suit their own taste.

The newel-post light is a typical Victorian fixture that has vanished from the modern home. While you may feel that a bronze statue or a cluster of imitation candles is out of place on your own newel post, such a light can take many forms and provide handy illumination for people climbing the stairs. You could choose a contemporary motif for your newel post. Or perhaps you would like a lamp from the 1880s or 1890s designed on a graceful vase-shaped bronze body, topped with an opaque glass shade.

Or adapt the Victorian style to your own and buy an antique fixture that has been electrified. Commissioning an artist to design one to your personal taste is another possibility. A small fixture might be best, since few modern homes have twelve-foot high ceilings in the entry hall. A newel-post light is a good way to spice up the vestibule, a space too often bland.

A massive newel post supports a faceted Japonaise-style lamp in a Kalamazoo, Michigan, interior, left.

BRACKETS AND SCONCES

Victorian wall lamps come in two different styles: bracket lamps, which were generally fueled by kerosene, and sconces, fueled by gas. The kerosene versions had the advantage of portability. In the nineteenth century, home owners used both types of lamp throughout the house, although wall lamps were especially favored in bedrooms, kitchens, and hallways. Wall fixtures sometimes came with attached reflectors for added brilliance, and were often used beside a mirror for the same reason. Both sconces and brackets were among the most common of Victorian fixtures.

Brackets were generally more utilitarian and less decorative than sconces. Brackets frequently had elbow joints that allowed them to be conveniently positioned for the best light. Sconces came straight out of the wall and were fixed in place. As with other objects of Victoriana, both brackets and sconces benefited from the Victorian love of ornament. Graceful scrolls, adorned with embossed and incised designs in iron, supported glass shades that came in many styles and colors, including translucent white, blue, and cranberry pink; these shades often bore etched designs. Some supports were wrought with three-dimensional leaves, flowers, and berries. Among the most beautiful are the pivoting gas fixtures from the 1890s, with iridescent glass shades shaped like lilies and morning glories.

Brackets and sconces are the Victorian fixtures most easily found in reproduction. A number of companies offer literally hundreds of styles, plain and fancy, and most offer catalogues to make selection easy. Because of their popularity in the nineteenth century, antique wall fixtures are easy to find as well. Victorian restorations are usually a rich source of ideas for anyone trying to decide among the many styles.

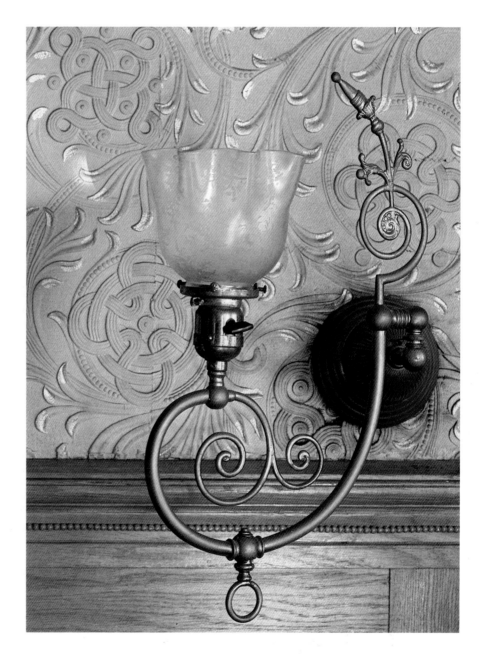

Original Lincrusta wallpaper, touched with gold, provides an elegant backdrop for this scroll-shaped brass sconce, topped with a graceful tulip shade, above.

TRANSITIONAL FIXTURES

The late 1880s and early 1900s saw the appearance of the transitional fixture, designed to alleviate the annoyances caused by the erratic performance of early electrical generators. These fixtures were lit by two different types of power—electricity and either kerosene or gas. It's easy to tell these lights from those fueled purely by kerosene or gas; they have a circle of arms that point up (for gas or kerosene) and another set that point down (for electricity). In fact, the novelty of a lamp that could shine its light directly down upon a surface was one of the strongest selling points of early electric lamps. Designers took full advantage of the

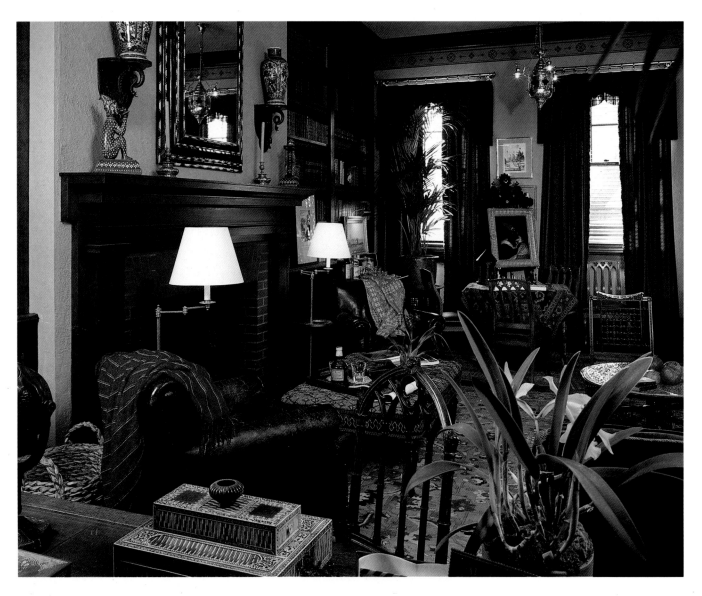

opportunity to create lamps with graceful down-turned bulbs and shades. Many of these lamps looked like flowers, enhanced with fluted glass shades that resembled petals.

A small transitional fixture hangs from the ceiling to cast light on this room resplendent in Victorian objects and furniture, above.

ART NOUVEAU AND ARTS AND CRAFTS LAMPS

Upright lamps with domed leaded-glass shades, the most famous of which are those designed by Louis Comfort Tiffany, were actually the first style designed specifically for electric bulbs. These first appeared around 1890.

The Arts and Crafts movement of the 1890s (stemming from the English Aesthetic movement) promoted honest handwork, structural ornament, and the integrity of natural materials. It produced furniture and lighting that was dramatically opposed to the exuberant ornamentation of the high Victorian period. The best of American Arts and Crafts furniture (often called "mission" for its starkness) was distinguished by clean lines and elegant simplicity. Arts and Crafts lamps, like their turn-of-the-century Art Nouveau counterparts, were designed for use with electric light bulbs. But unlike Tiffany's sensuous creations, Arts and Crafts lamps were deliberately down to earth. They sported square, bulky, wood-framed shades covered in translucent parchment or filled in with stained glass in simple floral or geometric patterns.

Both Art Nouveau and Arts and Crafts lamps were designed and manufactured mainly for the wealthy, and genuine examples of both styles are often very expensive today. High-quality reproductions are also costly, since the handwork that goes into them is even more precious now than it was at the turn of the century. Low-priced reproductions, alas, are often priced that way because of poor workmanship.

Pebbled glass, simple styling, and the use of metal straps and chains mark this hanging lamp as an Arts and Crafts original in an interior designed by Johnson/Wanzenberg, right.

CANDLES AND CANDLESTICK LAMPS

Even with the many alternatives that were increasingly available, candlelight still held a fascination for Victorians. The romantic glow cast by lit candles didn't vanish from the parlor with the advent of gaslight and electricity: The Victorians continued to use candles as atmospheric lighting for parties and dinners. The candle holders employed for this purpose ranged from massive candelabra to single candlesticks, but all were beautifully made and strikingly ornamented, in materials from silver to pressed glass.

The Victorians not only loved real candles, they also appreciated gas and electric fixtures in the form of simulated candles. Some were simply electrified candle-sockets into which a bulb was placed and covered with a shade. Others mimicked eighteenth-century style candle-holding wall sconces and chandeliers. Some dangled prisms for additional brilliance. Antique candle holders, real and electrified, were produced in abundance in the nineteenth century and many antique dealers sell them. In addition, reproduction candle holders in authentic or contemporary materials also provide a romantic nineteenth-century note at little cost.

Elaborate candlesticks and a candelabrum adorn the mantel of this elegant room in the Banning Museum, Wilmington, California, left.

A variety of Victorian style shades, opposite page, decorated with fringe and colored silk are handmade by artisan Sue Johnson.

LAMP SHADES

During the early Victorian period, lamp shades were simple and relatively unadorned. Often, they were nothing more than clear glass globes meant to protect the flame from drafts while allowing as much of the relatively feeble light of the candle or kerosene lamp to illuminate the room as possible. With the arrival of gaslight, however, shades became more elaborate. Late Victorian parlor lamps, although fueled by kerosene, often wore fancy shades, since the general level of lighting was much higher in the 1880s and 1890s.

Like the reproductions readily available today (often from original molds), Victorian glass shades came in many varieties. In monotints there were plain, clear, or colored shades, while other shades come in one color with contrasting color trim. Still others were etched with various designs—among them snow flakes, paisley, and the classical Greek key. Some globes were made in ornate shapes, such as a bunch of grapes, a swirled flame, or a slender tulip.

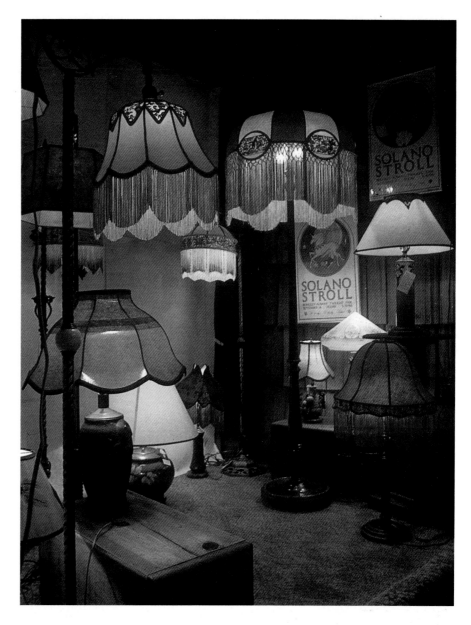

Fabric shades could be plain or elaborate, but most were quite ornate. Many were frilled, beaded, or fringed; often they were a combination of all three. They were made from a variety of materials, including parchment, linen, silk, leather, and heavyweight paper.

Some parlor lamps had globular glass shades hand-painted with flowers or sentimental scenes. Louis Comfort Tiffany designed elegant stained-glass shades embellished with wisteria, lilacs, poppies, lilies of the valley, and other floral motifs.

Victorian housewives with time on their hands devoted themselves to creating their own lamp shade designs. They sewed ruffles, stitched beads, and attached fringe; the more artistically inclined painted glass shades. Some even adorned paper lamp shades with pierced and cut-out designs of flowers, dolls, or landscapes.

Today, many craftspeople carry on in the Victorian spirit with lamp shades of all types. Some artisans offer a single standard line of shades. Others can create a custom confection of pleats and fringe. All subscribe to the Victorian tenet that what is useful should also be beautiful.

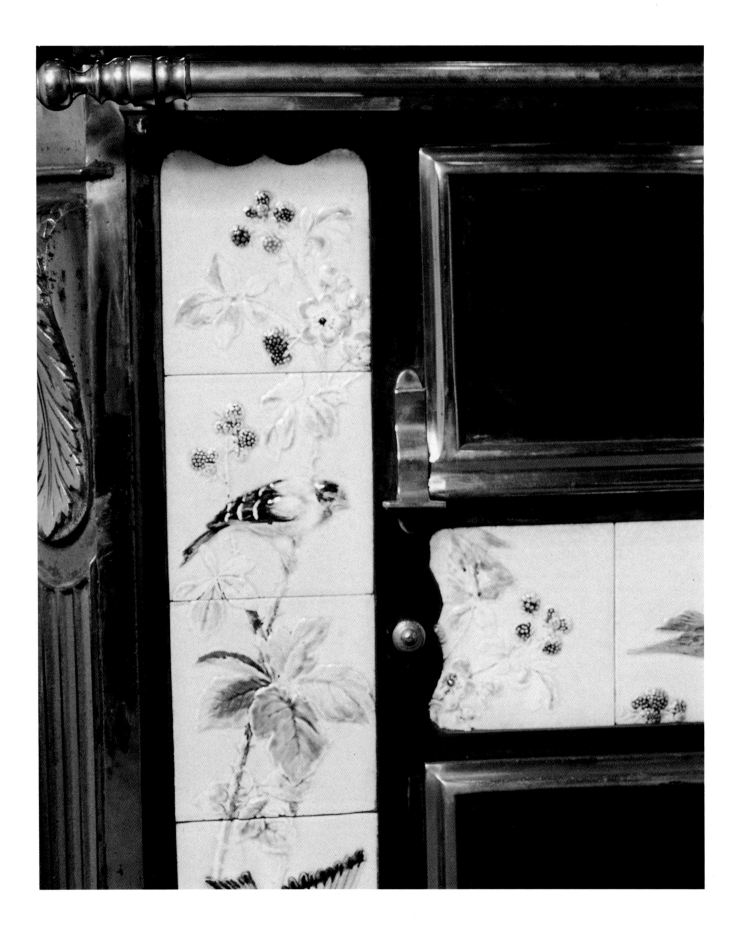

FIXTURES AND DETAILS

What we think of as mundane items—bathroom fixtures and interior hardware—are particularly good examples of the Victorian love of ornament. Utilitarian items as diverse as cupboard fittings, toilet tanks, and cooking stoves received decorative touches from the hands of Victorian designers. Hinges were embossed with feather designs. Cast-bronze doorknobs were reeded and fluted like classical columns. Porcelain sinks and toilet bowls were painted with roses and wildflowers.

At the same time, the Victorians showed respect for simplicity. Those who find the idea of painted sink basins overwhelming can opt for fixtures bearing sculpted designs in low relief. Accessorized with gleaming brass faucets, a rococo mirror frame, and a high-tank toilet, the result is a Victorian ambiance without risk of sensory overload.

The kitchen is another room where Victoriana can be dressed up or down. True nineteenth-century kitchens were plain and utilitarian, places for servants rather than company. But the modern kitchen is a place for family, guests, and good times. No longer is the maid or the woman of the house stuck in social Siberia fixing dinner. Victorian Revival kitchens are Victorian in spirit, with rich ornament, deep colors, and lots of decorative details.

Victorian hardware, ranging from simple to ornate, can go far to evoke a sense of period in both the contemporary and the Victorian Revival house. The booming business in salvage and reproduction hardware attests to its great versatility.

BATHROOMS

Modern bathrooms weren't widely incorporated into houses until early in the twentieth century. As late as the 1870s, even the wealthiest Victorians were bathing in zinc tubs set in front of the bedroom fire. But the turn-of-the-century fashion for "sanitary" interiors created a desire for separate rooms for personal ablutions. The style was to conceal fittings inside other pieces of furniture: sinks were hidden within dressers; baths in closets; and toilets in cabinets.

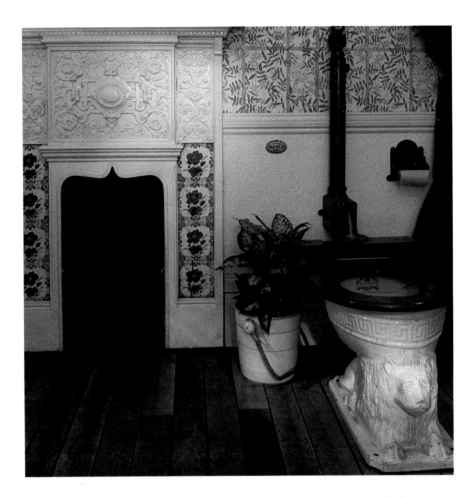

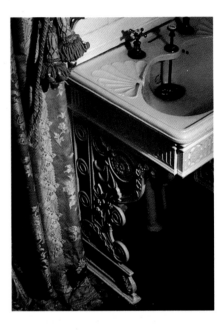

An 1890s cast-iron lavatory stand comes from Lady Bullough's bathroom in Kinloch Castle on the isle of Rhum, Scotland, above.

A fireplace, decorative tiles, floral paper, and a high-tank toilet make a cheerful bathroom nook, left.

Bathrooms in nineteenth-century houses were often converted from rooms designed for other purposes such as bedrooms and therefore were generally quite large. They usually kept the fixtures—ornamental woodwork, stained glass, wooden floors (often softened with rugs)—from the room's previous incarnation. The extra space allowed the inclusion of furniture rarely seen in modern bathrooms, including sofas, chairs, and bookshelves.

Turn-of-the-century bathrooms were more like their modern counterparts. Concern for hygiene led to tiled floors and exposed pipes for easy cleaning. Tubs were raised up on ball and claw feet so that germs could not linger underneath. Overhead showers were all the rage, found mainly in fashionable homes.

Even during the brief three decades that bathrooms were used in Victorian life, our innovative ancestors came up with several ingenious ideas for luxurious bathing. In fact, the Victorians and Edwardians had more of a choice of bathroom fixtures than we do now ourselves, not to mention bigger bathrooms to put them in. Reproductions or elegant old fixtures are better engineered, more convenient, and better looking than the majority of modern examples.

SINKS AND FAUCETS

The classic Victorian sink is a large oval basin set in a slab of marble. Other typical Victorian sinks sat atop gleaming varnished mahogany enclosures whose doors concealed unsightly pipes. Turn-of-the-century versions, motivated by a desire for hospital-like cleanliness, were supported on pedestals or by gleaming chromed metal legs. Copper plumbing shone beneath.

The Victorians also made sink tops of granite, slate, and white porcelain. For those who prefer it, plastic laminates are easy to clean and now come in very realistic approximations of actual stone.

Victorian faucets, too, came in a variety of decorative shapes, styles, and materials, including brass, china, chrome, marble, onyx, and crystal.

Victorian faucets were available in three basic styles. Lever-handled faucets had curved, flat-bladed handles that swing up or out at the ends. Porcelain versions of this style have rounded, teardrop-shaped handles. The porcelain handles are sometimes adorned with painted flowers. Wood handles follow the same teardrop shape. The familiar cross-handled faucet originated with the Victorians and, like the lever handle, was made of metal, porcelain, or wood. The knob faucet, too, was available in ornamental stones, such as marble, various colors of onyx, and crystal. Some styles were simple disks, others chunky cylinders. Still others were faceted like precious gems.

For the purist, Antique Baths & Kitchens of Santa Barbara, California, makes reproduction taps that have separate spouts for hot and cold water. Their "Deluxe Faucet," of knobbed brass, resembles a rather elegant laboratory gas outlet. Simpler versions have lever- or cross-style handles.

For those who like their hot and cold water pre-mixed to the proper temperature in the modern fashion, a variety of Victorian adaptations abound. One good

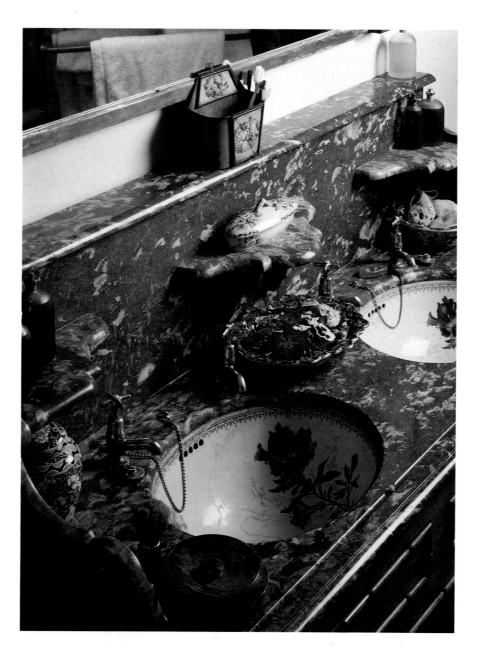

source is the Chicago Faucet Co., in business since 1901, located in Des Plaines, Illinois.

A bold marble counter and cross-handled taps set off china basins in this English bathroom, above.

111

TUBS

Old tubs and reproduction tubs are longer and deeper than modern designs, so if you like to loll about in the bath, a Victorian tub is for you. These come in several different materials and three basic styles: those enclosed in a wooden box, usually of polished mahogany; those that stand off the floor on ball and claw feet; and a third type, that rests on the floor and has solid squared sides, but does not have a wooden enclosure around it.

Whatever the style, you can choose from various materials. The most expensive, authentic, and longest lasting bathtubs are made of porcelain over cast iron. These tubs hold heat well (important for enjoying a long soak!) and resist chipping. The next best are steel tubs, which are lower in price. The least expensive are tubs made of fiberglass-reinforced polyester and acrylic resins. These come in a range of styles, including some that are reminiscent of Victorian models, but unfortunately can be subject to scratches unless care is taken.

Tub faucets and pipes in authentic designs provide the finishing touch. These are available in styles that complement sink fixtures. Some attractive tub faucets feature high-arched gooseneck spouts with projecting taps for a real Victorian look. Others have a more modern appearance; only the nineteenth-century handles and spout stick out from the wall. Shower and tub faucet combinations come in both versions. Matching bidet fittings are often also available.

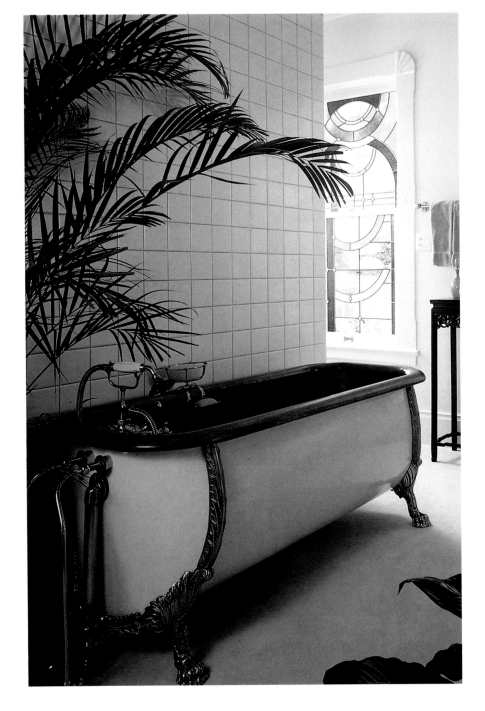

A claw-footed china tub is a dramatic presence in this bathroom, right. A mahogany rim, gleaming exposed pipes, and a tall palm add to the cozy atmosphere.

SHOWER HEADS AND BATH ACCESSORIES

The shower bath was a late Victorian innovation that did not appear until 1900. But those turn-of-the-century showers were more like home spas than today's showers with their paltry sprays. They often featured waist-high and foot-level as well as overhead sprays to treat the entire body to an invigorating rinse. And the overhead fixture was wide, filling the entire shower enclosure with water. While the sybaritic spas of yesteryear must be custom made and are often prohibitively expensive, old-fashioned broad showerheads in both porcelain and brass finishes are readily available in reproduction.

Victorian-style bath accessories provide the final touch for your nineteenth-century bathroom. These include brass shower curtain rings, brass plated pipes and drains, and even brass shower caddies. A matching brass shower curtain support is another possibility. In addition, you may want to look for items such as soap dishes, bath trays, and towel racks. Authentic pieces are often available from antiques dealers.

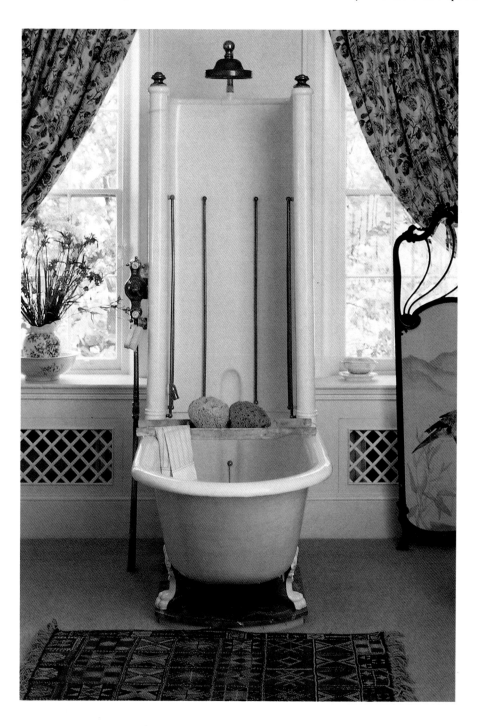

A tall Edwardian shower enclosure is coupled with a white china tub, left. It's not clear how the inhabitants kept the floor dry. But a wire tub tray stocked with sponges promises plenty of old-fashioned convenience in this English bathroom.

TOILETS

Victorian toilets came in two types: pull chain, with a wall-hung tank; and the more familiar low-tank style. Reproduction toilet tanks and bowls are available from Antique Baths & Kitchens in Santa Barbara, California. Owner S. Chris Rheinschild makes both pull-chain and low-tank types. The pull-chain design has an oak wall tank, with brass supporting brackets, pipe, handle, and pull chain. The low-tank toilet also has a tank made of oak with brass fittings. Both designs are available with oak seats.

If the idea of wood-trimmed fixtures does not appeal to you, you can create a similar Victorian ambience with white porcelain fixtures. The colored bathroom fixtures now available—in black, deep blue, etc.—would seem at first to fit in perfectly with the Victorian love of drama and ornament. It's true that the deeper colors could work well in a Victorian Revival bathroom. But the usual pastels—pink, yellow, pale blue—are not as successful. If you already have these fixtures in your bathroom, rely on wallpaper, paint, and accessories to make your statement.

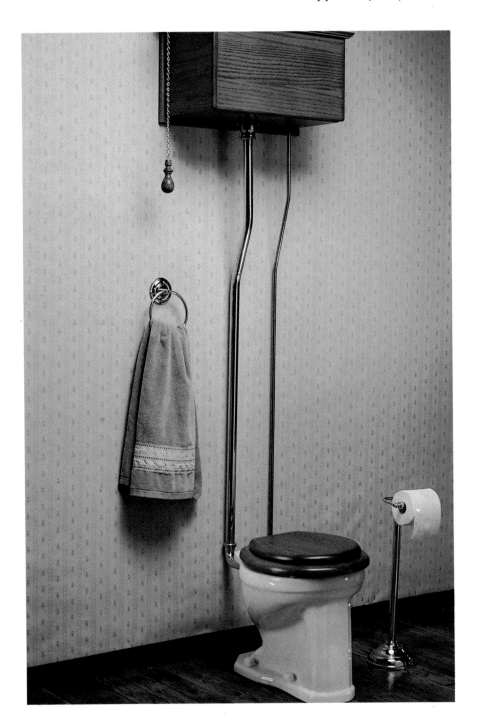

A-Ball Plumbing manufactures this contemporary Victorian style high-tank toilet with a wooden seat, left.

KITCHENS

True Victorian kitchens appear rather bare to the modern eye. The Victorians relegated food preparation to servants, and as a result, nineteenth-century kitchens were often plain and unornamented, especially when compared with the rest of the house. The Victorian Revival kitchen, then, usually draws on the spirit of Victorian design rather than attempting a literal reproduction.

One Victorian precedent you will probably want to follow is that of easy-care surfaces—tile, slate, and metal. Add modern high-quality laminates to this list and you have a number of suitable choices. Another attractive feature of Victorian kitchens is their large size. They provide a space large enough for families and friends to gather—an amenity that suits the casual spirit of today. Another aspect of the Victorian kitchen that has been staging a comeback is the use of wood flooring.

While you would not want to give up the modern technological conveniences to buy Victorian era kitchen appliances, you should give some thought to what your refrigerator, stove, and sink look like. The simpler and more efficient the better—and the more in keeping with the true Victorian feel. You might even consider a restaurant stove—or an English Aga, a stove that has several ovens, kept at different temperatures. The Aga, fueled by coal or sometimes even wood, is never turned off. This works well in the cold damp British climate but is not so well suited to the United States.

As for sinks, many reproductions are available. Antique Baths & Kitchens of Santa Barbara, California, for example, offers three Victorian-style sinks. All are modeled after kitchens from actual Victorian homes. One is of heavy gauge copper, while the others have copper basins inside square wooden frames. Antique Baths and Kitchens also offers appropriate kitchen faucets, both wall- and counter-mounted.

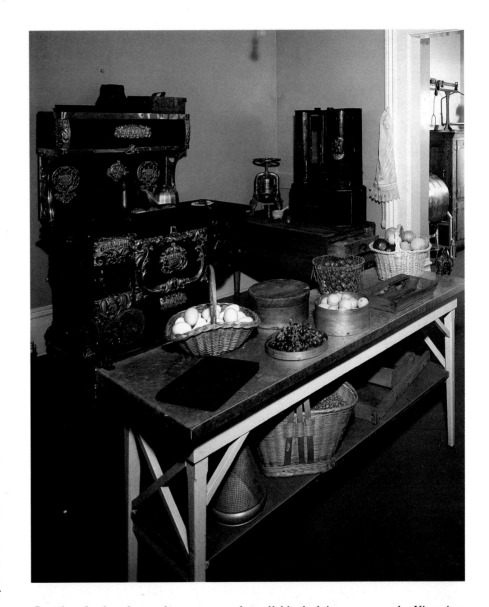

Despite the handsome brass-mounted, well-blacked iron stove, the Victorian kitchen of the Banning Museum in Wilmington, California, above, was not a showplace for company. It was intended for utilitarian purposes. The lady of the house, no matter how poor, had at least one servant to perform cooking chores.

CABINETS

While the woodwork in the Victorian kitchen was not as elaborate as in the rest of the house, it still demonstrated the nineteenth-century love of ornament. Wainscoting was common, and many kitchens were circled with a plate rail for storage and display.

Open shelving was another feature of a Victorian Revival kitchen. Harriet Beecher Stowe, author of *Uncle Tom's Cabin*, and her sister Catharine Beecher co-wrote books about domestic science aimed at educating the nineteenth-century housewife. The sisters advocated shallow open shelves for storage of household products.

Not only would the kitchen goods be easy to find, since most came in decorative tins (highly collectible today), but they also made a cheerful display.

While the modern concept of kitchen cabinets did not exist in Victorian times, custom-made cabinetry, for those whose pocketbooks can support it, provides an alternative. Smallbone, an English firm with an American branch, will design and build luxurious kitchens and baths. While not strictly authentic, these designs can be tailored for a Victorian flavor, by using dark woods and elaborate moldings.

If Smallbone's services are beyond your means, there are other ways to achieve a Victorian or Edwardian look. Architectural salvage companies are a good place to look for authentic turn-of-the-century glass-fronted cabinets. The junkyard provides another inexpensive source of period items. With the current revival of interest in Victorian style, some manufacturers of stock cabinetry have included Victorian-style designs in their selection. These include not only plain glass-fronted cabinet doors, but also those with designs in leaded and stained glass.

These limed oak cabinets, above, in the Victorian manner are actually contemporary kitchen fittings designed by Smallbone, Inc.

HARDWARE

Even the blandest 1950s tract house can be infused with Victorian style. A simple change of hardware throughout the house can work wonders. And the choices are myriad. A catalogue for one manufacturer of reproduction hardware, Ritter & Son, contains over 400 items. These include drawer pulls, keyholes and keyhole covers, and latches of cast brass, china, or wood.

A suite of brass drawer pulls with cast and stamped geometric patterns provides one possibility. These would be perfect in a late Victorian Aesthetic-style room filled with bold simple furniture and large scale prints. The ornate incised designs come in a variety of combinations—squares and diamonds with raised centers, rosettes, and incised rectangular pulls. Many have coordinating keyholes. They would be appropriate both for restoring Aesthetic-style furniture or for use on cabinets in kitchens or baths. A brass "spool knob" bears a stylized daisy on its flat face.

Teardrop pulls, with ornate brass backplates and dangling knobs of polished wood, give a touch of authenticity. Strap handles, used on furniture, provide a graceful way to pull a drawer open. Solid brass and china knobs come in several sizes and can be used on room doors as well as cabinets.

The selection of brass pulls is also beguiling. Dangling drop pulls are shaped like ribbons and bunches of flowers. Others exhibit shell motifs or classical acanthus and honeysuckle designs. Brass bin pulls, shaped like miniature hoods, have geometric and floral ornament that resemble carved versions of Oriental rugs. Two-piece catches have tiny round knobs for drawing back their fastenings and similar decorative ornament.

Finally, for those who prefer a less ornate look, there are authentic reproduction hinges and latches for Victorian iceboxes. These are available in both polished brass and nickel-plated brass. The simple latches, with their gleaming downturned, thumb-operated levers, are utilitarian works of art. The hinges, with triangular, pierced flaps, are unadorned and beautiful. Other icebox hardware can be used on drawers and cabinets as well, including strap-handle "lifts"—either smoothly rounded or incised with abstract flowers—once employed for raising wooden icebox lids. Kitchen cabinet "Hoosier" latches, opened by pressing a teardrop-shaped lateral lever, are designed along similar unaffected lines. Trilobed or butterfly hinges add to the distinguished simplicity.

A lever doorhandle from Ayrshire, Scotland, top, and a c.1851 filigreed latch from a Windsor station, bottom, show how the Victorians lavished ornament on the humblest details.

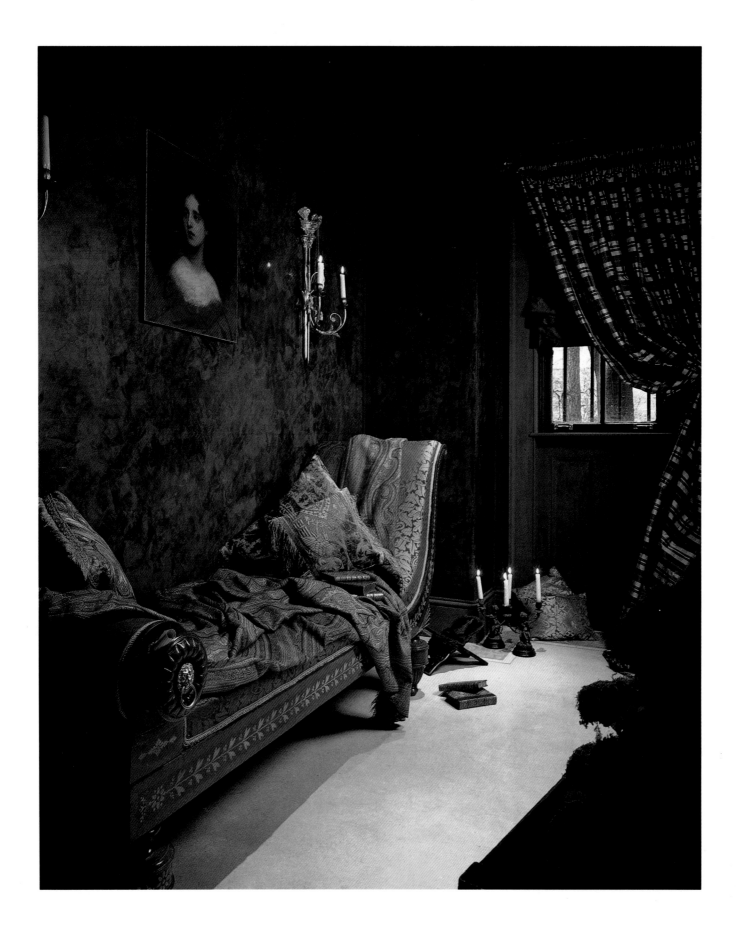

9

SPECIAL ACCENTS

The home was the center of the Victorian world. It was a place for self-expression, elaborately accessorized and highly personal. At the same time, it served as the family's social façade and material showcase. Decorative accents, from handmade picture frames to lavishly swagged and valanced windows, were an essential part of the Victorian style.

In addition, proper Victorian wives and daughters devoted a great deal of attention to the creation of "fancywork": Handmade objects—tea cozies, lampshades, wall hangings—reflected varying degrees of proficiency and function. The scope of techniques was also broad, embracing all sorts of needlework including beading, cross-stitch, as well as decorative painted finishes, stenciling, and fretwork.

This chapter will describe both authentic period accents and unusual selections that embody the spirit rather than the letter of Victoriana. You don't necessarily have to stick to a particular Victorian style. Eclecticism in a variety of revival styles was an aspect of nineteenth-century interior fashion. The Victorians themselves chafed at restrictions, taking every opportunity to express their individuality in their home decor. While the popular concept of Victoriana embraces delicate lace, romantic velvets, and rosy tones, there is much more to the style than that. The Victorian era saw the rise and fall in popularity of every style known to mankind— Greek, Egyptian, Renaissance, rococo, Gothic—in addition to those it invented on its own, such as Aestheticism, Arts and Crafts, and Queen Anne.

STENCIL KITS

The Victorians used stenciling as an easy and versatile way to ornament walls, floors, and ceilings. On the floor, stencils imitated more expensive kinds of decoration, such as rugs and parquet flooring. Stenciled wall patterns mimicked elaborate papers, expensive architectural details, or wood paneling. Many grand Victorian homes have walls stenciled in a diaper pattern, a large-scale, interlaced pattern, usually floral or geometric in design, that repeats diagonally over the surface of the wall. These were often accented with touches of gold leaf.

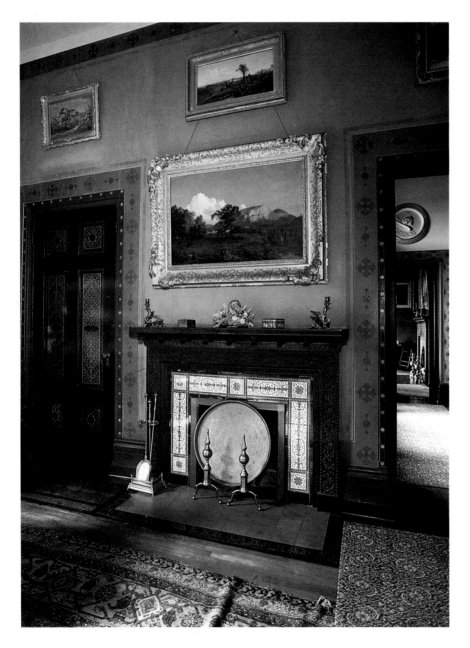

At Olana, his home and studio beside the Hudson River, artist Frederick Edward Church employed bold motifs stenciled along the edges of room openings as decoration, above.

In combination with walls painted a solid color, stencils can be used to create a decorative band, or frieze, just below the ceiling. The frieze is generally one to two feet deep, so a large-scale pattern should be used here. You could also install a cove molding—a large concave trim that bridges walls and ceiling (see chapter 4 on ceilings for illustrations). Use of stenciling here makes the cove molding into an attractive transitional locus between the wall and ceiling.

In addition, stenciling on the ceiling itself gives an impression of richness. Stenciled panels and borders can imitate expensive architectural details for a fraction of the cost. Ceilings of small rooms, such as entries or hallways, can be stenciled in overall patterns. Motifs can be used to accent the corners and center of a ceiling for a precise but informal look.

The top of the dado or wainscoting, known as the wipeline, is another good area for stenciling (and has the advantage of concealing dirt). Ceilings were most often adorned with overall, large-scale stencils that often simulated architectural details such as beams or coffering.

The eclecticism of the period makes patterns easy to find. The revival styles popular in the latter half of the nineteenth century mean that Egyptian, Greek, Roman, Arabic and Renaissance

Artist John Canning used a delicate floral motif to stencil this frieze along the cornice of a Hartford, Connecticut, room, right.

Canning employed a striking neoclassical motif of triglyphs and bellflowers along a chair rail, left.

styles are all appropriate. Fashion, rather than historical precedent, ruled the Victorian home.

Several companies, including Dover Publishing, offer pattern books filled with stencil designs. Or you could go to a Victorian source, such as *The Grammar of Ornament* (1850) by Owen Jones, and create your own stencil based on one of the authentic patterns shown there. Old or reproduction fabrics are also a fruitful source of possible stencil patterns. Flat, stylized patterns, such as those popular during the Eastlake craze of the 1870s and 1880s, using geometric and abstract floral motifs, are another good choice.

Stenciling can serve as an overall pattern, as a border, or as an accent. A current fashion is stenciling that looks worn and faded, as if it had been applied several decades earlier and recently discovered beneath layers of wallpaper. This effect can be achieved by using a stipple brush to remove paint and soften the colors. You can also apply white paint or other background color over the stenciled image for a similar effect.

COLUMNS AND CAPITALS

Classical columns can also create a grand historical ambience in your home. These differ from pilasters (discussed in chapter 5 on walls) in that they are freestanding and often load-bearing. Columns can be used to replace a load-bearing wall. They can also serve as decorative accents in an archway, in the corners of a room, or as a screen dividing a large room into more intimate areas. By their very nature, they often serve as both screen and divider.

The shafts of columns come in three varieties—fluted, plain (both rounded), and "plantation," the rec-

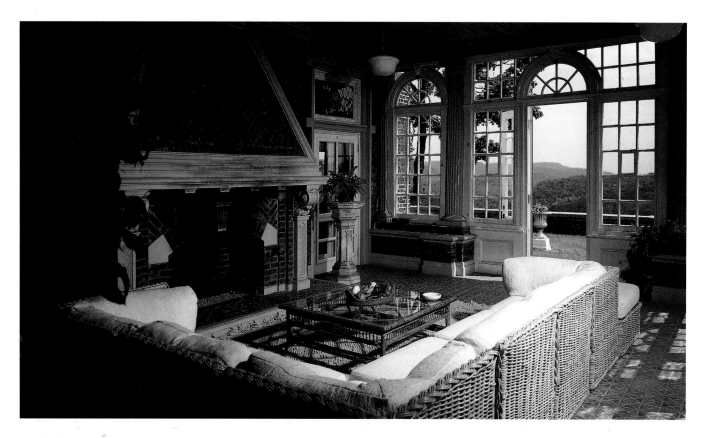

tangular posts with inset panels often seen on large homes of the antebellum South. The capital of the column—the decorative top—dictates its style. The three basic styles are Doric, essentially plain, with only a thin line of simple beaded molding; Ionic, characterized by its volutes, or spiral scrolls; and Corinthian, the most elaborate, embellished with sprays of stylized acanthus leaves. In addition, there are many variations on these styles. The Victorians liked to employ

combinations of motifs to create capitals that don't really belong to any of the recognized styles.

Columns and capitals are available from various sources. Some architectural salvage yards can supply genuine nineteenth-century columns taken from demolished homes of the era. Some foundries offer cast iron and cast aluminum columns and capitals, made from genuine Victorian molds. Lightweight columns made of fiberglass and finished to look like stone are also available.

A screen of carved columns adds drama to a wall of windows in this room designed by In Design, above.

CONSERVATORIES

The conservatory is the quintessential Victorian room. Filled with exotic blooms and dense greenery, often highlighted with a fountain or aquarium, the Victorian conservatory was lush, attractive—and romantic, considered an ideal spot for proposals and flirtations. The whole idea was to create a luxuriant, tropical ambiance that still functioned as a room.

Correctly accented, conservatories add a Victorian note to any home. Among the possible Victorian touches are a cast-iron settee, a splashing fountain (see chapter 10 on gardens), statues on a Victorian theme—a boy with his dog, a deer, a bird. Many museum houses from the Victorian era include a conservatory and provide ample inspiration for the Victorian Revival interior. If space or budget make the addition of a full-size conservatory impractical, consider a greenhouse window, decorated with period plants—ferns, fuchsia, potted palms, lilies, and orchids.

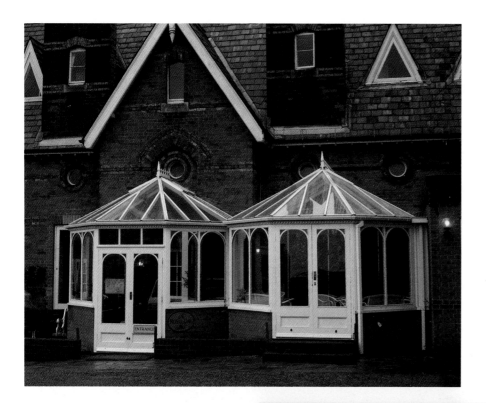

A late-nineteenth-century English house with peaked gables, a slate roof, and stringcourse of striped brick boasts a pair of apsoidal-roofed conservatories of cast iron, above.

A Nottinghamshire conservatory displays a truly Victorian sense of comfort with a cast-iron settee and a profusion of plants, right.

UPHOLSTERY

The eclecticism of Victoriana gives you numerous choices of fabric patterns and textures. The classical restraint of the 1840s blends nicely with light, clear colors, small-scale prints, and smooth fabrics such as silks and chintzes (or more reasonably priced imitations). "More is more" might have been the motto of the high Victorian era: Upholstered pieces were buttoned, tufted, fringed, shirred, and ruffled, covered in a variety of brocades, damasks, velvets, and prints both large and small. Animal prints and tapestry patterns were also particularly popular.

These rich patterns, often in dark, warm colors, were used in conjunction with lavish trimmings, braids, and tassels. The intricately detailed surfaces of the fabric harmonized with the curves and curlicues that distinguished the Rococo and Renaissance Revival furniture then popular. Pillows adorned with needlepoint and crewel embroidery added to the profusion of sensuous textures on display.

But with the rise of the Aesthetic Movement, a design reform philosophy that began in Britain in the 1860s and soon swept America, everything changed. In England, critics such as John Ruskin, William Morris, and Charles Eastlake set themselves the task of raising the standard of British craftsmanship and cosmetic arts. They had a vision of a new, moral society symbolized by a return to quality handcraftsmanship.

The Aesthetic Movement took many forms, but in general it called for a return to medieval inspirations in interior design. In fabrics, this led to a preference for quiet colors, usually grayed tones, and small, geometric or stylized floral designs, away from what Eastlake called "horticultural rugs and zoological hearth rugs," in one of his many disdainful descriptions of the mid-Victorian love for highly realistic textile designs incor-

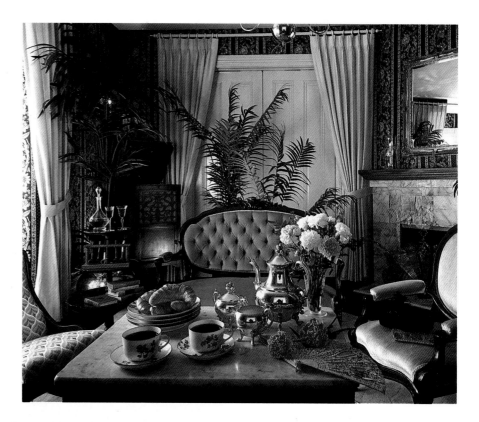

porating fruit and flowers.

William Morris started his design firm, Morris and Company, in 1861, along with a group of fellow-minded artisans. They undertook interior design commissions, murals, architectural projects, and the design and manufacture of wallpapers and textiles. Of all of these, Morris's designs for fabrics have proved the longest lived. Densely patterned with stylized yet recognizable native flora and fauna, they are known for the characteristic intertwining vines that appear

A tufted love seat and Louis XVI Revival chairs demonstrate the importance of rich upholstery fabrics in creating the proper Victorian atmosphere, above.

throughout Morris's work. He also experimented with vegetable dyes to create their distinctive soft, clear hues. His fabrics are marked by a range of dull greens, rust, ocher, sage, citron, gold, and peacock blue.

CURTAINS AND DRAPES

Elaborately draped and layered window hangings were a hallmark of the Victorian interior. These draperies were not only stylish but practical, proclaiming the good taste and propriety of the home owner and serving as a barrier against drafts, light, and sound.

The typical nineteenth-century window was muffled beneath four layers of curtains. Closest to the glass was a thin, sheer curtain of delicate netting, known as a "glass curtain." Over this hung a lace undercurtain. Atop the undercurtain was the main drapery, usually of rich velvet or brocade. Festoons and swags, often adorned with braid and tassels, further embellished this layer. The whole ensemble was topped with a decorative valance known as a lambrequin, made of stiffened fabric and affixed horizontally to the room cornice.

Not all Victorian windows wore such lavish dress. Wooden venetian blinds (used in both Britain and the United States starting in the eighteenth century) offered one alternative. Pull-down roller shades made of stiffened fabric were another option. Invented in the nineteenth century, these simple devices often wore decorative stencils—landscapes, mottoes, or floral prints. Magazines recommended readers to make their own shades using patent spring rollers and fine linen, translucent artist's tracing cloth, or opaque oilcloth. Any color could be used, although neutral tones—white, buff, or gray—that did not unduly change the cast of the light streaming through were preferred.

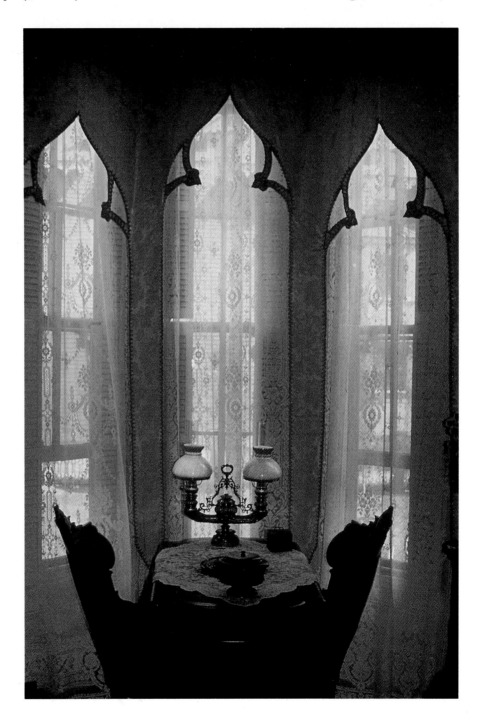

Tall Gothic windows, draped in sheer patterned fabric, right, provide a stunning backdrop for a cozy table for two at The Abbey, a bed and breakfast in Cape May, New Jersey.

Elaborate window swags set the tone for an elegant interior, following page, designed by Clare Fraser Associates.

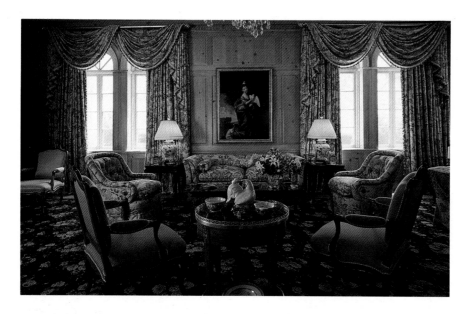

The world of Victorian window dressing is a rich one indeed. It presents a complicated trans-atlantic episode in the history of interior design. The European tradition of bed and window hangings came to the New World with the colonists, but the necessities of a pioneer culture greatly simplified American fashions, while the influence of the elaborate French style, with its multiple layers and lavish trims, did not catch on. As a result, eighteenth-century Americans created a native style that used less fabric in window hangings.

However, nineteenth-century Americans made up for this neglect with a vengeance. The increase in American fortunes and income manifested itself in a craze for ornate and detailed window furnishings. In Britain, of course, the genealogy of window hangings followed a different progression. The lavish hangings that came as a new development in the United States originated there. The British were comfortable with ornate drapes and therefore tended to be more re-laxed about their use of fabric. Nevertheless, the 1800s were a period when windows were dressed as strictly and correctly as were middle-class ladies.

Other Victorian window styles (and there were many) include the following:

Draperies frame each
side of the window, with
the top rod concealed by a
valance or lambrequin.

Material swags across
the top of the window, with
the ends (known as tails or
jabots) cascading down the
sides. Swags were used alone
or atop formal draperies.

Venetian, Austrian,
and Roman shades are raised
and gathered by an
arrangement of cords. These
were distinguished by the
intricacy of the gathering.
Roman shades are the most
tailored, Austrian the frilliest,
with the Venetian shade
falling in between the two.

Interior shutters (then known as blinds) were often used to control light. But these practical arrangements were often concealed by the curtains described above, which were hung from rods supported by extension brackets, extending into the room so that the curtains cleared the shutters when these were folded up at right angles to the window.

This was rather an awkward contrivance, however. Expensive custom-made shutters that folded into recesses in the window frame were one solution. Another was to keep the upper shutters closed, although this blocked some of the light in the room. Since these shutters had adjustable louvers, a compromise was possible. Opening them allowed light into the room while maintaining privacy and permitting the curtains to lie flat.

Towards the end of the century, simpler window treatments, in accordance with the Arts and Crafts trend, became fashionable. The plainest window treatment employed sheer panels of fabric hung on rods inside the window frame, descending just to the sill and covering only the glass. Fabrics used in this way include laces and sheer muslin in various patterns, usually in white or off-white. Sometimes a second, bottom rod was used to keep the material taut. In these cases, a householder might choose to gather the material in the center with a ribbon band, creating an hourglass shape (especially favored for bedrooms). A single pair of curtains on the bottom half of the window was known as Morris or half curtains, often used when the upper part was of decorative stained glass.

FANCYWORK

Victorian "ladies of the house" often found time hanging heavy on their hands. Aside from needlework (making clothes), genteel women had no creative outlet other than decorous craftwork, generally employed to beautify the home.

Alas, much of the fancywork that has survived is, to be frank, not very good. However, a good deal of it does have charm, if only because it has survived from an era so different from our own.

Readers may want to follow in the footsteps of those nineteenth-century ladies and try their hands at one or

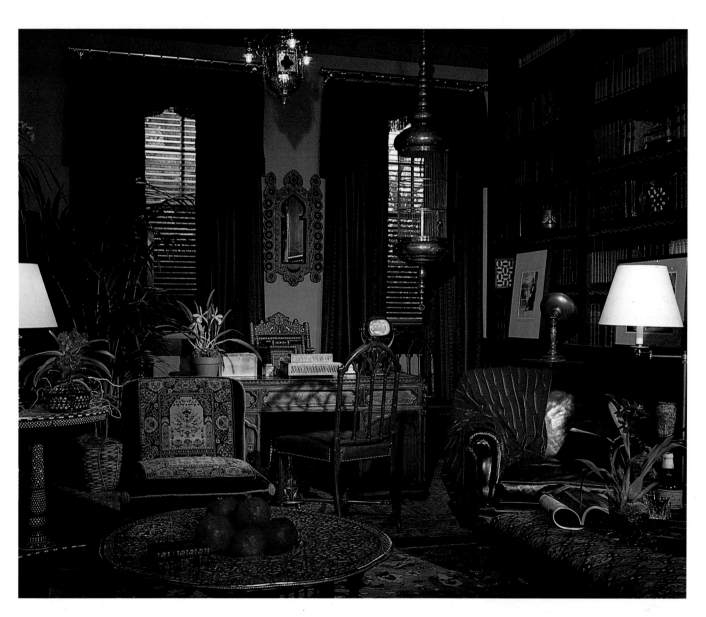

more of these Victorian crafts. Alternatively, they may choose to buy examples of the real thing from antiques dealers. Whatever their origins, accessories made by a loving inhabitant remain the mark of a true Victorian home.

Following is a description of some of the most popular types of Victorian fancywork.

A variety of fancywork objects, such as mosaic boxes, needlepoint pillows, and a carved mirror frame create a feeling of intimacy in this room designed by Johnson/Wanzenberg, above.

BERLIN WORK This was the Victorian name for needlepoint. While the craft later degenerated into stitchery done on cardboard with perforated holes, initially the designs were printed directly onto the canvas mesh. Favorite subjects were birds and flowers, historical figures and scenes, and copies of famous paintings.

BEAD WORK Victorian ladies used the glass beads produced by the thousands in Venice in the early 1800s to adorn small items—purses, work boxes, and pin cushions. They also worked them on a special loom to make mats, hanging baskets, and lambrequins. Beads also appeared on lavish fringes for furniture and drapes.

FRETWORK This craft was popular with both sexes. Also known as scrollwork, jigsaw work, and Sorrento carving, the diversion consisted of using a delicate handsaw—a jigsaw—to cut out patterns in wood traced from one of the many pattern books

These unpretentious English bedrooms are made doubly comfortable by the collection of humble fancywork pieces, above and left, that cover every surface.

available. Fretwork appeared on numerous items, including those ubiquitous Victorian items, knickknack shelves and wall pockets, and other, smaller pieces such as picture frames.

LAMP SHADES Decorated lamp shades were extremely popular in the nineteenth century. Clever ladies employed a number of different methods to create them. One popular technique was called "embossing on cardboard," which consisted of making a series of cuts halfway through the cardboard, using a sharp knife held at an angle. When illuminated from behind, the raised cuts cast decorative shadows. Another style, known as "diaphne," involved sheets of colored paper placed behind the slits in an attempt to create the

effect of stained glass. Shades for electric lamps employed actual slits made all the way through the cardboard. Designs of flowers, birds, and landscapes were popular patterns. Other versions incorporated fretwork or beadwork.

SPATTERWORK Paint sprayed or scattered over a stencil—usually of leaves and flowers or other images of nature. Victorian ladies used a wire sieve to make a fine spray of paint, but you can try a spray gun—it works just as well. This work appeared on lamp shades, book covers, and wastebaskets, but today looks pleasantly nostalgic framed and hung on the parlor wall.

SHELLWORK The Victorians loved shells and glued them to all kinds of objects to make mantel

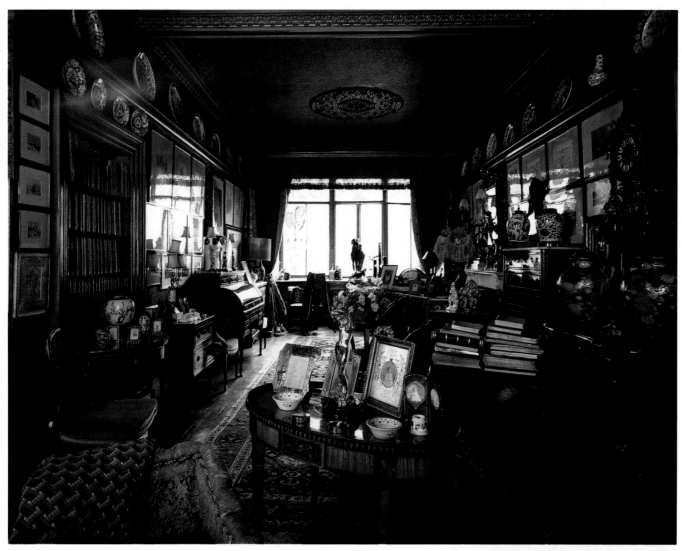

A sophisticated London study is made homier with piled books, painted china vases and plates, and a profusion of bric-a-brac, above.

Framed silhouettes and a console table top full of beloved objects add a straightforward touch to this drawing room, right.

decorations, vases, jewelry, and hair ornaments. Shellwork picture frames were another fashionable item, often used to frame, not surprisingly, seascapes.

BANDBOXES These items got their name from the boxes used to store men's collar bands. The Victorians recycled them, covered them with wallpaper, and used them to store miscellaneous items that did not fit in closets and drawers. Eventually the boxes became so popular that special papers were printed solely for use as bandbox covers.

Part Three

Beyond the House

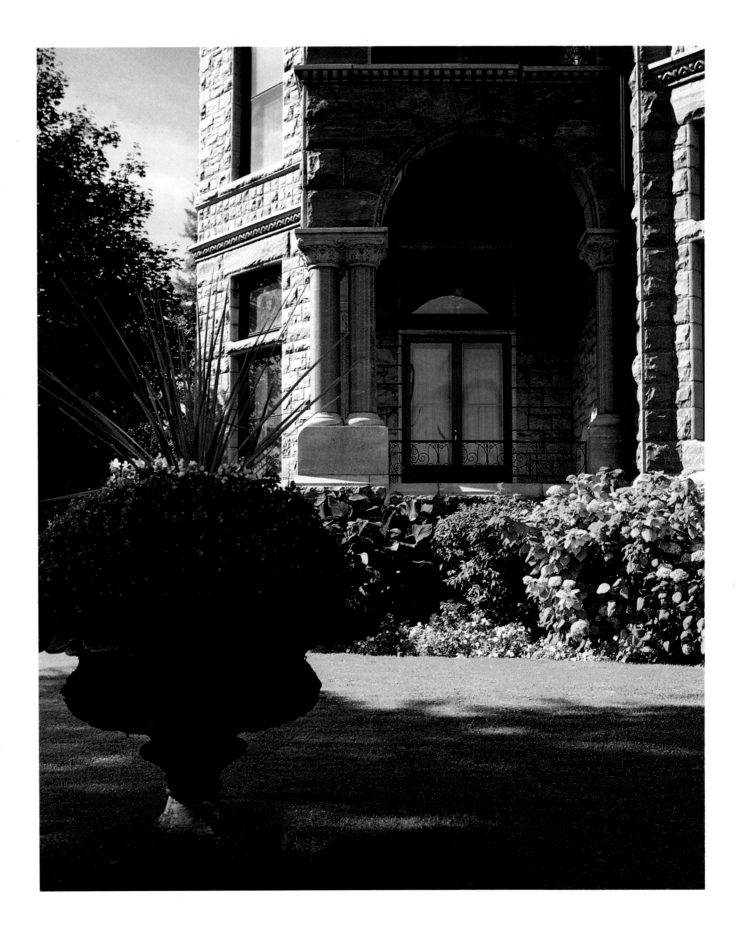

10

GARDENS

Fashions in Victorian gardens wavered between rigid, geometrically patterned formal gardens and "natural" masses of greenery throughout much of the century. In the United States, the strong influence of Andrew Jackson Downing prevailed due to the publication of his classic tome on landscape design, *A Treatise on the History and Practice of Landscape Gardening*, in 1841. Downing favored the English landscape style, carefully contrived to look as though it happened by accident. With the publication of his book, gardeners all over the country, rushed to tear out their formal plantings and substitute masses of greenery in their place.

A number of social factors promoted the success of Downing's ideas. The country had become quite prosperous; industrialization created several fortunes. The great outdoors was no longer a source of danger (wild Indians, inclement weather, malevolent insects, etc.). Instead, it had become a place of recreation and enjoyment.

Another factor was the increased availability of exotic plants exported from South America and the Far East. Nurseries sprang up around the country to supply the demand for colorful and unusual annuals and perennials. With these changes came the desire to beautify one's plot of land. A sense of pride in property emerged. The end result was the pleasure garden.

In Britain, the boom in gardening resulted from the growth of the middle class. For the first time, the majority of the populace was freed from making a living from the land and could enjoy cultivating it as a hobby instead. The houses of freshly built suburban subdivisions each had its own plot of land, with a suburban housewife to cultivate it.

The rich, of course, grew ever richer. The new fortunes of the nineteenth century were partially spent on the creation of country mansions with gardens to match. Throughout Britain, interest in garden cultivation was at a peak.

LANDSCAPING

I n the 1830s, landscape design was divided into two categories, according to which style of architecture it should accompany. Classical architecture fell under the classification of beautiful, while the more irregular styles—Gothic, castellated, Norman, Bracketed, and so on—required the use of the picturesque mode. The beautiful mode, which incorporated grace and harmony, consisted of gently rolling lawns, interrupted every so often with well balanced groupings of trees and bushes. Tranquil curved paths looped through the grounds, often marked by curvilinear flower beds, each bed planted with flowers that bloomed in a single color

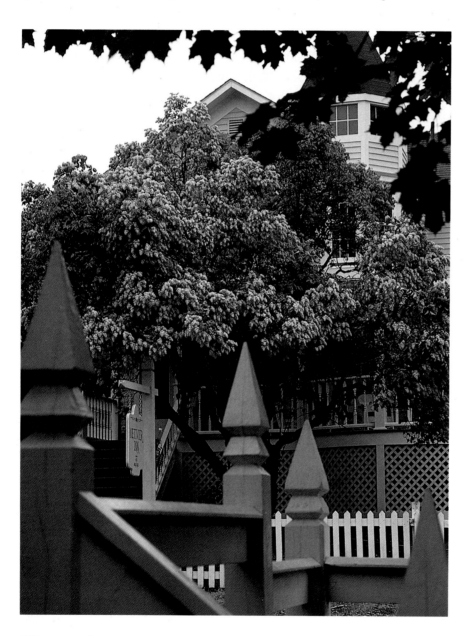

to create a much desired "brilliant effect." Fuchsia, red geraniums, salvia, and lobelia, with their bright petals, were among the preferred blossoms. Beds of flowering shrubs, such as syringas and lilacs, bordered the paths. In Britain, this style was known as Italianate and incorporated terraces, fountains, and parterres edged with boxwood hedges, intermingled with statuary, orange trees, and long gravel walks.

In contrast, gardens in the picturesque style strove to imitate untouched nature. The gardeners' goal was to create a romantic domestic wilderness, with cataracts, stone crags, and gloomy undergrowth—all on a fairly small scale, in most cases. Landscape designers working in this mode made use of evergreens, along with other irregular or dramatic trees. Rustic paths meandered through man-made forests, past rockeries and grottos. The flower gardens scattered about the grounds were irregular in shape.

Lilacs, carved wooden posts, a picket fence, and trellises combine to create a delightful setting in a Mackinac Island, Michigan, garden, above.

The garden of the Gingerbread Mansion Inn, located in Ferndale, California, opposite page, shows off a collection of topiary as well as bedding plants and ferns in front of its delightful porch.

After the 1860s, however, styles changed. With the advent of the streetcar and the growth of the suburbs, the average British or American family lived on far less land. A fine lawn studded with large tress was now the ideal, made possible by the newly invented lawn mower. Plantings and driveways were planned within this expanse of green. The most fashionable trees were the stately elms and beeches, while fast-growing varieties such as the silver maple ran a close second.

Shrubs, used both alone and in groupings, remained popular in the late nineteenth century. Natural looking clumps were used as borders and as screens while single shrubs appeared as accents in stretches of open lawn and at the center of flower beds.

Flower beds in general were very popular with the Victorians, who favored geometric shapes such as stars, crosses, and trefoils. The beds, planted with roses and colorful annuals, were often situated beside walkways and in other highly visible spots. Late Victorian gardens boasted various adornments, among them fountains, decorative urns, topiary, arbors, and gazebos. They were rigidly formal, but often striking, echoing the restraint of the late Victorian interior.

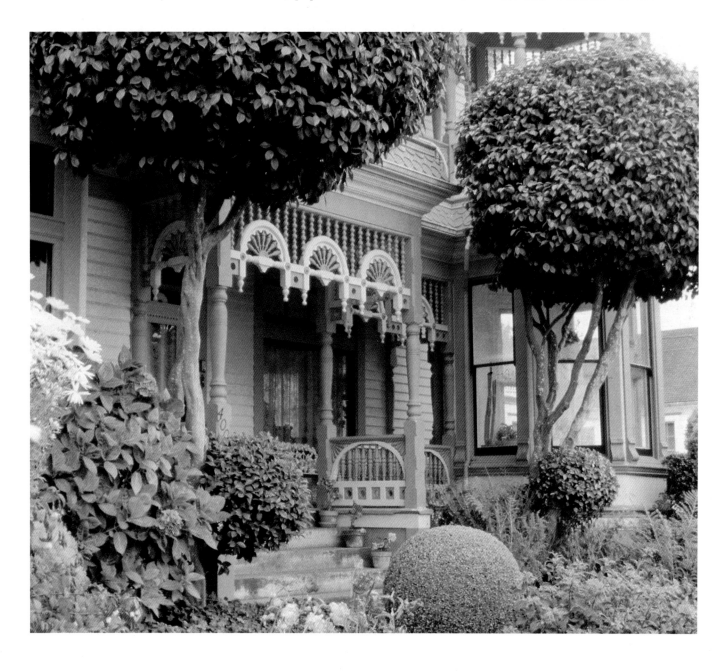

CAST-IRON DECORATIVE URNS AND BIRDBATHS

Cast iron played an important part in the decorative arts of the nineteenth century. Because of its versatility and low cost, it allowed everyone, rich and poor, access to luxurious architectural adornment. Properly finished and painted, iron could imitate many more expensive materials. Almost all of the different kinds of garden ornaments described below were originally created of cast iron. Modern-day replicas are often available in versatile cast polymer resins, which have the advantage of being impervious to weather.

Decorative cast-iron urns were popular accents in fashionable Victorian gardens. They were available in a few basic styles that could be mixed and matched to suit the taste of the individual home owner. They had square bases, either plain or adorned with ornamental figures. Urns came apart so that they could be moved easily. Bolted-on handles could be added to most designs for portability.

Urns were either used alone or as containers for plants, fitted with shallow interior bowls that could be filled with dirt. These bowls have funnel-shaped openings into a water reservoir that make these receptacles self-watering to a certain extent.

Arranged in single or double file, urns were often used to demarcate the terrace in front of the house or to line the driveway. A pair of urns framed many an entrance. Another formal use was to set them along both sides of the driveway. Out in the center of the yard, they created a focus for the garden design. When set on the ground amid plantings, they often sat atop a concrete pad to prevent tipping.

Several iron foundries can supply you with replicas of nineteenth-century urns, cast from the original molds. The principle of interchangeable elements still applies; you can choose the design that suits you and the design of your garden.

Birdbaths are another type of

garden ornament sometimes available in cast iron. These often look like a cross between an urn and a fountain. They consist of a wide, shallow bowl, filled with water, atop an ornamental sculpted pedestal. These bases are either classical, with fluting, spiral volutes, or acanthus leaves, like a Greek column; or like a cast statue, they come in the form of a faun or a classically draped figure.

An elaborate cast-iron urn, above, sports filigree handles and decorative rosettes behind a wrought-iron fence in Evansville, Indiana.

FOUNTAINS

The sparkle of spray in the sunlight and the peaceful plash of running water were beloved elements in the Victorian garden setting. Grand houses had indoor fountains as well. Many nineteenth-century families installed fountains to mark significant occasions that were personal, such as a marriage or birth, and civic, perhaps a town anniversary.

Victorian era fountains most often consisted of two different designs. One had an arrangement of central spills—two or three bowls brimming water—often topped with a small statue. The other was in the form of a large statue bearing a basin, sometimes set within a larger vessel or container.

Both types of fountains boasted fancy and fanciful designs—frogs or turtles ringing the edge of the basin, for example, interspersed with waterlilies and ivy leaves. The sculpted pedestals often carried watery motifs, including sea horses and marsh birds entwined with cattails. Fluted columns—adorned with such classical motifs as a lion's head and acanthus leaves—were also popular.

The statues that adorned these fountains were in the time-honored classical tradition—child with a swan, a boy riding a dolphin, a young man entwined with a snake. These formal figures were often perched atop a base designed to look like a pile of rough-hewn rocks.

The decoration also served to vary the direction of the water flow, creating interesting patterns. Sometimes the water emerged from the mouth of the statue. (Some infamous versions were less delicate.) For fountains that lacked a central statue, the spray might spurt from a ring of nozzles placed around the rim, or from a single large outlet in the center of the basin.

These fountains are not as complicated to install as they might seem at first. The kinds now available come with their

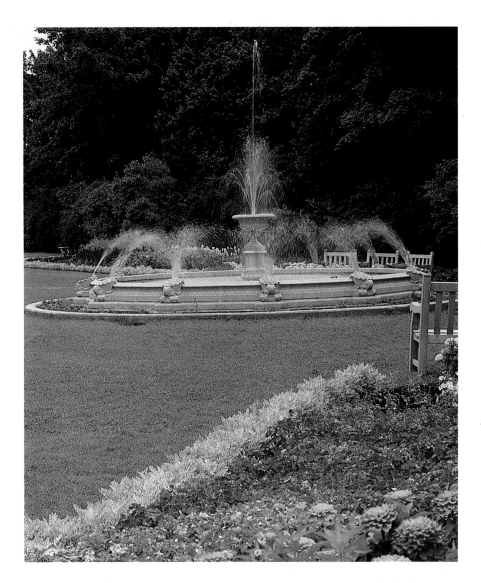

own reservoirs and small electric motors to aid in recycling the flow of water. Many foundries, such as Georgia's Moultrie Manufacturing, offer replicas of genuine Victorian era fountains.

A fountain makes a refreshing spectacle on an expanse of lawn edged with Victorian style bedding, above.

STATUES

The use of garden statuary goes back to the eighteenth and early nineteenth century, when members of the aristocracy hired landscape designers to create broad, sweeping vistas surrounding their country homes. Statuary, classical tempiettos (small temples usually circular in plan, with a conical roof supported by columns), and fake ruins ("follies") all helped to punctuate the view and create points of interest.

Smaller versions of these statues later appeared in Victorian domestic-scale versions of aristocratic landscapes. They were generally classical in nature, sometimes even copies—in stone or cast iron—of well-known pieces in museums or private collections. Subjects included ladies clad in flowing drapery, boys with foxes, dying gladiators, and fauns with grapes. Animals were also popular subjects. Foxes, deer, and dogs were among the most common.

In fact, the Victorian appreciation for garden and lawn statuary has survived to this day, although in a rather debased form. The draped ladies and jaunty fauns of the nineteenth century are the ancestors of today's gnomes, pink flamingos, and lantern-bearing jockeys. If you are in search of something more refined to serve as the focal point for your own lawn, garden, or rockery, check with salvage companies, such as New York's Irreplaceable Artifacts, which has a separate division devoted to garden items. Modern versions are available from a wide variety of sources, including mail-order catalogues and garden centers.

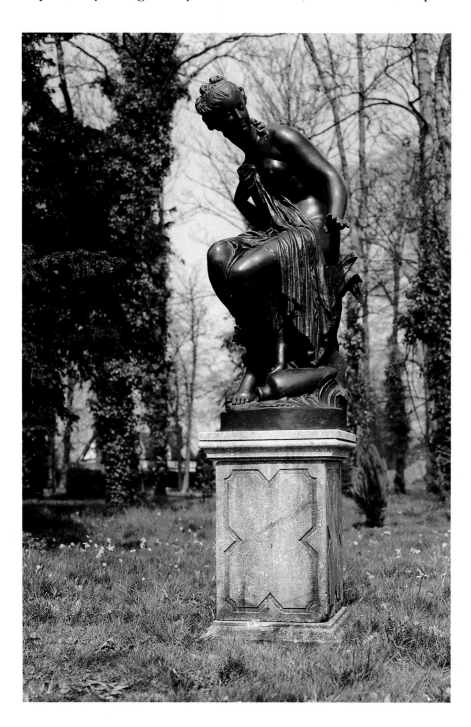

A graceful cast-iron goddess on a pedestal, left, is a decorative presence on a broad greensward near Cheltenham, England.

The two faces of Victorian fences: Cast-iron curlicues, opposite page, left, surround the Queen Victoria Inn, Cape May, New Jersey. A whimsical white picket fence hems in a neatly trimmed hedge, opposite page, right.

FENCES

The Victorians employed all manner of decorative railings and posts, most often of ornamental cast iron, to adorn their lawns and protect their property against wandering dogs and trespassers. Cast iron could be reproduced in almost any form for which a mold could be made. Manufacturers put out a variety of patterns, from rustic to floral to gothic.

These cast-iron fences were often smaller in scale than their grand estate predecessors. They were generally from three to four feet high. The result was a cozy, domestic effect—of decorative trim for the lawn.

The most common structural design for the Victorian garden fence consisted of three horizontal bars that supported a screen of vertical palings. These in turn were carried by posts, anchored with stone or iron footings. Added strength and reinforcement came from larger corner posts and gate posts.

The ornamental tips of the vertical palings came in a broad range of shapes, offering Victorian home owners a chance to indulge their creativity. Crosses and spearheads were among the favorite shapes. Simple in form, they echoed the monumental solidity of medieval forms. Also popular was Gothic tracery, with its intricate ornamental finials.

At the opposite end of the design spectrum, rustic motifs—flowering vines and bunches of grapes reproduced in metal—were also very fashionable. Another popular rustic style was the cast-iron fence that imitated those made of cut saplings—a romantic pioneer effect. Scrolls, motifs common to the eighteenth century, also appeared frequently in fence designs.

Gates and corner posts usually differed in design from the rows of pickets, tending to be more elaborate. Gates especially displayed complex whorls, twining stems, and ornate finials. Corner and line post tops boasted round bosses, sometimes resembling acorns, to distinguish them from the ordinary palings that made up the bulk of the fencing.

Rich, massive, and durable, many Victorian designs have survived to the present day. However, the vast majority remain in their original sites—they were installed to last, and have proved difficult to dig up. Therefore, architectural salvage yards are an erratic source of genuine nineteenth-century examples. The good news is that several foundries continue to produce cast iron and even cast aluminum pieces from the original molds. (Cast aluminum has the advantage of being lighter and more durable.)

GARDEN FURNITURE

Our Victorian ancestors believed that sitting outdoors was beneficial to the spirit and soothing to the soul. They purchased and sat upon a vast variety of garden furniture, ranging from settees to hammocks to chaise longues. Cast-iron benches, tables, and chairs usually graced formal gardens, while wood and canvas furniture was used in less permanent settings, for example, at the beach or on a picnic.

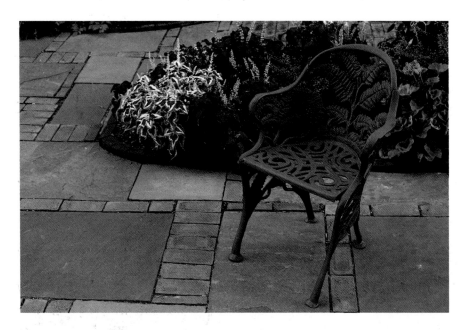

A commodious cast-iron garden chair provides a spot to settle for a peaceful spell amid the plantings, left.

A woodland glade in Flintham, Nottinghamshire, England, boasts elegant white garden chairs, below.

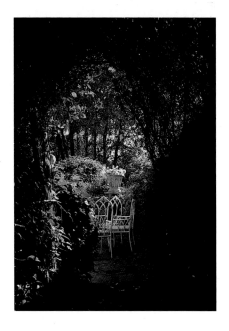

The quintessential Victorian garden bench, seen in both public and private settings, was of cast iron and adorned with curlicues and ivy leaves. It featured a delicate filigree back, scrolled arms, the legs twined with flowers and vines, and was often placed in a conversational grouping with matching chairs and tables. While few of the Victorian originals remain (many disappeared in World War II scrap drives), many foundries continue to produce pieces taken from the original molds. Some, such as Moultrie Manufacturing in Moultrie, Georgia, offer cast-aluminum versions, which are lighter and more durable. The Winterthur collection of garden furniture features an unusual, whimsical group of designs.

These delicate wrought- and cast-iron chairs, settees, and tables reproduce some of the charming pieces from the collection of Henry Francis du Pont.

Benches, swings, and chairs of teak or mahogany offer another Victorian possibility for the outdoors. You might have a soft spot for British architect Sir Edwin Lutyen's bench of 1913, a well-known Edwardian design distinguished by its gently curved arms and scrolled back. Several garden furniture suppliers feature a version of this bench.

Major manufacturers have gotten into the act as well. Well-known companies such as Brown Jordan, Lyon-Shaw, and Woodard now offer a line of furniture inspired by nineteenth-century designs, in addition to their sleek,

modern wares. These have the advantage of being widely available. They have polyester resin finishes, which make them impervious to weather. They come in a choice of colors (some more "Victorian" than others), as well as with cushions or vinyl straps.

ARBORS, SUMMERHOUSES, AND GAZEBOS

Victorian garden structures ranged from simple to elaborate. Some rather grand houses boasted what amounted to outbuildings, constructed in a decorative style to complement the main house. Gardens belonging to smaller houses might have included something less grand—a trellised arbor, a summerhouse with an amusing conical roof, or a modest, covered seat.

Over the past several years, garden structures have grown enormously in popularity and are widely available, even at some local garden centers and hardware stores. Most popular are arbors and small gazebos, but the

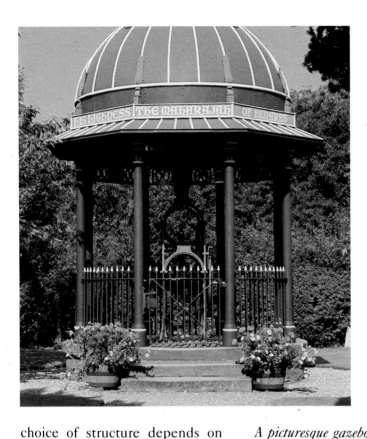 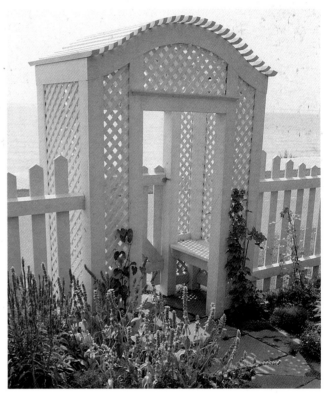

A picturesque gazebo occupies a prime spot in an English garden, above left. White-painted treillage makes a delightful gate near Lake Michigan, above right.

choice of structure depends on the scale of the garden and the needs of the individual home owner. If you do a lot of outdoor entertaining, perhaps an enclosure defined by trellis walls and open to the sky would serve as a small outdoor room for entertaining or relaxing. If you're a gardener, maybe you want a decorative shed to conceal your tools. Small children might appreciate a swing, or an open-sided gazebo with "secret" compartments concealed beneath built-in seats.

For some simple garden designs, it's feasible to do it yourself, or hire a local carpenter or builder. Many lumberyards sell ready-made trellises for constructing arbors, for example. If you're interested in something more elaborate, or you don't trust your own design skills, several companies make prefabricated garden structures. Among these are The English Garden by

Machin Designs, based in Wilton, Connecticut; and The Garden Concepts Collection of Memphis, Tennessee. Some garden supply catalogues, including Gardener's Eden, Clapper's, and Smith & Hawken, occasionally offer similar items. These catalogues are also useful sources for small-scale items that give an architectural effect, such as obelisk-topped planters.

Appendix

BIBLIOGRAPHY

Harriet Bridgeman and Elizabeth Drury, eds. *The Encyclopedia of Victoriana*. New York: Macmillan, 1975.

Ella Rodman Church. *How to Furnish a Home*. New York: D. Appleton & Co., 1882.

Clarence Cook. *What Shall We Do With Our Walls?* New York: Warren, Fuller & Co., 1881.
————. *The House Beautiful*. New York: Scribner, 1881.

Jeremy Cooper. *Victorian and Edwardian Decor: From the Gothic Revival to Art Nouveau*. New York: Abbeville Press, 1987.

Clem Labine and Carolyn Flaherty, eds. *The Old-House Journal Compendium*. Woodstock, NY: The Overlook Press, 1980.

Anthony N. Landreau. *America Underfoot: A History of Floor Coverings From Colonial Times to the Present*. Washington, D.C.: Smithsonian Institution Press, 1976.

Allison Kyle Leopold. *Victorian Splendor: Recreating America's Nineteenth-Century Interiors*. New York: Stewart Tabori & Chang, 1986.

Catherine Lynn. *Wallpaper in America from the Seventeenth Century to World War I*. New York: W. W. Norton & Co., 1980.

Florence Montgomery. *Printed Textiles: English and American Cottons and Linens, 1700–1850*. New York: Viking Press, 1970.

Roger W. Moss and Gail Caskey Winkler. *Victorian Exterior Decoration: How to Paint Your Nineteenth-Century American House Historically*. New York: Henry Holt & Co., 1987.

Richard C. Nylander. *Wallpapers for Historic Buildings*. Washington, D.C.: The Preservation Press, 1983.

David Stuart. *The Garden Triumphant: A Victorian Legacy*. New York: Harper & Row, 1988.

Peter Thornton. *Authentic Decor: The Domestic Interior, 1620–1920*. New York: Viking Penguin, 1984.

Gail Caskey Winkler and Roger W. Moss. *Victorian Interior Decoration: American Interiors. 1830–1900*. New York: Henry Holt, 1986.

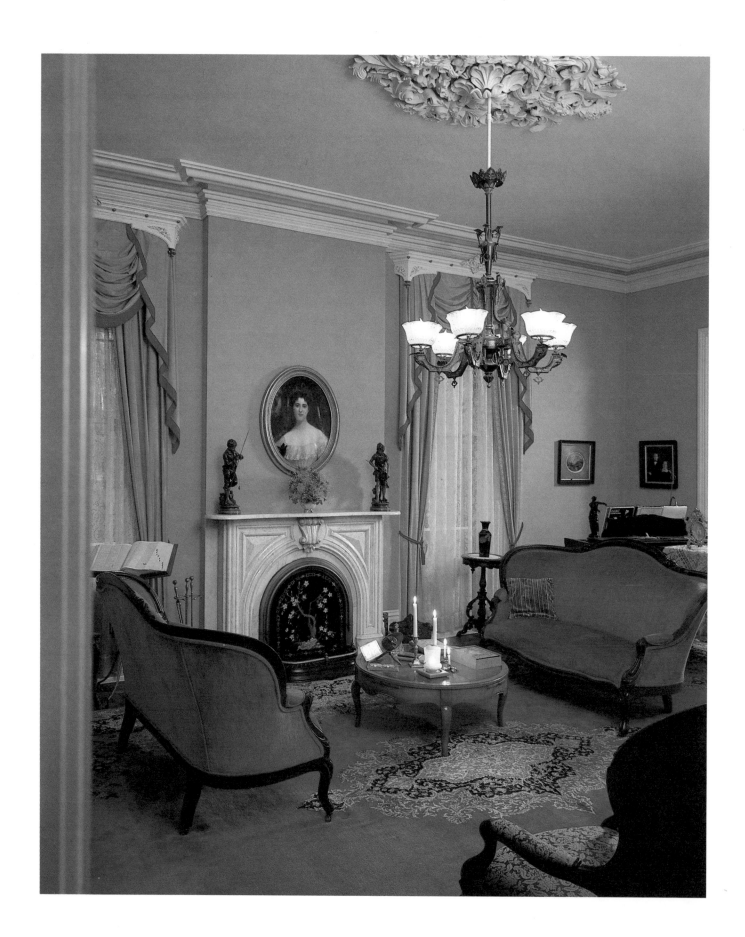

SOURCES

Part One
The Exterior

1 FAÇADES

Anthony Wood Products, Inc.
Box 1081x
Hillsboro, TX 76645
817-582-7225
Handcrafted Victorian gingerbread

Cumberland Woodcraft Co.
P.O. Drawer 609
Carlisle, PA 17013
717-243-0063
Specialize in grilles, fretwork, panels, brackets, and turnings

Finnaren & Haley
2320 Haverford Road
Ardmore, PA 19003
215-649-5000
Interior and exterior paints featuring a line of Victorian hues

Andreas Lehman/Thomas Tisch
1793 12th Street
Oakland, CA 94807
415-465-7158
Fine custom glasswork

Mad River Woodworks
1355 Giuntoli Lane
P.O. Box 163
Arcata, CA 95521
707-826-0629
Custom millwork

Marvin Windows
P.O. Box 100
Warroad, MN 56763
800-346-5128
Wooden windows in custom sizes

Pasternak's Emporium
2515 Morse Street
Houston, TX 77019
713-528-3808
Architectural antique dealer specializing in Victorian gingerbread

Pocahontas Hardware & Glass
P.O. Box 127
Pocahontas, IL 62275
618-669-2880
Stained and etched glass windows and doors

Shuttercraft
282 Stepstone Hill
Guilford, CT 06437
203-453-1973
Exterior shutters made from western pine; will ship anywhere

Silverton Victorian Millworks
P.O. Box 2987
Durango, CO 81302
303-259-5915
Victorian moldings, rosettes, and millwork; welcome inquiries for custom work

United House Wrecking Corp.
535 Hope Street
Stamford, CT 06906
203-343-5371
Stained glass from old houses

Vintage Woodworks
513 South Adams
Fredricksburg, TN 78624
512-997-9513
Custom Victorian millwork

2 UP ON THE ROOF

Campbellsville Industries, Inc.
P.O. Box 278
Taylor Boulevard
Campbellsville, KY 42718
502-465-8135
Steeples, cupolas, columns, balustrades

Cape Cod Cupola Co., Inc.
78 State Road
North Dartmouth, MA 02747
508-994-2119
Cupolas, steeples, weathervanes

International Building Components
P.O. Box 51
Glenwood, NY 14069
716-592-2953
Cupolas

United House Wrecking Corp.
535 Hope Street
Stamford, CT 06906
203-343-5371
Relics from old houses including cupolas and weathervanes

3 DOORS AND ENTRIES

Devenco Louver Products
P.O. Box 700
Decatur, GA 30031
404-378-4597
Custom-made wood slat venetian blinds

The Old Wagon Factory
103 Russell Street
P.O. Box 1427
Clarksville, VA 23927
804-374-5787
Windows, doors, and fretwork

Jill Pilaroscia
220 Eureka Street
San Francisco, CA 94114
415-861-8086
Architectural colorist

Grand Era Reproductions
P.O. Box 1026
Lapeer, MI 48446
313-664-1756
Screen and storm doors of hand-crafted hardwood

Oregon Wooden Screen Door Co.
330 High Street
Eugene, OR 97401
503-485-0279
Custom-made wooden screen doors

Pinecrest
2118 Blaisdell Avenue
Minneapolis, MN 55404
800-443-5357
Doors and windows

Pocahontas Hardware & Glass
P.O. Box 127
Pocahontas, IL 62275
618-669-2880
Custom-stained glass windows and doors

Andreas Lehmann/Thomas Tisch
1793 12th Street
Oakland, CA 94807
415-465-7158
Fine custom glasswork

Pease Industries
7100 Dixie Highway
P.O. Box 14-8001
Fairfield, OH 45014-8001
800-543-1180
Doors and windows

Part Two
The Interior

4 CEILINGS

AA-Abingdon Affiliates, Inc.
2149-51 Utica Avenue
Brooklyn, NY 11234
718-258-8333
Tin panels for metal ceiling installations

Chelsea Decorative Metal Co.
6115 Cheena
Houston, TX 77096
713-721-9200
Embossed metal for ceilings

Classic Ceilings
902 East Commonwealth Avenue
Fullerton, CA 92631
818-796-5618
Metal ceilings

The Fan Man
4614 Travis
Dallas, TX 75205
214-559-4440
Ceiling fans with light fixtures

Focal Point, Inc.
P.O. Box 93327
Atlanta, GA 30377-0327
800-662-5550
Ceiling medallions, moldings

W. F. Norman Corp.
P.O. Box 323
Nevada, MO 64772
800-641-4038
Metal ceilings, wall panels, and wainscoting; all patterns from original dies

5 WALLS

American Discount Wallcoverings
1411 5th Avenue
Pittsburgh, PA 15219
800-777-2737
Wallpapers, borders, and fabrics

Aristocast Originals Ltd.
6200 Highland Parkway, S.E.
Suite I
Smyrna, GA 30082
404-333-9934
Moldings, medallions

Bradbury & Bradbury Wallpapers
P.O. Box 155
Benicia, CA 94510
707-746-1900
Hand-printed Victorian wallpapers including William Morris designs

First Capital Wood Products, Inc.
147 West Philadelphia Street
York, PA 17403
800-233-9307
Wall and floor wood paneling

Old World Moulding
115 Allen Boulevard
Farmingdale, NY 11735
516-293-1789
Hardwood moldings, cornices, baseboards, and paneling

Raintree Designs
979 Third Avenue, #503N
New York, NY 10022
212-477-8594
Wallpaper and fabrics available through interior designers

6 FLOORS

American Olean Tile Co.
103 South Clark Street
Olean, NY 14760
716-372-4300
Tile manufacturer

Bruce Hardwood Floors
16803 Dallas Parkway
Dallas, TX 75248
214-931-3000
*World's largest manufacturer of
hardwood flooring*

J. R. Burrows & Co.
6 Church Street
Boston, MA 02116
617-451-1982
Large selection of imported rugs

**Desoto Hardwood Flooring
Co.**
P.O. Box 40895
Memphis, TN 38174-0895
901-774-9672
Hardwood flooring

**First Capital Wood Products,
Inc.**
147 West Philadelphia Street
York, PA 17403
800-233-9307
Wall and floor wood paneling

**Good & Co. Floorcloth
Makers**
Rt. 101 at Salzburg Square
Amherst, NH 03031
603-672-0490
Handmade floor cloths

Hartco/Tibbals Flooring
P.O. Box 1001
Oneida, TN 37841
615-569-8526
*Pre-finished solid oak parquet
flooring*

Kentucky Wood Floors, Inc.
4200 Reservoir Avenue
Louisville, KY 40213
502-451-6024
*Full line of hardwood flooring,
pre-finished and unfinished*

Mohawk
1755 The Exchange
Atlanta, GA 30339
800-554-6637
*Victorian style carpeting; call for
regional dealer information*

Summitville Tiles
P.O. Box 73
Summitville, OH 43962
216-223-1511
*Quarry tiles and hand-painted
ceramic tiles*

Terra Designs
241 East Blackwell Street
Dover, NJ 07801
201-539-2999
*Painted ceramic tiles and custom
tiles*

7 LIGHTING

Art Directions
6120 Delmar Blvd.
St. Louis, MO 63112
314-863-1895
*Hundreds of light fixtures including
gas and electric*

Burdoch Silk Lampshade Co.
1145 Industrial Avenue
Escondido, CA 92025
619-745-3275
*Embroidered and hand-sewn
Victorian shades*

City Lights
2226 Massachusetts Avenue
Cambridge, MA 02140
617-547-1490
*Large selection of restored antique
lighting*

Classic Accents
P.O. Box 1181
Southgate, MI 48195
313-282-5525
Solid brass lightswitch plates

Crawford's Old House Store
550 Elizabeth Street
Waukesha, WI 53186
800-556-7878
*Large selection of reproduction
Victorian lighting*

D. J.'s Arts & Crafts Shop
1417 Bridgeway
Sausalito, CA 94965
415-331-2554
*Lamps and light fixtures from the
Arts and Crafts Movement*

Illustrious Lighting
1925 Fillmore Street
San Francisco, CA 94115
415-922-3133
*Large selection of restored gas and
electric lighting*

Sue Johnson
1745 Solano Avenue
Berkeley, CA 94707
415-527-2623
*Handmade and embroidered
lamp shades*

King's Chandelier Co.
P.O. Box 667
Eden, NC 27288
919-623-6188
*Crystal and brass reproductions of
many Victorian styles*

Progress Lighting
G Street & Erie Avenue
Philadelphia, PA 19134
215-289-1200
*Victorian lighting fixture reproduc-
tions*

Rare & Beautiful Things
Restored Lighting
P.O. Box 6180
Annapolis, MD 21401
301-263-2357
*Specializing in restoration of
antique lighting*

Roy Electric
1054 Coney Island Avenue
Brooklyn, NY 11230
718-434-7000
*Large selection of gas and electric
fixtures*

Shades of a New Dawn
621 4th Street
Clovis, CA 93612
209-297-1514
*Supplies for making your own silk
lamp shades*

Shades of the Past
P.O. Box 502
Corte Madera, CA 94925
415-459-6999
*Handsewn Victorian silk
lamp shades; also restoration work*

Victorian Lightcrafters
P.O. Box 350
Slate Hill, NY 10973
914-355-1300
*Reproduction Victorian lighting fix-
tures and desk lamps*

8 FIXTURES AND DETAILS

A-Ball Plumbing Supplies
1703 W. Burnside Street
Portland, OR 97209
503-228-0026
Plumbing supplies and hardware

Antique Baths & Kitchens
2220 Carlton Way
Santa Barbara, CA 93109
805-962-8598
Fixtures for kitchens and baths

Bathroom Machineries
P.O Box 1020C
Murphys, CA 95247
209-728-2031
Victorian plumbing supplies

Besco Plumbing
729 Atlantic Avenue
Boston, MA 02111
617-423-4535
*Sinks, faucets, bathtubs, and
plumbing accessories*

Chicago Faucet Company
2100 South Nuclear Drive
Des Plaines, IL 60018
312-694-4400
*Kitchen and bathroom supplies and
fixtures*

**Classic Architectural
Specialties**
3223 Canton Street
Dallas, TX 75226
214-748-1668
*Huge selection of architectural orna-
mentation products*

Crawford's Old House Store
550 Elizabeth Street
Waukesha, WI 53186
800-556-7878
*Plumbing fixtures and hardware
supplies*

Ravenglass Party Ltd.
P.O. Box 612
Goodland, KS 67735
913-899-2297
*Reproduction Victorian mirrors,
cabinets, and stained glass*

Reggio Register Co.
P.O. Box 511
Ayer, MA 01432
508-772-3493
Cast-iron floor registers

Renovator's Supply
Old Mill
Millers Falls, MA 01349
413-659-2241
Hardware and plumbing supplies

Ritter & Son Hardware
P.O. Box 578P
Gualala, CA 95445
800-358-9120
800-862-4948 (CA only)
Brass furniture hardware

Roy Electric
1054 Coney Island Avenue
Brooklyn, NY 11230
718-434-7000
Plumbing supplies

Smallbone
150 East 58th Street
New York, NY 10150
212-644-5380
*English cabinetry company spe-
cializing in kitchens, baths, and
bedrooms*

Stanley Iron Works
64 Taylor Street
Nashua, NH 03060
603-881-8335
Antique cook stoves

Swan Wood Co.
1513 Golden Gate Avenue
San Francisco, CA 94115
415-567-3263
Custom-made oak medicine cabinets

Victorian Warehouse
109 Grace Street
Auburn, CA 95603
916-823-0374
Bath fixtures and light fixtures

9 SPECIAL ACCENTS

Arcadian Wood Products
3004 Cameroon Street
P.O. Box 2548
Lafayette, LA 70502
318-233-5250
Specialize in fireplace mantels

Bielecky Bros. Wicker Furniture
306 East 61st Street
New York, NY 10021
212-735-2355
Rattan, cane, and wicker furniture

J. R. Burrows & Co.
6 Church Street
Boston, MA 02116
617-451-1982
Fabrics and lace from the Victorian era

Country Curtains
Red Lion Inn
Stockbridge, MA 01262
413-243-1300
Victorian style curtains

Crawford's Old House Store
550 Elizabeth Street
Waukesha, WI 53186
800-556-7878
Victorian "general store" with lighting, plumbing, stencil kits, moldings, and fireplace mantels

Anton Feutsch
1507 San Pablo Avenue
Berkeley, CA 94702
415-526-6354
Custom woodcarver

Focal Point
P.O. Box 93327
Atlanta, GA 30377-0327
800-662-5550
Fireplace mantels

Fourth Bay
10500 Industrial Drive
P.O. Box 287
Garrettsville, OH 44231
800-321-9614
Imported cast-iron fireplaces; call for regional dealer

Hickory Chair Comp.
P.O. Box 2147
Hickory, NC 28603
704-328-1801
Furniture collections by Mark Hampton, and by the James River Collection

Homespun Fabrics
P.O. Box 3223
Ventura, CA 93006-3223
805-642-8111
Distributor of custom draperies

Hunt Galleries, Inc.
2920 Highway 127 North
P.O. Box 2324
Hickory, NC 28603
800-248-3876
Manufacturers of Victorian furniture

International Building Components
P.O. Box 51
Glenwood, NY 14069
716-592-2953
Wooden mantels; spiral and circular stair components

Wm. H. Jackson, Co.
3 East 47th Street
New York, NY 10017
212-753-9400
Carved wood mantels, fine fireplace equipment

Lace Connection
24 Mill Plain Road
Danbury, CT 06811
203-790-1007
Catalogue of imported lace from Scotland, Germany, and China

Laci's
2982 Adeline Street
Berkeley, CA 94703
415-843-7178
Fine selection of Victorian era laces, trims, and other textiles

Linen Lady
885 57th Street
Sacramento, CA 95819
916-457-6718
Specialize in lace curtains and handmade linens

London Lace
167 Newbury Street, 2nd Floor
Boston, MA 02116
617-267-3506
Reproduction Victorian lace

Magnolia Hall
726 Andover Drive
Atlanta, GA 30327
404-256-4747
Victorian reproduction furniture

Martha M. House
1022 South Decatur Street
Montgomery, AL 36104
205-264-3558
Victorian furniture

Old World Moulding
115 Allen Boulevard
Farmingdale, NY 11735
516-293-1789
Fireplace mantels

Raintree Designs
979 3rd Avenue, #503N
New York, NY 10022
212-477-8594
Wallpapers and fabrics

Rue de France
78 Thames Street
Newport, RI 02840
401-846-2084
Imported lace from France

Scalamandré
950 3rd Avenue
New York, NY 10022
212-980-3888
Manufacturers of upholstery and drapery fabric

A. F. Schwerd Manufacturing Co.
3215 McClure Avenue
Pittsburgh, PA 15212
412-766-6322
Custom designed and stock wooden columns

Steptoe & Wife
322 Geary Avenue
Toronto, Ontario
Canada M6H2C7
416-530-4200
Reproduction cast-metal spiral staircases

United House Wrecking Corp.
535 Hope Street
Stamford, CT 06906
203-343-5371
Relics from old houses including fireplace mantels

Vintage Valances
P.O. Box 43326
Cincinnati, OH 45243
513-561-8665
Custom-made drapes and soft fabric valances

Wecker Textiles
P.O. Box 212
Punta Gorda, FL 33950-0212
813-637-9225
Lace curtains; wholesale and retail

Wicker Cottage
P.O. Box 42274
Houston, TX 77242
713-781-0678
Extensive line of wicker furniture

Part Three
Beyond the House

10 GARDENS

Ballard Designs
2148-J Hills Avenue
Atlanta, GA 30318
404-351-5099
Architectural accents for the garden

Blueberry Hill
17159 Beaver Springs
Houston, TX 77090
713-893-4112
Custom Victorian mailboxes and other exterior details

Brown Jordan
9850 Gidley Street
El Monte, CA 91734
818-443-8971
Outdoor furniture; call for regional dealer

Cedar Gazebos
10432 Lyndale
Melrose Park, IL 60164
312-455-0928
Gazebos

Clappers Catalogue
1125 Washington Street
West Newton, MA 02165
617-244-7909
Gardening catalogue

Dover Publications
180 Varick Street
New York, NY 10014
212-255-3755
Nature catalogue and garden books

Eagle Triumph
Division of Colonial Foundry
240 Sargent Avenue
New Haven, CT 06511
203-777-5564
Cast-aluminum furniture

Garden Concepts Collection
P.O. Box 241233
Memphis, TN 38124-1233
901-756-1649
Garden furniture, gates, and trellises

**Gardener's Eden
Williams-Sonoma**
P.O. Box 7307
San Francisco, CA 94120-7307
415-421-4242
Gardening supplies; call for catalogue

Irreplaceable Artifacts
14 2nd Avenue
New York, NY 10003
212-777-2900
Original architectural artifacts

Kloter Farms Inc.
257 Crystal Lake Road
Ellington, CT 06029
800-225-5800
Gazebos

Lyon-Shaw
P.O. Box 2069
Salisbury, NC 28145-2069
704-636-8270
Outdoor furniture

Machin Designs (USA) Inc.
557 Danbury Road (Route 7)
Wilton, CT 06897
203-834-9566
Gazebos, greenhouses, and garden furniture

Moultrie Manufacturing
P.O. Box 1179
Moultrie, GA 31776
912-985-1312
Cast-aluminum columns, gates, fences, garden furniture, fountains, urns, and plaques

Smith & Hawken
35 Corte Madera Avenue
Mill Valley, CA 94941
415-381-1800
Garden furniture and supplies

Otto Wendt & Co.
417A Gentry
Spring, TX 77373
713-288-8295
Specialize in cast-aluminum furniture, mailboxes, and garden accessories

The Winterthur Collection
Winterthur Museum and
Gardens
Winterthur, DE 19735
302-888-4600
Garden furniture

Woodard
317 South Elm Street
Jackson, MI 48867
517-784-6413
Outdoor furniture

DESIGNERS, ARCHITECTS, AND CRAFTSPEOPLE

Artistic License
1925A Fillmore Street
San Francisco, CA 94115
415-922-2854
A guild of craftspeople specializing in Victoriana including original and reproduction lighting, renovations, handprinted wallpapers, etc.

John Canning
Decorative Painter
Box 822
Southington, CT 06489
203-621-2188

Crimmins Construction
47 Pemberton Road
Wayland, MA 01778
617-655-8528
Remodeling, restoration, and custom building

Decorating Connection
24 Mill Plain Road
Danbury, CT 06811
203-790-1007
Retail interior design service

Clare Fraser Interior Design
Clare Fraser
127 East 59th Street
New York, NY 10021
212-737-3479

Larry W. Garnett & Assoc., Inc.
4710 Vista Road
Pasadena, TX 77505
713-487-0427
Designers of Victorian house plans

Noel Jeffrey, Inc.
215 East 58th Street
New York, NY 10022
212-935-7775
Interior designer

Johnson/Wanzenberg
211 West 61st Street
New York, NY 10023
212-489-7840
Interior designers

Erik Kramvik
30 Stilling Avenue
San Francisco, CA 94115
415-333-4932
Specializes in Victorian exterior restorations

J. P. Molyneux
29 East 69th Street
New York, NY 10021
212-628-0097
Interior designer

New Victorians, Inc.
P.O. Box 32505
Phoenix, AZ 85064
602-956-0755
Victorian-influenced house plans

Jill Pilaroscia
220 Eureka Street
San Francisco, CA 94114
415-861-8086
Architectural colorist

Victorian Interior Restoration
2321 Sidney Street
Pittsburgh, PA 15203
412-381-1870
Specialize in restoring the interiors of old houses

Winans Construction
5515 Doyle Street, #9
Emeryville, CA 94608
415-653-7288
Specialize in renovation and restoration of old structures

INDEX

PHOTO CREDITS

A Ball Plumbing, *114*; The Abbey, *125*; Arcaid, photos by Lucinda Lambton, *84, 110(2), 117(2), 123(bottom), 140(right), 141(left)*; Architectural Heritage, *138*; Antoine Bootz for Noel Jeffrey Inc., *65(right)*; Bradbury and Bradbury Wallpapers, *63, 66, 68, 71(bottom)*; Barbara J. Buchbinder-Green, *20, 26, 29(left), 30(top and bottom, right), 45(top), 48(bottom, left)*; J.R. Burrows & Co., *80, 90(bottom), 144*; Karen Bussolini, *6(left), 7(left), 77, 78, 82, 121(2), 139(right), 140(left)*; Mark Citret, *65(left)*; Cleveland Publicity Services Ltd., *123(top)*; Derrick & Love, *64, 74, 122,126*; ©Peter Mauss/Esto, *97*; Bruce Glass, *32, 52, 70, 76, 83*; Good Floorcloth Makers, *86*; John Hall, *7(center), 9, 10, 19, 21, 22, 24, 40, 62, 87, 91, 104, 105, 118, 127*; Illustrious Lighting, *100(right)*; Wm. B. Johns & Partners, *71(top), 73*; Sue Johnson, *107*; Ken Kirkwood, *37*; Balthazar Korab, *23, 27(right), 28, 31, 36(right), 38, 39, 42, 48(top, left), 58, 59, 72, 75, 89, 90(top), 100(left), 102, 103, 132, 134, 136, 137, 141(right), 146*; Lucinda Lambton, *7(right), 11, 30(left), 35, 128(bottom), 129(bottom), 142*; Norman McGrath, *16, 27(left), 29(right), 41, 45(bottom), 46*; Kent Oppenheimer, *53, 106, 115*; Robert Perron, *6(right), 25, 34, 49(right), 60, 79, 92, 99, 120*; Joelle Pineau, *43, 98(2)*; Pinecrest Inc., *51(left)*; Queen Victoria Inn, *139(left)*; Arthur Sanderson & Sons Ltd., *14, 54, 130*; Scalamandré, *69*; Smallbone Inc., *116*; Jessica Strang, *12, 108*; Syndication International Ltd., *111, 113, 128(top)*; Andreas Lehmann/ Thomas Tisch, *51(right)*; Joan Hix Vanderschuit, *36(left), 44, 112, 124*; Victoria Society of Maine, *94*; Peter Vitale for J.P. Molyneaux, *13*; Bob von Normann for The Gingerbread Mansion, *135*; Elizabeth Whiting, *6(center), 49(left), 50, 56, 61, 85, 88, 93, 101, 129(top)*; Winans Construction Incorporated, *48(right)*.